THE SECRET MESSAGE
OF TANTRIC BUDDHISM

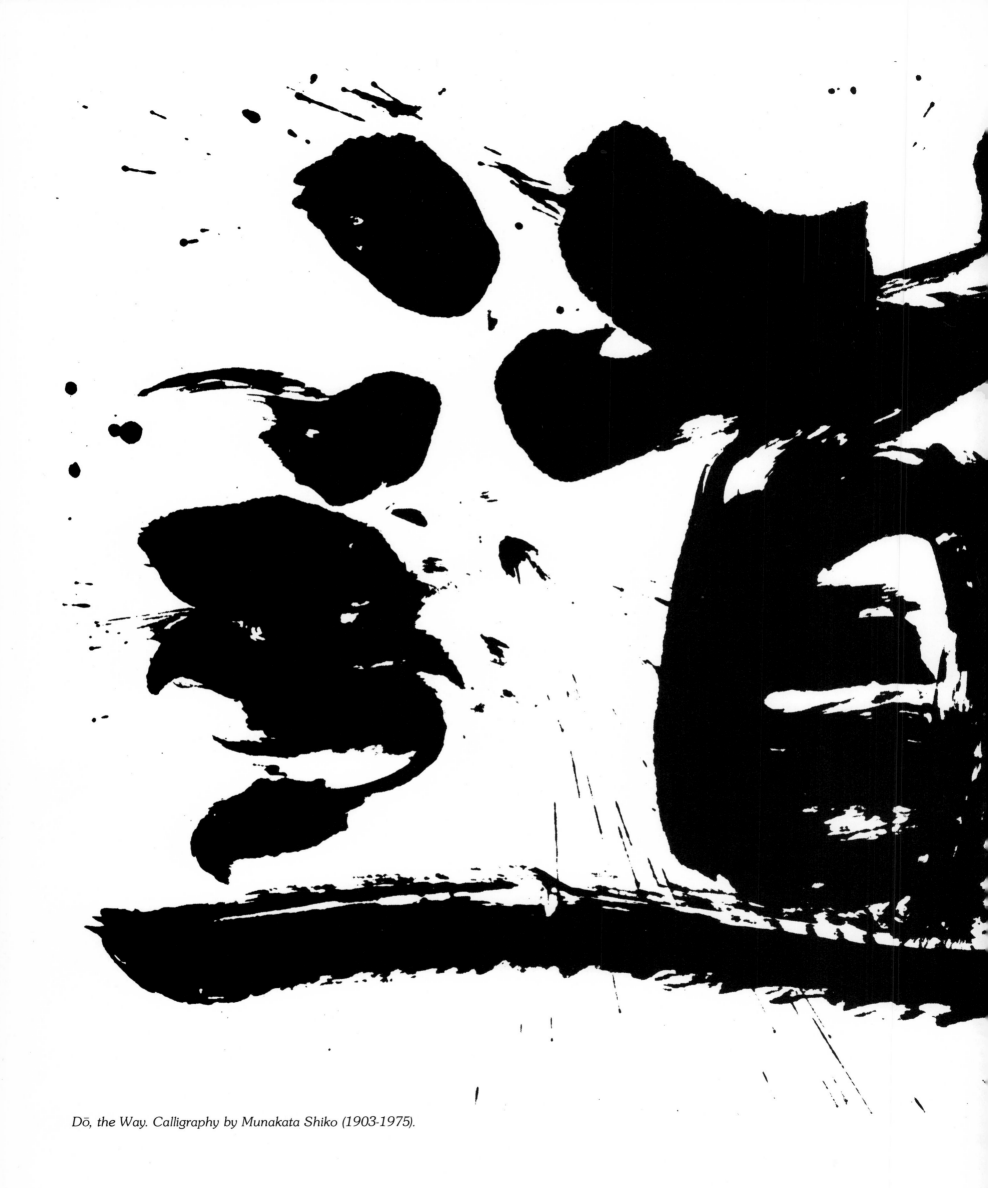

Dō, the Way. Calligraphy by Munakata Shiko (1903-1975).

Pierre Rambach

THE
SECRET
MESSAGE
OF
TANTRIC
BUDDHISM

RIZZOLI
NEW YORK

Published in the United States of America in 1979 by

RIZZOLI INTERNATIONAL PUBLICATIONS, INC.
712 Fifth Avenue/New York 10019

Translated from the French by Barbara Bray

Library of Congress Catalog Card Number: 78-58701

ISBN: 0-8478-0192-6

Printed in Switzerland

The way of the mandalas

There are many Ways of attaining Enlightenment, of becoming aware of our own true nature. Some of these Ways, based essentially on the various techniques of yoga, were first discovered in India and later taken up by the Chinese, who adapted them to their particular purposes without abandoning their own traditional Way of Tao. The Japanese in their turn borrowed the Chinese Ways, with their elements of Taoism, and practised them in a modified form while at the same time retaining their ancestral Shinto religion (the Way of the Spirits). Dō or Tō is the Japanese reading of the ideogram Tao. In Japan, any art or technique may be regarded as a Way to Enlightenment. The West has taken an interest in some of them—the Way of tea, the Ways of flowers, of archery, of agility (judō). But there are many others: the Way of the paint-brush, the Ways of music and of perfumes (incense). One of the maxims in the *Sakutei-ki* or *Secret Book of Gardens* tells us that one purpose of the Japanese garden was to lead the inmates of the house to which it belonged along the path to Enlightenment.

The poet Zen Ikkyū (1394-1481), although he experienced a first Enlightenment at the age of twenty-six, declared that passionate love, with which he became acquainted when he was seventy, was the Way par excellence.

So anyone seeking to know his own true nature may choose the Way that seems best suited to his character, talents and tastes. But to advance along that Way he must seek and find a Master. For all ways are initiatory, taking some time and involving some degree of difficulty, and all, after a certain level has been reached, are secret. Every School of Buddhism naturally puts forward its own Way as the most effective.

This book describes the Way of the Mandalas, the Way advocated by the Masters of esoteric Buddhism, one of the Ways which are swift but hard. The choice was made not out of a morbid love of difficulty, but because the Way of the Mandalas is still very little known outside Japan, where it is still practised, and also because in the matter of iconography it is one of the most richly endowed of all the Ways.

The Way of the Mandalas or Way of Images is so called because it cannot dispense with visual aids: drawings, paintings and sculptures executed according to a system of symbols which originated in India. Its liturgical language is Sanskrit, which has no connection with Chinese or Japanese but is very close to certain European tongues. Thus, paradoxically enough, esoteric Buddhism's difficult Way of the Mandalas, which comes to us from the Far East, is in a way quite near to us, and the symbolism found in its iconography has links with Western symbolism both Christian and pre-Christian.

It seems to me that the reproduction of these esoteric images, here mostly Japanese, will, far from disorienting the reader, enable him to glimpse the Way to which they belong, so that as he perceives their fundamental meanings and responds more fully to their appeal, he will at the same time inevitably be led to make comparisons with his own culture and its modes of expression, and thus be brought nearer to the object of all art: that knowledge of the Ultimate Reality of the Universe which is also the knowledge of his own nature.

With this end in view I have avoided the usual distinctions between official and popular, major and minor art, and present on an equal footing works ancient and modern, known and unknown, whether they are the boast of a museum or temple or lie neglected along some pilgrims' way. The examples have been chosen for the message they contain or the comparisons they suggest rather than for their appeal to contemporary taste, still all too often influenced by the aesthetic criteria of classical antiquity.

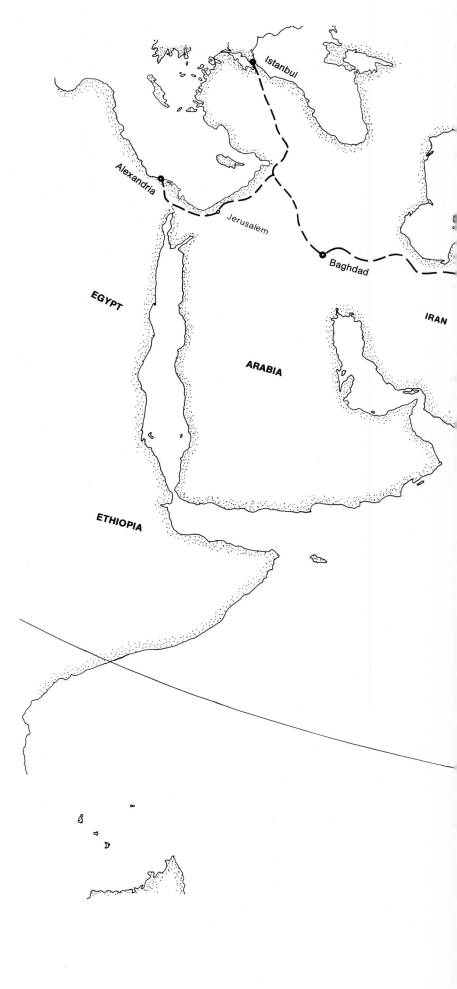

The Way of the Mandalas, born of the fusion between the highest metaphysical speculation of Northern and Southern India, could not enter China until that other great creative country had been brought into contact with India by the expansion of the Celestial Empire. Indian missionaries, making their way round the insurmountable barrier of the Himalayas, were then able to reach the capital of T'ang China. We shall see later how from there the teaching of the Way of the Mandalas spread to Japan, but this map shows us already that Ch'ang-an, the T'ang capital, was also linked to the Mediterranean by a route frequented in the eighth century by Muslim caravaneers whose civilizing influence reached as far as the centre of France. Thus ideas were able to circulate from the shores of the Pacific and the Indian Ocean to those of the Atlantic. Now, in the second half of the twentieth century, with the end of Europe's destructive hegemony over the rest of the world, and with the recent alliance between the two great powers of China and Japan, perhaps we shall again see ideas making their ancient journey from East to West.

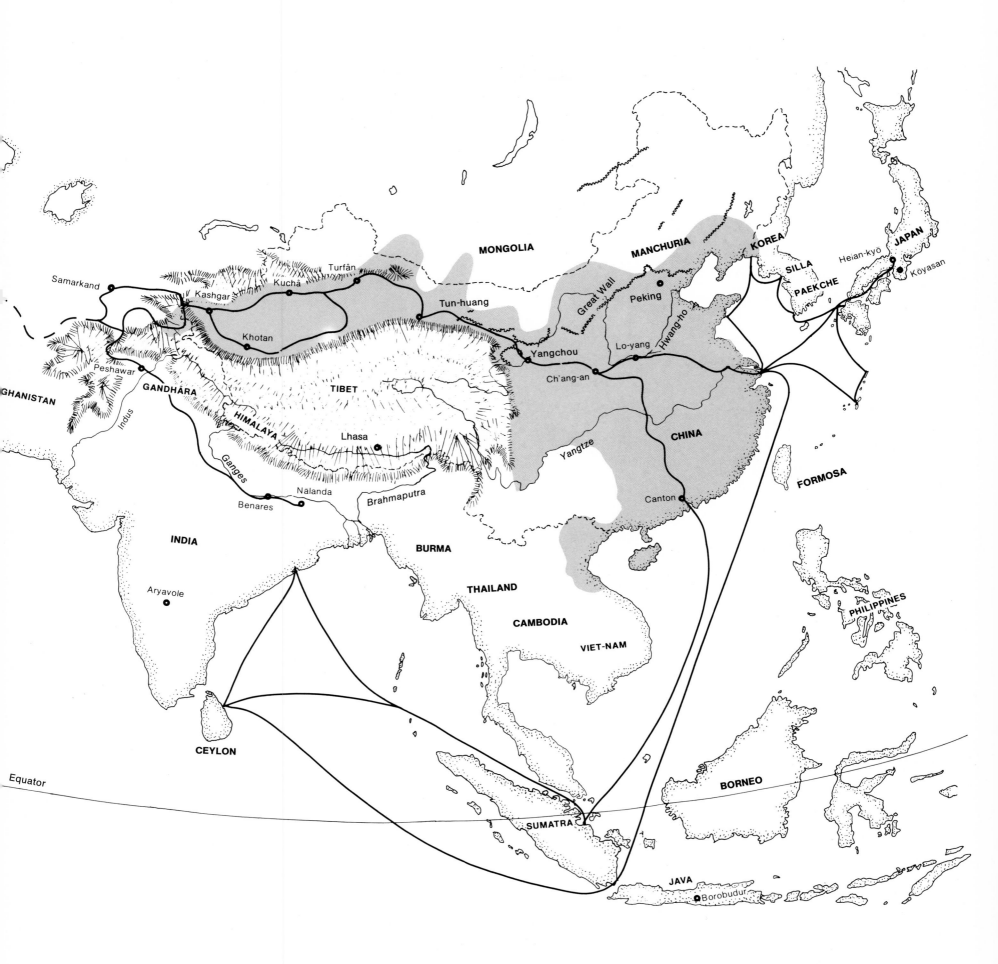

*The paths followed by the Third Vehicle
in the seventh and eighth centuries, and T'ang China.*

Drawing of the Buddha Śākyamuni in the Asuka-dera.

Transmission to Japan
of the secret teachings
of India

The Eight Patriarchs
of the esoteric tradition

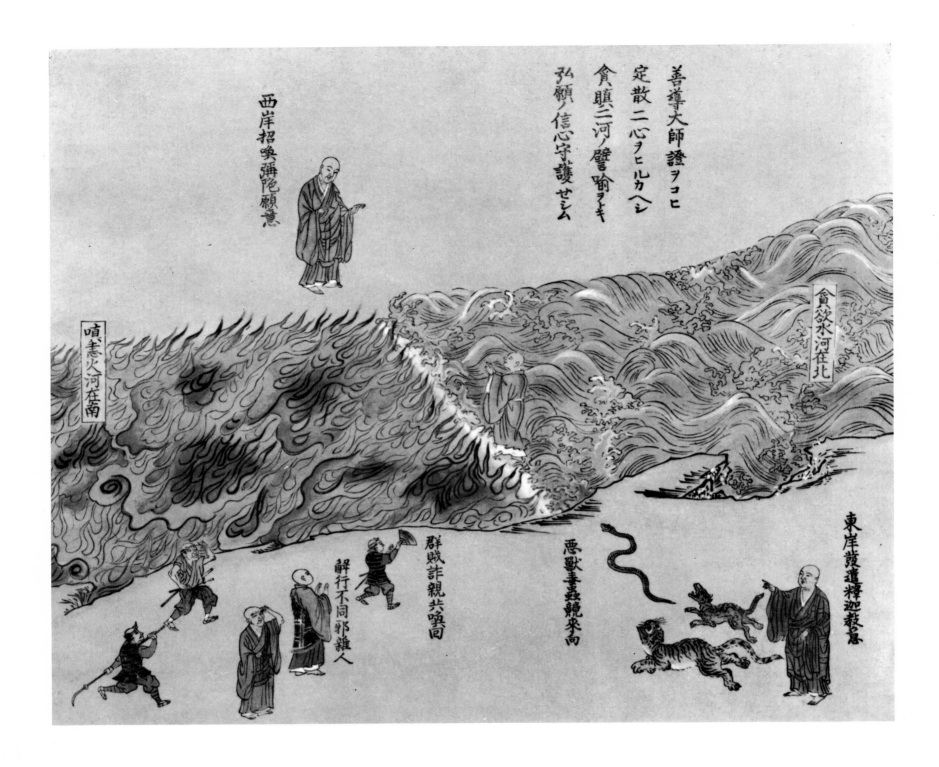

善導大師證ヲコヒ
定散二心ヲヒルカヘシ
貪瞋二河ノ譬喩ヲトキ
弘願ノ信心守護セシム

西岸招喚彌陀願意

貪欲水河在北

瞋恚火河在南

東岸發遣釋迦教意

群賊詐親共喚回

惡獸毒虫競來向

解行不同ノ邪雜人

A monk attempts to cross the river—to escape from
saṃsāra, the realm of the Relative, and attain nirvāṇa,
the Absolute. He is urged on by the historical Buddha,
who can be seen in the lower right-hand corner (east).
The way is strait between the river of Water to the north
(greed) and the river of Fire to the south (hatred). The
monk can no longer turn back because fierce animals
and brigands lurk on the bank he has just left. On the
other bank the Amida Buddha awaits him in his Pure
Land of the West. The monk does not yet know that
deliverance lies within his own existence and that there is
thus no river to cross. Coloured print, eighteenth century.

THE PARADOX OF BUDDHISM AND THE SILENT SAGE

In the India of the fifth century BC, in the depths of the forest, in mountain caves and on the roads, wayfarers must often have met with Buddhist ascetics and Jain monks travelling singly or in small groups. They practised every kind of austerity and mortification in an attempt to eliminate all attachment and desire and thus, as they believed, to leave the shores of illusion behind, cross the river of migration (saṃsāra) and land on the shore of deliverance (nirvāṇa). In modern terms we might express this as leaving the realm of the Relative in order to attain the Absolute. But the contrast between Relative and Absolute is one of the illusions due to the imperfect functioning of the human mind, for if the Absolute exists it is the All, which by definition includes the Relative. And so there are no two shores, there is no river to cross, and no opposition between saṃsāra and nirvāṇa. Duality will cease to exist if we undo the chains that fetter our minds. The duality of mind and body is also an illusion. Mortification of the flesh is therefore not merely useless but positively harmful. Desires cannot be eliminated, because they are one aspect of the All. It is said that Siddhartha Gotama became the Buddha after having accepted a bowl of rice from a woman. According to a theory recently put forward by a group of Japanese experts working with Professor Nakamura, the Buddha was born in 483 BC, not 560 BC as was previously thought. In that case it would be in 444 BC, after nine years of wandering, that he became the Enlightened One. Siddhartha Gotama, of the princely clan of the Śākya, is known to history by the name of Śākyamuni, the silent Śākya. The Sanskrit word muni, which is translated as "sage" or "saint," in fact comes from mauna, meaning silence. "Those who speak know not; those who know speak not." Anything that may be said about the Absolute is untrue by virtue of the very fact that it is said, with words which belong to the realm of the relative. And so the Buddha did not try to explain what Tathatā —Thusness, Things-as-they-are—was, to the countless disciples attracted by his spiritual influence. There is no Beyond or hereafter. There is no difference in kind between enlightened and unenlightened. Awakening is only becoming

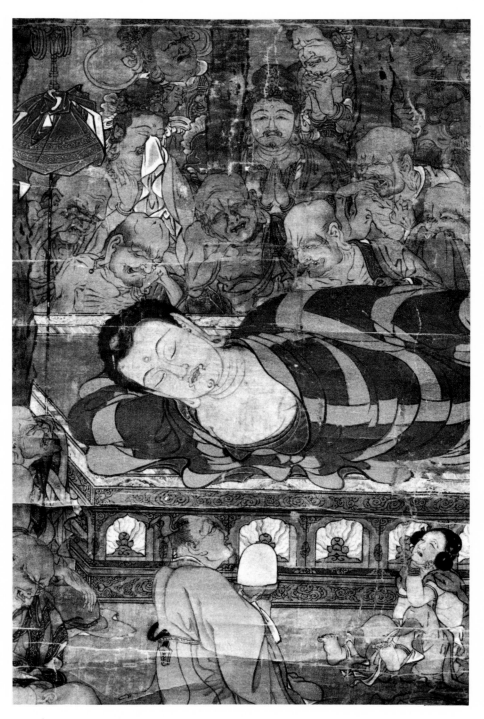

The Śākyamuni Buddha, surrounded by his weeping disciples and by praying gods, attains parinirvāṇa *at the age of eighty, without having been able to explain to men the content of his Enlightenment. Detail of a painting on silk, fourteenth century.*

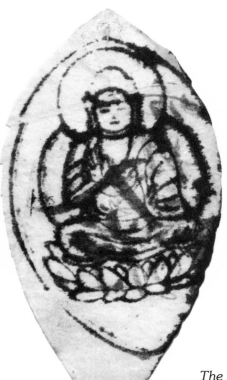

The Master of Medicine. Ink on paper cut out in the shape of a lotus petal. Dated 1207.

aware of what IS. In the fifth century before Christ mankind was not yet ready to understand this message, so the Buddha was silent about the content of Enlightenment. He confined himself to a diagnosis of the disease which afflicted humanity ("All life is suffering"), stating its cause ("The cause of suffering is ignorant desire"), to declaring that "it is possible to abolish suffering," and to presenting the cure (the Noble Eightfold Path). Thus the Buddha acted not as a prophet but, in listing the "Four Noble Truths," as a physician to the age he lived in. At the request of his disciples he agreed to spend the rest of his life as a sort of hospital administrator, organizing a monastic order and working out rules and practices which would enable his contemporaries, men and women, to aspire towards spiritual cure, Illumination, with the best possible chance of success and relying solely upon their own strength. It is thus, in the guise of the "Master of Medicine" (in Sanskrit, Bhaiṣajyaguru; in Japanese, Yakushi Nyorai), that we shall often encounter the Buddha in the temples of Japan from the seventh century on, before the secret teaching reached there at the beginning of the ninth century.

THE MASTER OF MEDICINE

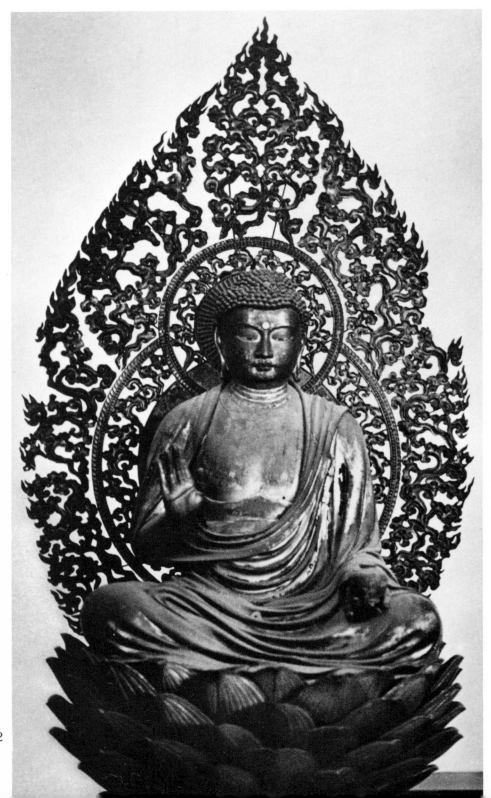

The Master of Medicine in the Tōdai-ji in Nara. Heian period (794–1184).

The Master of Medicine (Yakushi Nyorai) in the kōdō of the Horyū-ji in Nara. Cypress wood sculpture carved in 990, height 2.47 metres.

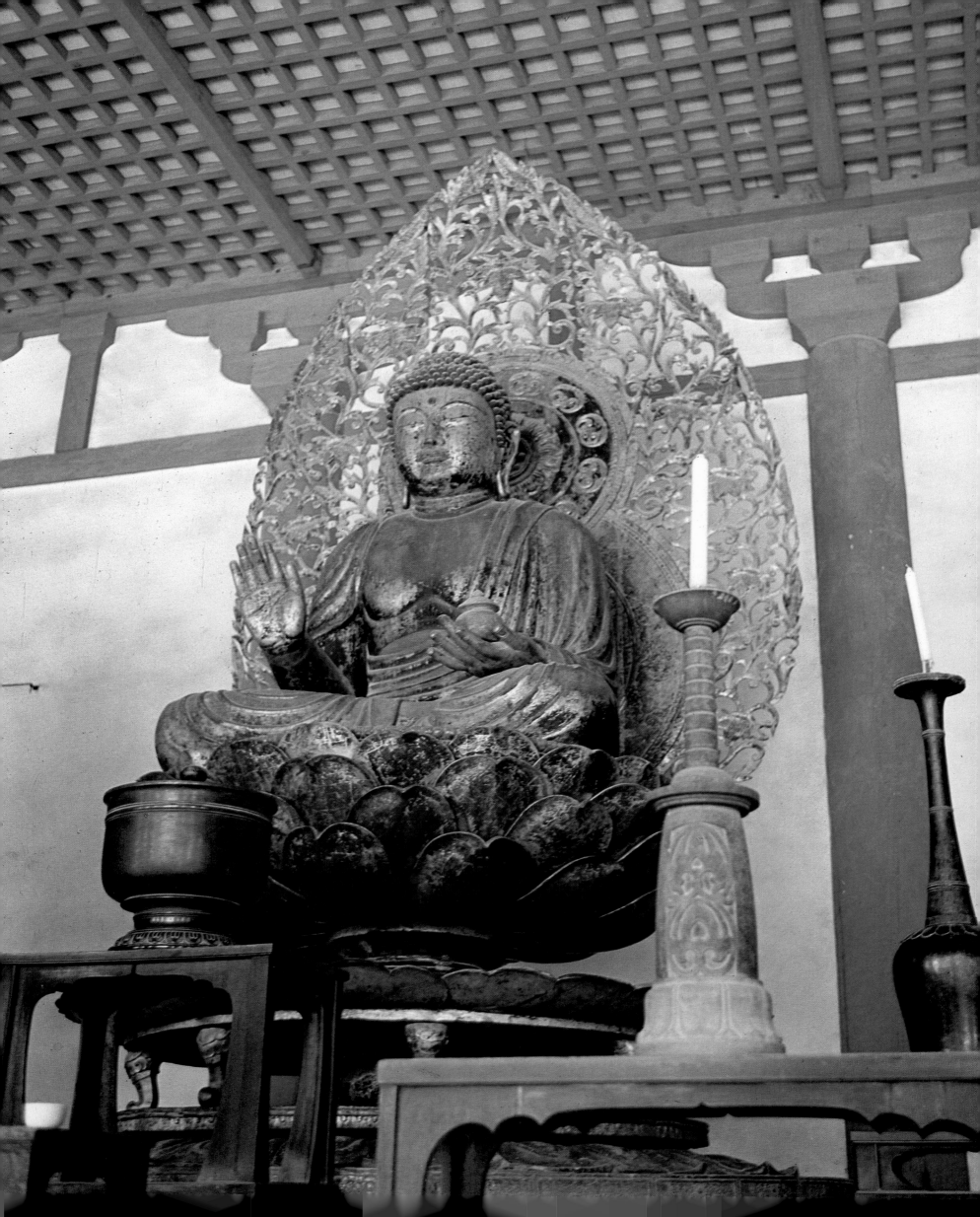

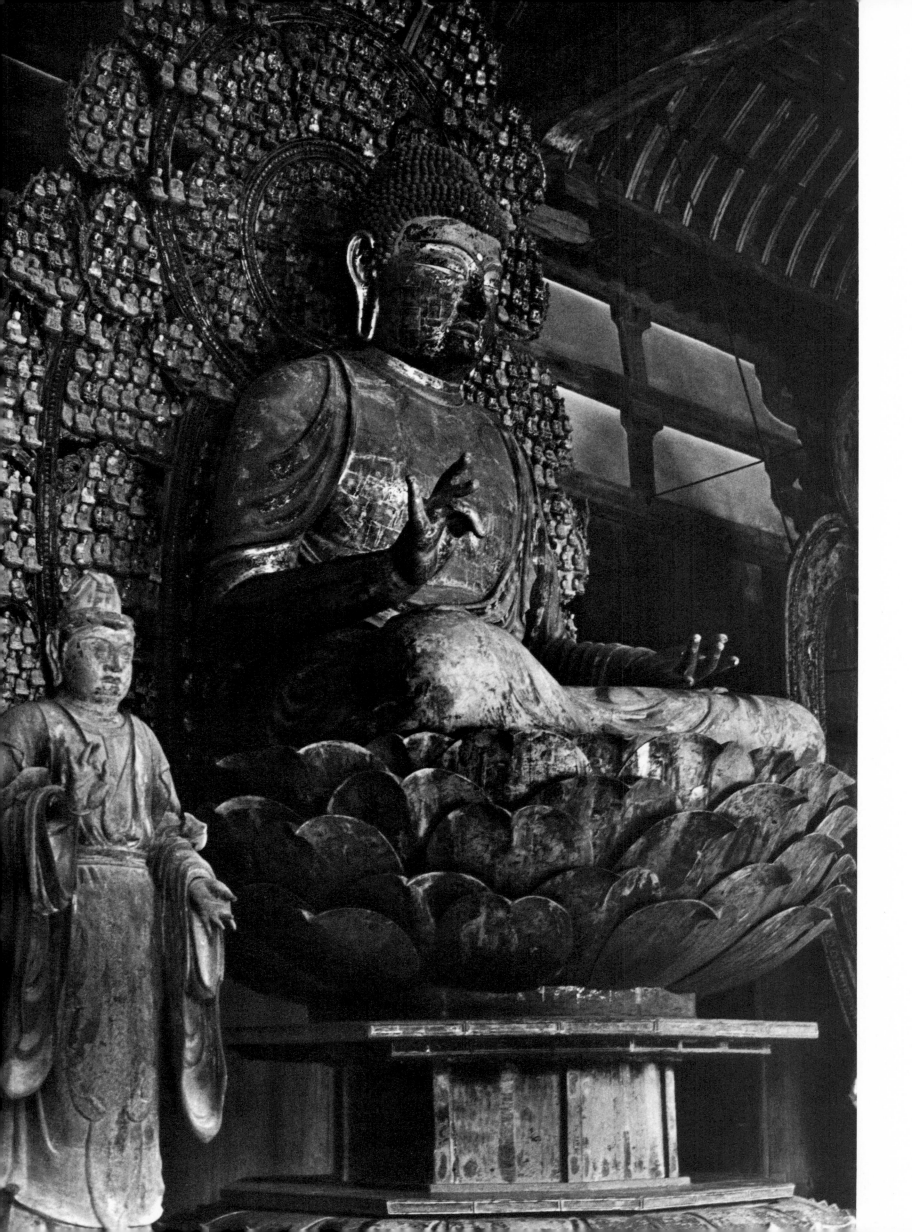

THE TATHĀGATA, THE GREAT ILLUMINATOR

The great "achievement" of the Buddha was to prove that Enlightenment *(bodhi)* was accessible on earth to human beings *(sattva)*. The Buddha was neither the first nor the last man to attain the state of "illumination." The illuminating principle thus exists independently of all the Buddhas themselves. It is the Tathāgata, "He who has become aware of Tathatā," of "Things-as-they-are." The historical Buddha is simply one manifestation of Tathāgata, also called Mahāvairocana, the "Great Principle of Enlightenment." Although the Buddha could not reveal to ignorant mankind the content of Enlightenment, of *Tathatā*, his message was not lost: it was heard by the mythical disciple Vajrasattva, who enclosed it in a *stūpa* of iron until the right moment should come for it to be revealed. Vajrasattva, "Creature of Diamond" (which by its hardness symbolizes Wisdom), is an image of humanity, and the *stūpa* of iron represents the human heart.

A hundred years after the Buddha's death, by which time many Buddhist communities had sprung up, there arose the first disagreements about methods of "cure," which some people judged too difficult. The monk Mahādeva brought about the first schism by relaxing the rules. Reacting against the formalism into which those he called "the Elders" *(sthavira)* had fallen, having already divided themselves up into eleven Schools of thought, Mahādeva proclaimed that any man could become a Buddha even without entering a monastery, and that it was no longer forbidden to use *mantra* (magic formulas) as an aid to meditation. He was also the originator of the *Mahāyāna* or Great Vehicle, open to all who follow the path of deliverance; he scornfully referred to the method of the "Elders" as the *Hinayāna* or Small Vehicle. In the centuries that followed, Mahāyānist thinkers divided into two Schools: the "School of Mind-Only" and the "School of Wisdom." According to the first, the world of phenomena is the product of human thought, and the four consciousnesses of which it consists must be transformed into wisdom, the four wisdoms of the Tathāgata. The monks of the "School of Wisdom," known also as the "School of the Middle," stressed the non-substantial nature of the Ultimate Reality of the Universe, which they called *śūnyatā* or the Void. The sages of this School, by exploring the concept of the Void in all its implications and in particular by asserting the emptiness of time, would soon be able to disclose what the Buddha himself had been unable to reveal to men. Humanity was about to receive the secret message of the Tathāgata, of Mahāvairocana, the Great Buddha of the Sun.

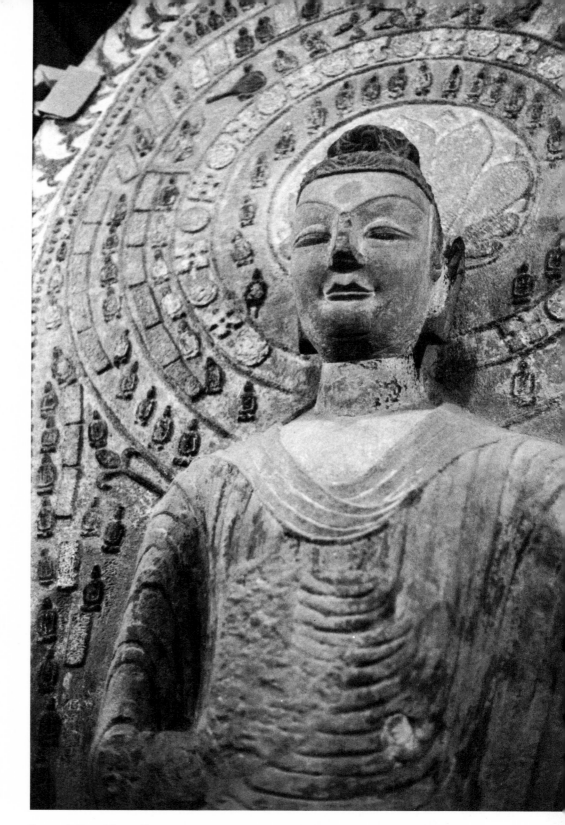

One of the oldest Chinese representations of the Tathāgata. Middle of the fifth century. Northern Wei dynasty.

◄ *The Vairocana Tathāgata (Roshana butsu) in the Tōshōdai-ji in Nara is the oldest Vairocana in Japan to have remained in its original setting, which is a faithful reflection of the T'ang temples in China. According to tradition this sculpture, 3 metres high, was made by Chinese and Japanese artists in 759. The body and head are made up of a figure of lath covered with thirteen layers of lacquered fabric; the hands are of solid wood, painted. Of the thousand Buddhas in the halo, 322 are original and the rest were redone between the twelfth and sixteenth centuries. They are the Buddhas of the three worlds, present, past and future. Vairocana, the Illuminating Principle, is seated on a lotus flower, an image of the incommensurability of the Universe and of the interpenetration of the worlds. Each petal represents a universe made up of a hundred times a hundred million worlds.*

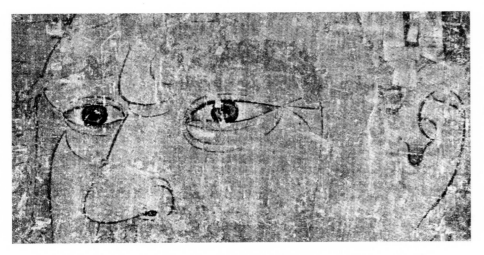

The eyes of Nāgārjuna (Ryūmyō), the Third Patriarch of the "ritual tradition," First Patriarch of the "propagation of doctrine." Detail of the original painting brought back by Kūkai from T'ang China in 805 and preserved in the Tō-ji in Kyōto.

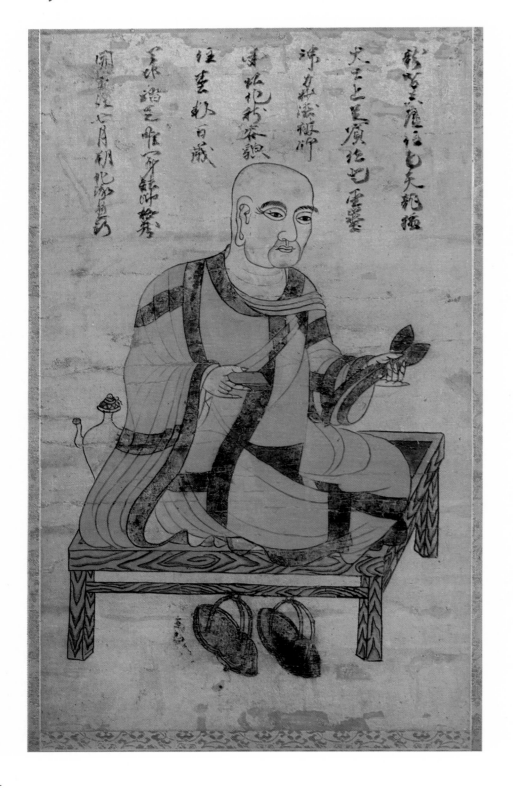

Nāgabodhi, the Fourth Patriarch of the "ritual tradition," Second Patriarch of the "propagation of doctrine." Coloured print, 1426.

THE APPEARANCE OF NĀGĀRJUNA IN SOUTHERN INDIA

Eight hundred years after the Buddha's death, in the last years of the fourth century AD, Nāgārjuna appeared in Southern India. He opened the "*stūpa* of iron" and found himself face to face with Vajrasattva, who gave him the "Great *Sūtra* of the Two Principles." With Nāgabodhi, Nāgārjuna's disciple, we emerge from the realm of myth and enter that of history. Nāgabodhi is regarded as the Fourth Patriarch of Esoteric Buddhism, the first being the Tathāgata himself, the second the mythical Vajrasattva, and the third the legendary Nāgārjuna. It should be noted that since the Indians, unlike the Chinese, never bothered to set history down in writing, our historical knowledge of the India of antiquity is chiefly derived from accounts brought home by Chinese pilgrims.

THE FOURTH PATRIARCH

If Nāgabodhi was Nāgārjuna's disciple he must have lived in the fifth century. But we come across him again in the eighth century in Southern India, in Ceylon, and in the monastery of Nālanda. Did he live for several centuries, as his disciple Śubhakarasiṃha (637–735) claimed? Śubhakarasiṃha's own burial stele bears the inscription: "My Master's face was that of a man of forty; but he was already eight hundred years old." It is more probable that the name Nāgabodhi refers to two members of a line of sages who handed down the secret teaching from one to another between the fifth and eighth centuries. It was during those four centuries that the doctrine of Esoteric Buddhism took shape. But Buddhism, by adopting tantric ideas, encouraged a revival of the ancient Brahman ideas which led to the rise of Hinduism, and in the eighth century Hinduism eventually overwhelmed Buddhism in India.

TANTRISM AND TANTRA

Before going any further we must explain what is meant by tantrism. *Tantra* in Sanskrit means the warp or weft of a fabric, doctrine, rule, book of teachings. In the wider sense *Tantra* signifies that which spreads knowledge; in a more restricted sense it means esoteric literature. These secret books of teaching deal with knowledge of divinity, techniques of concentration (*yoga*), and such practical religious activities as the making of images, the building and consecration of temples, methods of worship, the hierarchy of living beings, the drawing up of *mantras* (magic formulas), *yantras* (diagrams) and mandalas, and the use of *mudrās* (manual gestures which play an important part in ritual). The object of tantric practices is to obtain specific results —for example, rain—with the aid of "magical" processes. In tantric Buddhism the paramount aim was to be Enlightenment. Among the tantric ideas already present in the India of antiquity was the belief that man possessed a divine spark, but that through ignorance he was unaware of it; the belief that knowledge is useless unless it is transformed into

experience; the idea that the microcosm and the macrocosm are identical; and the belief that revelation took place not on earth but on Mount Sumeru. So deeply rooted in India were tantric ideas and practices that people probably continued to observe even those which had been refuted by the Buddha. They may be supposed to have lain dormant during the period of Buddhism's early development, only to reappear and gain in strength from the second century on.

Between the fifth and eighth centuries tantric Hinduism and Buddhism, the latter now become tantric too, continued side by side. The support of the Emperor Asoka (264–227 BC) had helped Buddhism to spread and establish itself firmly in India, but at the beginning of the fifth century AD the last Buddhist empire, that of the Guptas, collapsed before the Hun invasion. The small kingdoms which then sprang up in the various provinces were ruled over by Hindu kings. Buddhist communities, no longer subsidized, could not afford now to build churches and monasteries; many people even had to give up the religious life. Judging from the archaeological evidence, the fifth century, when the earliest Hindu temples were making their appearance, was a period of withdrawal for Buddhism. The early Hindu temples are still standing, and can be seen in a fair state of preservation in the little village of Aiholli in the middle of the Deccan, in roughly the same latitude as Goa. They are the work of the first kings of the Chalukya dynasty, who came from the north, as is indicated by the name they gave to their first capital: Aryavole, or the city of the Aryas. The earliest temple of all, which was consecrated to Viṣṇu, is built like a Buddhist church, and the face of the god recalls that of the Buddhas of the Gupta period. But later temples mark the beginning of a new art which was a perfect reflection of tantric ideas. These ancient Chalukya temples are the oldest known attempts to transcribe in stone and in the three dimensions of space the secret yantras and mandalas which epitomize the Hindu view of the world. The temple represents the Universe, seen as a great Being with gods and goddesses symbolizing its function, energy and will. The phenomenal world is the materialization of the divine thought, but since thought is nothing if it is not action, the inseparable couple, Thought-Action, Cause-Effect, are represented in terms of the god and his consort, his śakti, his creative energy. Sexual symbols already played an important part in these early temples. The cubic shrine, an image of the Earth, is surmounted and penetrated by a curved tower, the sky, the sun, thought, the phallus of Śiva. The gods are represented in their dual aspect, male and female, Śiva-Parvati, Viṣṇu-Lakṣmi, and sometimes androgynously. The outsides of the temples swarm with life, and it is easy to distinguish the hierarchy of beings in their ascending order. The inside of each temple is empty. In the middle is the linga, symbol of creation, the phallus of Śiva emerging from the yoni or vulva of the goddess.

Neither at Aiholli, where there are a hundred or so temples, nor at Badami or Pattadakal, the two subsequent capitals nearby, did I see any trace of Buddhist architecture; but on the other hand there is no evidence of religious persecution or intolerance. At Badami there is a temple hewn out of the cliff in the sixth century by Jain ascetics, with an inscription recording a gift made to the community

Viṣṇu of the post-Gupta period at Aiholli, 550 AD.

TANTRIC HINDUISM IN THE FIFTH CENTURY

Chalukya art: Androgynous Śiva, sixth century, and divine couple, seventh-eighth century.

17

HINDU TEMPLE AND BUDDHIST MANDALA

Sixth-century Hindu temple.

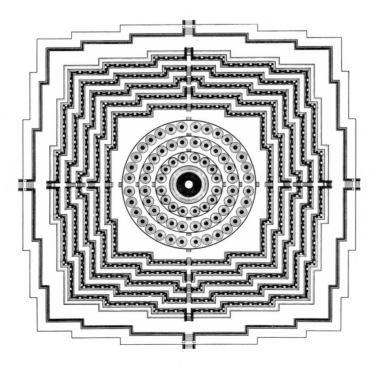

Plan of Buddhist temple at Borobudur in Java. The base represents the "pattern" of the passions, the five stepped terraces the "pattern" of form, and the three circular terraces the "pattern" of non-form.

by a Chalukya king. But although Buddhism was no longer to be found in the Deccan, it has not disappeared. Gathered together in the great monasteries in the north, like Nālanda, or living in small communities in the south, there were monks influenced by the same tantric ideas who drew up the second basic text of esoteric Buddhism. This was the *Mahāvairocana Sūtra,* the Sūtra of the Great Illuminators, a product of the latest stages of the "School of Wisdom," which stressed the idea of the Void as the Ultimate Reality of the Universe. It was not so much a metaphysical treatise as a detailed description designed to make possible a graphic representation of the *Garbhadhātu maṇḍala,* the mandala based on the Womb or uterus. All the Buddhist deities are classified and arranged around the central Mahāvairocana. Forming an outer border are all the Hindu divinities incorporated into the Buddhist pantheon and regarded as aspects or emanations of the Tathāgata. The analogy between this mandala and contemporary Hindu temples is striking. Like the temples, the mandala is in the form of an oriented square; there are doors on each of the four sides; the symbols employed are the same. The reason why Buddhist temples built on the model of the Womb mandala have not been found in India is that the role of the Buddhist mandala was quite different from that of the Hindu temple. The mandala was intended to help transmit the secret teaching and to act as an aid in the initiatory ritual leading to individual Enlightenment, whereas the Hindu temple was built by a prince so that Brahman priests could celebrate rites there which would afford his kingdom divine protection.

While for political reasons Buddhism seems to have declined in India itself from the fifth to the eighth century, it continued to flourish in Ceylon, Burma, Thailand and Cambodia, and its influence spread to China and Java. In the latter two countries especially, Buddhist missionaries endeavoured to make known the latest developments of the Mahāyāna. In 520 AD Bodhidharma, who came from southern India, landed in Canton and began to teach one of the most highly evolved forms Buddhism has ever attained. It was based essentially on the practice of meditation (in Sanskrit *dhyanā,* which became Ch'an in Chinese), and made it possible to acquire sudden Enlightenment without the aid of the *sutras.* This direct method met with considerable success in China, and from the thirteenth century began to spread in Japan under the name of Zen. Esoteric Buddhism is seen to have been flourishing in Java at this period from the fact that the largest temple ever built on the model of a tantric mandala (113 metres square and 40 metres high) is the temple of Borobudur, erected in the middle of the island half-way through the eighth century.

THE MONASTERY OF NĀLANDA

At the beginning of the eighth century the most important centre of esoteric Buddhism was the great monastery of Nālanda in north-east India. It is here that we meet again Nāgabodhi, Fourth Patriarch of the secret teaching, under the name of Dharmagupta. At this period Buddhist "theologians" effected a synthesis between the two main currents of Mayāhānist thought—the "School of Wisdom" and the "School of Mind-Only"—declaring that the Ultimate Reality of the Universe can only be a product of our own minds and that it can only be the Void, since no component of the human mind has any substantial reality. Henceforward the two great *sutras* produced by the two Schools ceased to be the expression of two opposite ideas. The affirmation that "I am one with the Tathāgata" in all that I do—the three kinds of act, of body, word and mind, all being supposed to coincide with those of the Tathāgata—meant that a dialectic was established between the Tathāgata and ordinary Beings, between the One and the Many, between Absolute and Relative. The two mandalas described in the two sūtras no longer represented two different trends, but stood rather for two aspects of an Ultimate Reality which was in fact the Void.

TANTRAYĀNA, THE THIRD VEHICLE

After the Great and Small Vehicles, the Third Vehicle —called variously that of the Diamond *(Vajrayāna)*, of the "magic" formulas *(Mantrayāna)*, of the tantra *(tantrayāna)*, or of the mandalas *(Maṇḍalayāna)*—was to offer men, all men, the chance of attaining deliverance in the course of their present lives. The historical Buddha, it is said, predicted that his Law would not survive longer than a thousand years on Indian soil. He was right; but eleven centuries after his death the secret teaching was to spread in China, and a century later to reach Japan, where it has continued to be handed down until the present day. It was in Nālanda that the "Third Turn of the Wheel of the Law" was initiated. Nālanda is now no more than an expanse of ruins. Of the monastery which for centuries sheltered up to three thousand monks there remain only some stretches of brick wall, the relics of rows of cells, assembly rooms and library. But at the top of a polygonal tower I discerned the head of a Buddha in stucco. Was it already there when Nāgabodhi, several times a centenarian, taught at Nālanda? Was it seen by the future Fifth Patriarch, Vajrabodhi, in the year 681 when he entered the monastery at the age of ten? Could it be the oldest representation of the Tathāgata? The prototype of all the Vairocanas carved throughout the following centuries in China and Japan? I was so impressed by the radiance which emanated from this early Solar Buddha that the photograph I took of it twenty-seven years ago has been with me ever since. I am even inclined to say it was the reason for all my subsequent visits to Japan. For me, as for esoteric Buddhism, everything begins at Nālanda.

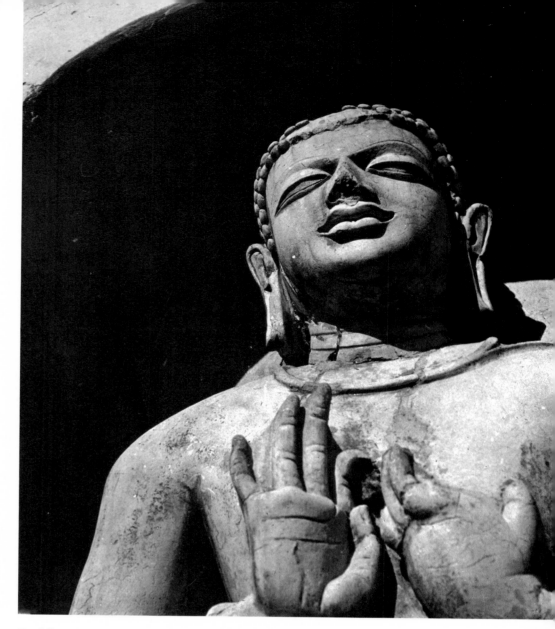

Buddha in stucco, Nālanda Monastery, eighth century.

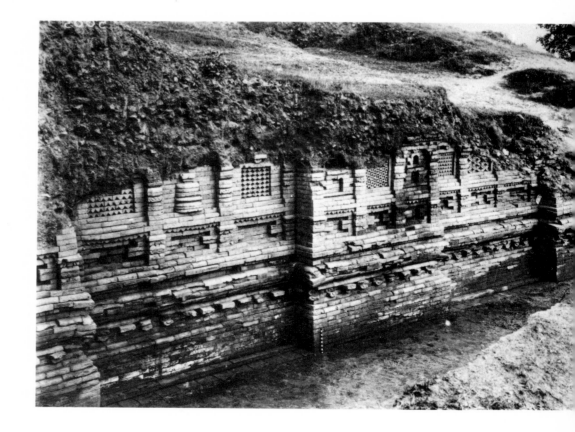

Ruins of Nālanda Monastery, buried under several metres of earth and twelve centuries of oblivion.

Śubhakarasiṃha (in Chinese Shan-wu-wei, in Japanese Zemmui Sanzō), Fourth Patriarch of the "propagation of doctrine" (637–735). Japanese copy made in 826 from the original brought back by Kūkai from T'ang China in 805.

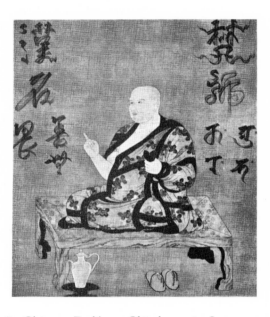

Amoghavajra (in Chinese Pu-k'ung Chin-kang, in Japanese Fūkūkongō), Sixth Patriarch of the "ritual tradition," Fifth Patriarch of the "propagation of doctrine" (705–774). Detail of the original painting brought back by Kūkai from T'ang China in 805 and preserved in the Tō-ji in Kyōto.

The Eight Patriarchs of the "ritual tradition"		The Eight Patriarchs of the "propagation of doctrine"	
Mahāvairocana Tathāgata	1st		
Vajrasattva	2nd		
Nāgārjuna	3rd	1st	
Nāgabodhi	4th	2nd	
Vajrabodhi (671-741)	5th	3rd	
		4th	Śubhakarasiṃha (637-735)
Amoghavajra (705-774)	6th	5th	
		6th	I-Hsing (683-727)
Hui-kuo (746-805)	7th	7th	
Kūkai (774-835)	8th	8th	

Vajrabodhi, in Chinese Chin-kang-chih, in Japanese ▶ Kongōgoshi Sanzō, Fifth Patriarch of the "ritual tradition," Third Patriarch of the "propagation of doctrine" (671–741). Copy of a copy of the original brought back by Kūkai from T'ang China in 805. The four Sanskrit letters, lower right, give his Indian name, and the ideograms his Japanese name.

THE FIRST INDIAN MISSIONARIES IN EIGHTH-CENTURY T'ANG CHINA

In the year 650 the young Śubhakarasiṃha, then aged thirteen, fled the throne offered him by the king his father and became a monk at Nālanda. After a lifetime spent in esoteric studies under the Fourth Patriarch, Nāgabodhi, he was sent by his illustrious Master to China. He travelled across Kashmir and Tibet, and reached the capital, Ch'ang-an, in the year 716. He was then eighty years old! His fame as a spiritual master had gone before him, and the emperor received him with great respect. He was said to have mastered the three secrets of the body, the word and the mind, and could cause rain to fall by reciting *mantras*. With the help of a Chinese disciple, he made the first translation of the *Sūtra of the Great Illuminator (Mahāvairocana Sūtra)*. The Sanskrit text consisted of more than a hundred thousand lines, and Śubhakarasiṃha translated just the essential parts in the form of a summary. He died in 735 at the age of ninety-nine.

Vajrabodhi, who was to become the Fifth Patriarch of esoteric Buddhism, was born in 671. He too came from a princely family. At the age of ten he started studying grammar at Nālanda, and then went on to apply himself to the *Sūtras* of the Great Vehicle. Between the ages of thirty and thirty-eight, after meeting Nāgabodhi in southern India and becoming his disciple, he was initiated into esotericism. He decided to go on from Ceylon to China, where he had been told that Buddhism was spreading rapidly. He embarked on one of a fleet of thirty-five Persian merchant ships which first touched land in Sumatra. After staying there for five months he sailed again, accompanied by a fourteen-year-old disciple, Amoghavajra, who never again left him and who later became the Sixth Patriarch. Thirty ships were lost in a storm during the voyage, but Vajrabodhi landed in Canton in 719, at the age of forty-eight. The emperor of China invited him to Ch'ang-an. The chronicles relate that he had altars put up in two temples for the celebration of initiation ceremonies, that he commissioned the painting of a mandala, cured one of the emperor's daughters after she had been in a coma for ten days, and like Śubhakarasiṃha could cause rain to fall. He was the author of many translations, and went on with his esoteric teaching up to his death in 741 at the age of seventy-one.

On his master's death, Amoghavajra left China for his native Ceylon, where he in his turn met the renowned Nāgabodhi, who initiated him into the secret doctrine. He travelled all over India looking for *sutras*, and returned to China in 746. The esoteric creed, which had enjoyed the favour of three successive emperors, spread through all classes of society. The second half of the eighth century witnessed the peak of esoteric Buddhism in China. Amoghavajra translated a hundred or so Sanskrit texts, and when he died in 774, at the age of seventy and laden with honours, the emperor suspended his audiences for three days as a token of mourning. The centre of esoteric Buddhism was the temple of Ta-hsing-shan, the biggest temple in the T'ang capital. At this time Ch'ang-an was the greatest cultural centre in the world. It was a tolerant, cosmopolitan city, with sixty-four Buddhist temples for men

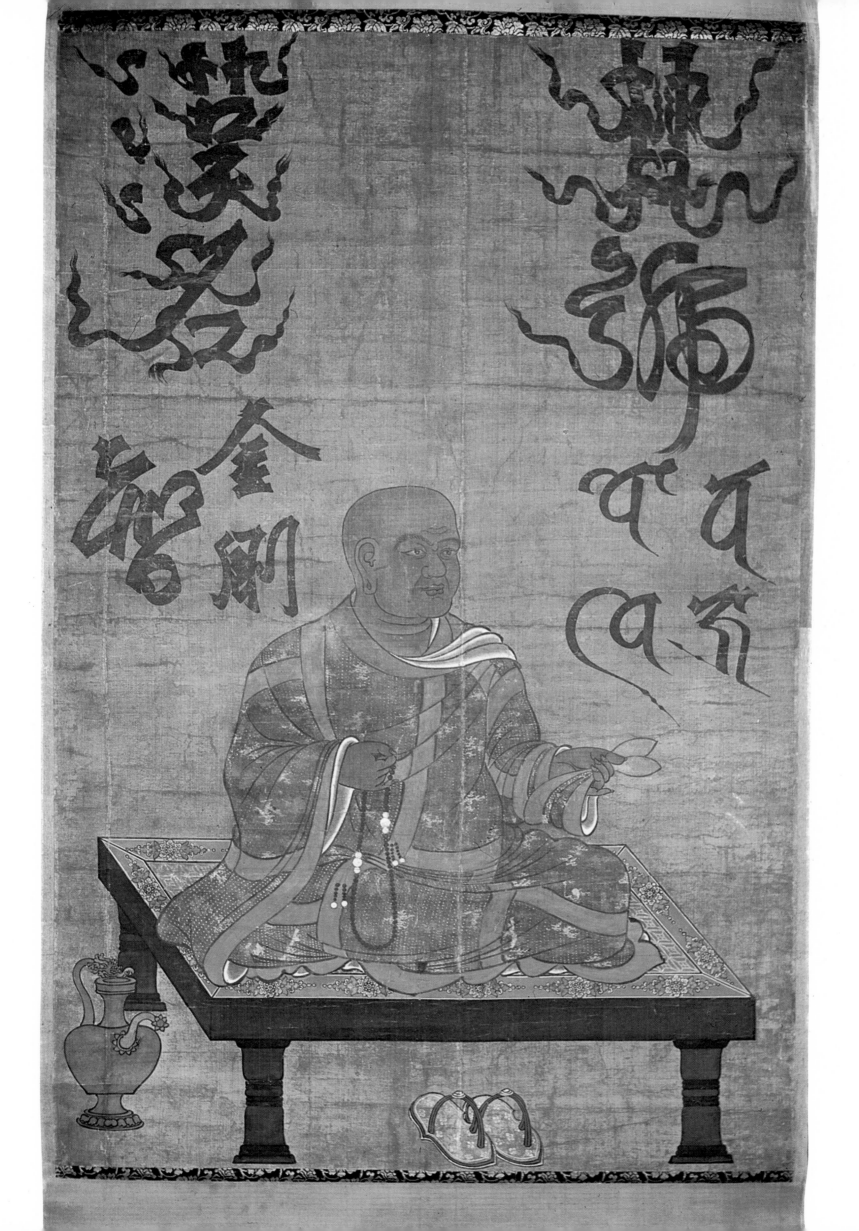

"MIXED" ESOTERIC BUDDHISM IN TIBET

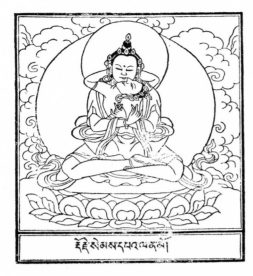

Yab-Yum, Tibetan image of the Father-Mother.

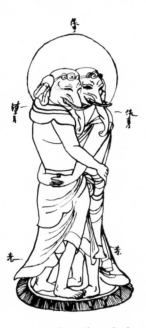

An elephant-headed couple embracing: the only erotic representation in Japanese Tantrism.

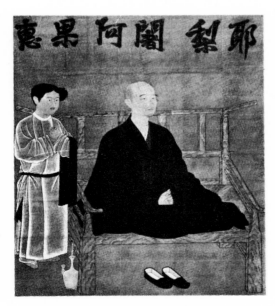

The Chinese Hui-kuo (in Japanese, Keika Ajari), Seventh Patriarch (746–805). Japanese copy made in 826 from the original painting brought back in 805 by Kūkai, who was his disciple.

and six for women, ten Taoist temples for men and six for women, and three foreign temples, of which one was Nestorian Christian and another Zoroastrian. In addition there were many Moslems, and Indian influence was very strong. The fame of the temple at Ta-hsing-shan had spread to Japan, where it was known as "the Nālanda of China."

Nāgabodhi played an essential part in the transmission of the secret teaching, not only because he initiated the Fifth and Sixth Patriarchs but also because he sent them to China. By transposing the teaching centre of tantric Buddhism from India to China, from Nālanda to Ch'ang-an, he enabled it to survive. For in India by the end of the eighth century the dividing line between Buddhism and Hinduism was becoming more and more blurred. Amoghavajra was the last Indian sage to teach the orthodox esotericism usually called "pure" or "right-handed" as opposed to that taught at the Vīkramaśīla monastery in north-west India. It was this latter "mixed" or "left-handed" esotericism which reached Tibet at the end of the eighth century. It was based on an excellent Tibetan translation of the *Mahāvairocana Sūtra*, but was also strongly influenced by tantric Hinduism, and in particular the idea of Śakti as active and creative energy, the female aspect of the god. Because of this element, sexual rites and symbols play an important part. In esoteric Buddhism, Enlightenment is regarded as the union of Wisdom—awareness of the non-existence of all phenomenal appearances—and Compassion; but for tantrists of the left hand Wisdom was female and Compassion male, and the union between the two was depicted in Tibetan iconography by the Yab-Yum, an image of the "Father-Mother," in which the deity is sexually united with his consort in a symbol of cosmic creation, a representation of the perfect union between the two aspects of the Absolute, the static and dynamic, manifested in the world in male and female form. This is only a ritual representation of the Awakening experienced by the bodhisattva and his spouse. According to the doctrine of the Void, an image is only an artifice devoid of reality, which we must abandon when we become aware of our Buddha essence. In the tradition of "pure" esotericism passed on from Nālanda to Ch'ang-an, while, as we shall see, sexual symbolism is not absent, it never occurs iconographically in the form of deities joined in the sexual act. Esoteric Buddhism was introduced into Tibet much later than into China, and to its borrowings from Shaktism must be added other borrowings from local cults and beliefs. This is why present-day Tibetan tantrism is markedly different from the kind which reached Japan from China and established itself there. When Amoghavajra died in Ch'ang-an in 774, esoteric Buddhism was firmly rooted in T'ang China. It no longer needed the aid of Indian sages, for the *sūtras* and their commentaries upon them had been translated. Moreover it was a Chinese—Hui-Kuo, his favourite disciple—whom Amoghavajra chose as his successor, appointing him the Seventh Patriarch.

Kūkai as a child is here represented as a deity of the Diamond pattern, seated on a lotus which is contained in the lunar circle of thought. Painting on silk, fourteenth century.

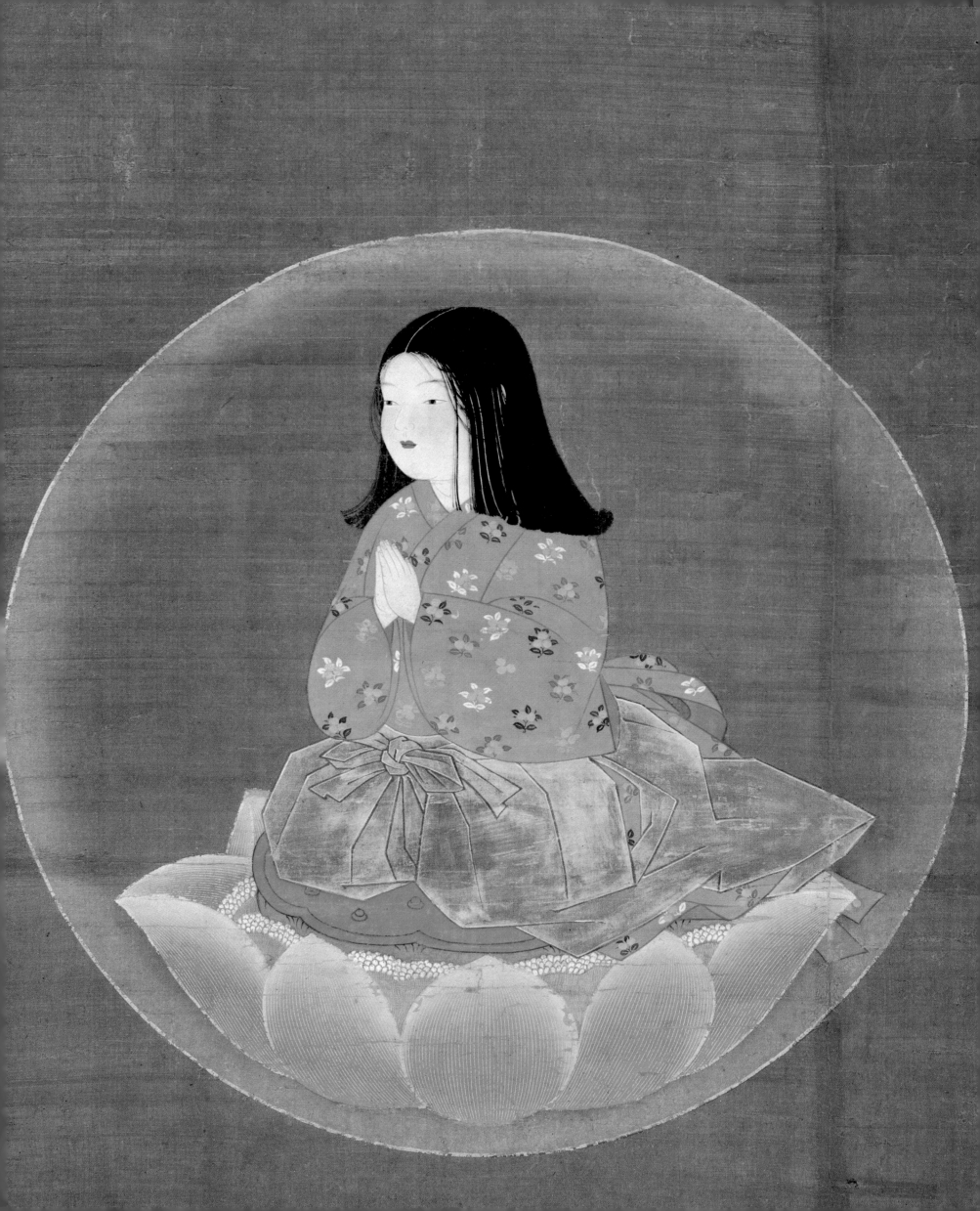

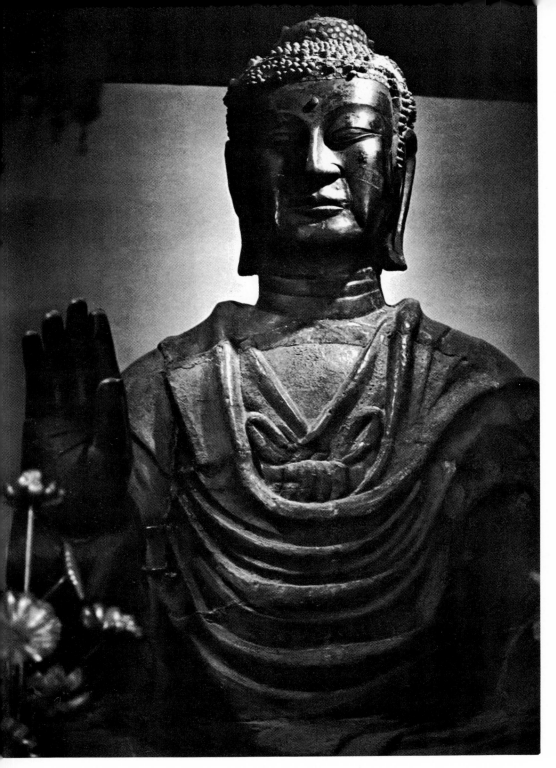

The Śākyamuni Buddha in the Asuka-dera, Nara region, executed in bronze in 606 by the Korean sculptor Toribushi, is the oldest Buddhist statue in Japan. It is 2.70 metres tall.

JAPAN IN 774, THE YEAR OF KŪKAI'S BIRTH

The transmission of orthodox esotericism was nevertheless in danger, and might have come to an end once and for all had it not been for a providential event which occurred in 774: the birth in Japan of Kūkai. Thirty-one years later, in the year of his own death, Hui-Kuo was to initiate Kūkai and appoint him Eighth Patriarch, with the task of propagating the secret doctrine in his own country. In China itself, after its period of glory under the T'ang dynasty, esotericism failed to survive the brutal persecutions to which Buddhism was subjected by imperial decrees issued between 842 and 845. In the year 845 alone, 4,500 monasteries and 40,000 temples were destroyed, and 260,500 monks and nuns were forced to abandon the religious life. After Nālanda and Ch'ang-an, Heian-kyō (present-day Kyōto) was henceforth to be the centre of esoteric Buddhism. Heian-kyō was the new capital which the emperors of Japan were in the process of building on the model of the Chinese capital.

In 774, the year in which Amoghavajra died and Kūkai was born, Japan was still culturally dependent on China. Buddhism was already very widespread in the country: in 552 an envoy from the Korean kingdom of Paekche had presented the Emperor Kinmei with a statue of Buddha and a number of Buddhist *sūtras*. The same year marked the beginning of what the Japanese called the Asuka era. There were already large numbers of Chinese and Korean workers and craftsmen living at this period in Yamato province, in which was situated the seat of the central power, Nara. It was these workers and craftsmen from the continent who, together with the latest techniques in pottery, weaving and metal-work, also introduced the Chinese system of writing, and Buddhism. The earliest sculptures of the Asuka era, completely alien to the Japanese spirit, were the work of

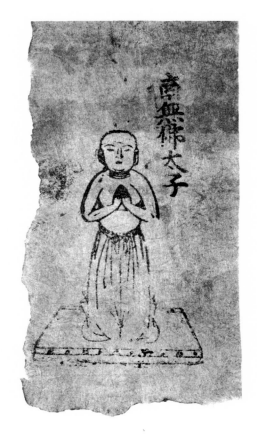

The Prince Regent Shōtoku (574–622), nephew of the Empress Suiko, who made Japan into a Buddhist state organized on the Chinese model, is here represented as a pious child. Print, fourteenth-sixteenth century.

these immigrants. In 558 the prince regent Shōtoku-Taishi, known to history as an ardent defender of Buddhism, decided to build a great temple in order to place his country under the protection of the Buddha. It took from 592 to 612 to complete the construction of the Asuka-dera (*dera* or *tera* meaning Buddhist temple). It no longer exists today, but the great bronze statue it contained, in the Korean style and dating from 606, has survived. In 607 building began on the group of temples at Hōryū-ji (*ji* also denotes a Buddhist temple), miraculously preserved up to the present time. Contemporary documents tell us that for the building of Hōryū-ji six monks, a number of carpenters and tile-makers, together with various other experts, came over specially from Korea. The year 645 marked the beginning of the Hakuhō period (645–710), during which five capitals were built one after the other and then abandoned—or rather moved, since the temples were dismantled and reassembled on new sites. Thus the Kōfuku-ji and the Yakushi-ji were transferred to their present sites at the foundation in 710 of Heijō-kyō, the sixth capital, built, like the previous ones, on the model of Ch'ang-an. Buddhism was advancing by leaps and bounds.

In the year 730 the emperor ordered a temple to be built in each of the sixty-four provinces, and in Nara commissioned the construction of the monumental Tōdai-ji, which with its huge statue of the Śākyamuni was to become Japan's central shrine. But in 730 there were already circulating in the monasteries of Nara copies of the Chinese translation of the *Mahāvairocana Sūtra* made ten years earlier by the great master, Śubhakarasiṃha. When the national temple of Tōdai-ji was finished, it was not a statue of the historical Buddha that was placed inside it, but an effigy of Mahāvairocana, the Great Solar or Cosmic Buddha. Japan was opening its doors to esoteric Buddhism. Now, in the middle of the eighth century, the monks divided their time between the study of Chinese texts and political intrigue. Some of those who saw Buddhism simply as a way of attaining salvation left the city of Heijō-kyō to preach directly to the people. Others, who had studied the first tantric texts from China and were acquainted with the new form of Buddhism which made Enlightenment possible in the course of the present life, withdrew to the mountains to meditate. The Nara clergy had become so powerful that their temporal influence threatened central government power. The emperor decided to leave Nara and found a new capital. During the subsequent fifty years, seven capitals were initiated one after the other on different sites, but work on all of them was eventually abandoned.

It was during this period of political, social and religious ferment that Kūkai was born in the year 774 on the island of Shikoku. His parents were of noble family, and when he was fifteen they sent him to study Chinese in the capital, Nagaoka-kyō, founded five years earlier. Destined for a high place in the government, he studied in college until he was twenty, when he decided to become a monk and left the city for a hermitage in the mountains. This was in 794, when the Emperor Kanmu laid the foundations of Heian-kyō. For the next ten years Kūkai lived the life of a wander-

The three-tier pagoda in the Yakushi-ji, built in 680 in the capital of Asuka and transferred to Nara in 710, is the oldest witness to Buddhist architecture in Japan.

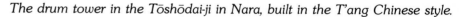

The drum tower in the Tōshōdai-ji in Nara, built in the T'ang Chinese style.

YOUTH OF KŪKAI AND DEPARTURE FOR CHINA

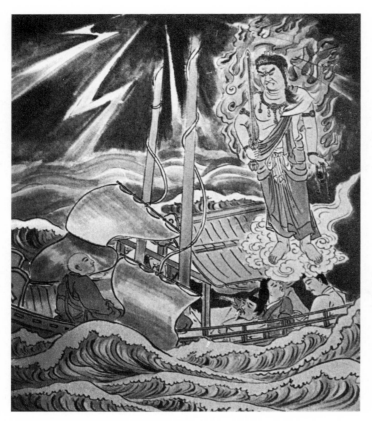

Crossing the China Sea, Kūkai is caught in a terrible storm. Fudō-Myōō appears to him.

ing monk. He meditated in the forest, studied tantric texts and dreamed of going to China to learn Sanskrit. The opportunity occurred in 804. Kūkai was able to join an expedition escorting an ambassador to Ch'ang-an. Four ships left a port in Kyūshū. The first, with Kūkai and the ambassador on board, reached China a month later. The second took two months; the third, swept away in a storm, ran aground in the south; the fourth was lost with all hands. After travelling for five months across China, Kūkai at last reached the T'ang capital. But it was not until after the Japanese ambassador had left that he met Amoghavajra's successor, Hui-Kuo, the Seventh Patriarch. A description of this encounter has survived. Here is a translation from *Sources of Japanese Tradition*, edited by Wm. Theodore de Bary, Columbia University Press, 1958: "I called on the abbot in the company of five or six monks from the Hsi-ming Temple. As soon as he saw me he smiled with pleasure, and he joyfully said: 'I knew that you would come! I have been waiting such a long time. What pleasure it gives me to look on you today at last! My life is drawing to an end, and until you came there was no one to whom I could transmit the teachings.'"

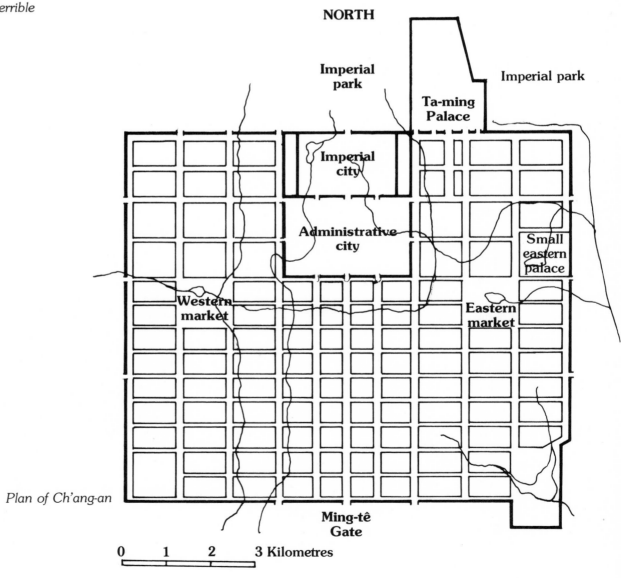

Plan of Ch'ang-an

CH'ANG-AN, THE T'ANG CAPITAL

The outer ramparts of Ch'ang-an measured 10 kilometres from east to west and 8.5 from north to south. The 25 avenues lined with ditches and planted with trees were from 70 to 150 metres wide. The town was made up of 110 walled quarters with gates which were closed at night. In the middle, an inner enclosure contained the forbidden city, made up of the imperial and administrative cities. The T'ang capital was above all an expression of the omnipotence of the state. Ch'ang-an was undoubtedly the world's biggest city in the eighth century, but it is hard to arrive at an exact figure for its population because within the ramparts there were many monasteries, temples, gardens and plots of cultivated land.

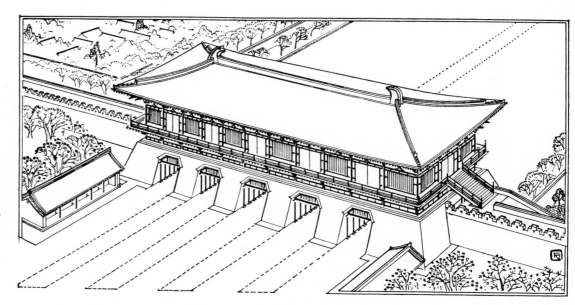

Reconstruction of the great central Southern Gate: Ming-tê, 55 metres wide. From a Chinese archaeological review, 1977.

Overall view of the imperial city of Ch'ang-an in 1735.

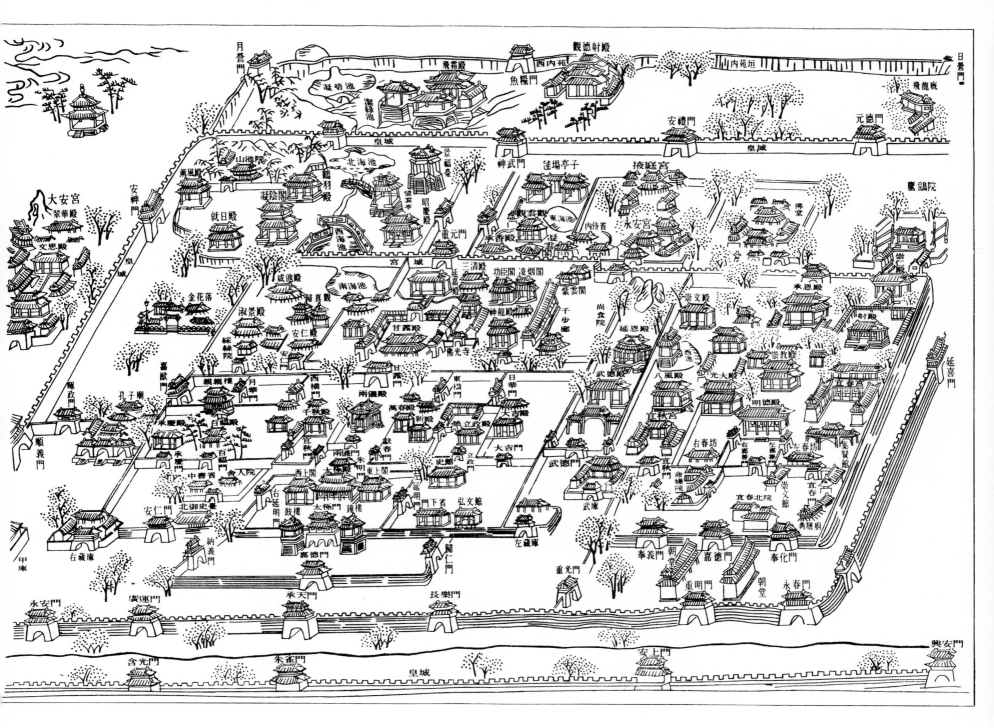

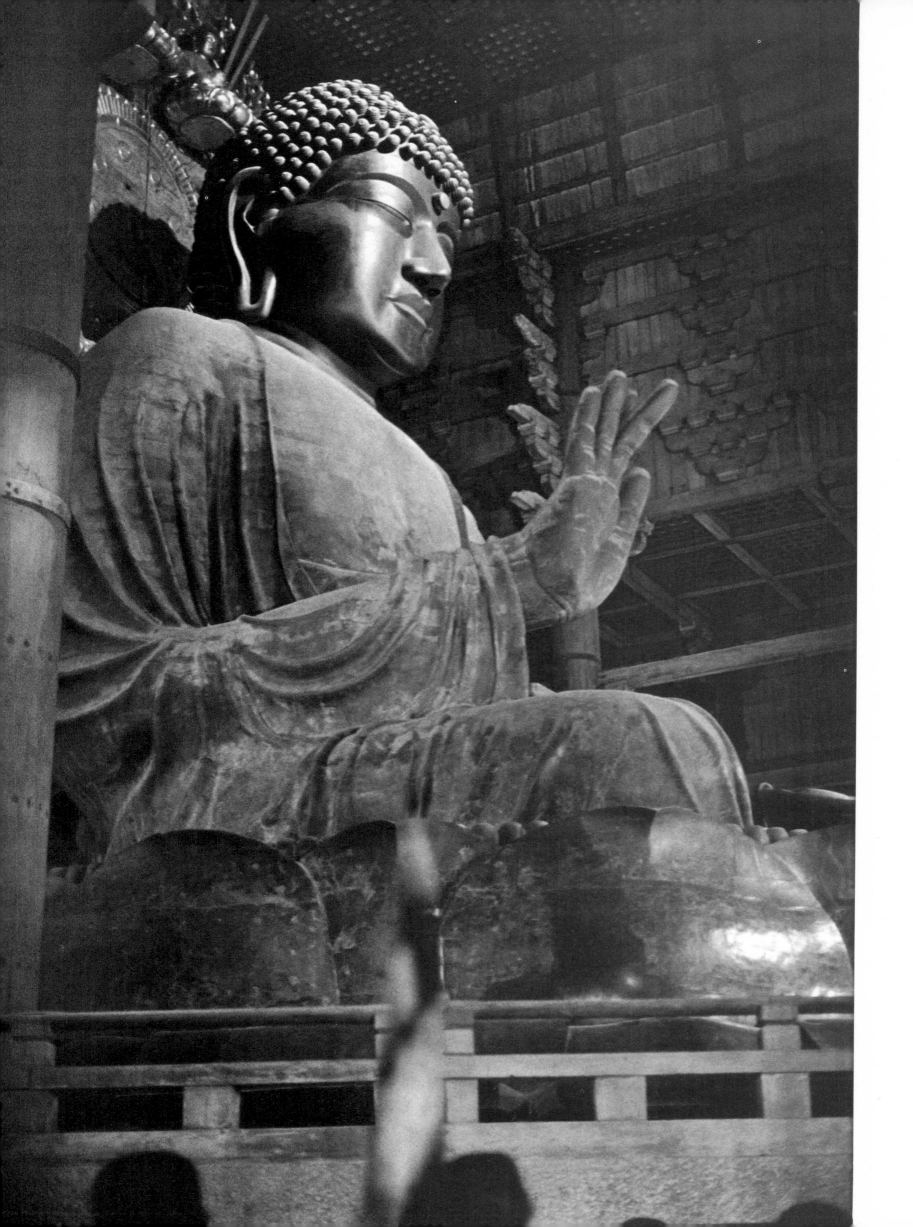

MEETING WITH THE
SEVENTH PATRIARCH

Two months later Kūkai received final initiation and was ordained Master of esoteric Buddhism and Eighth Patriarch. The Seventh Patriarch could die in peace: the tradition would not be lost. It was thus that he gave his successor his parting instructions: "Now my existence on earth approaches its term, and I cannot long remain. I urge you, therefore, to take the two mandalas and the hundred volumes of the Esoteric teachings, together with the ritual implements and these gifts which were left to me by my master. Return to your country and propagate the teachings there.

"When you first arrived I feared I did not have time enough left to teach you everything, but now my teaching is completed, and the work of copying the *sutras* and making the images is also finished. Hasten back to your own country, offer these things to the court, and spread the teachings throughout your country to increase the happiness of the people. Then the land will know peace and everyone will be content. In that way you will return thanks to the Buddha and to your teacher. That is also the way to show your devotion to your country and to your family. My disciple I-Ming will carry on the teachings here. Your task is to transmit them to the Eastern Land. Do your best! Do your best!" Kūkai had expected to stay in China for twenty years. In obedience to his Master's wishes he stayed only thirty months. But he used that time to improve his knowledge of Sanskrit, calligraphy and poetry. He returned to Japan in 806 at the age of thirty-three, bringing with him a precious cargo of 142 *sutras*, 42 Sanskrit texts, 32 commentaries, 5 mandalas, 5 portraits of patriarchs, 9 ritual implements and 13 miscellaneous objects given by his Master Hui-Kuo.

KŪKAI RETURNS TO JAPAN

After landing in Kyūshū, Kūkai was confronted by a considerable setback. He had to wait three years for an answer to his letter to the imperial court asking permission to go to Kyōto and found a new school of Buddhism. He had come back either too soon or too late. The Emperor Kanmu, founder of Kyōto, was dead, and his successor, Heizei, favoured Saichō, another monk who had gone to China at the same time as Kūkai but returned much sooner, after only thirty days in the monasteries of Mount T'ien-t'ai.

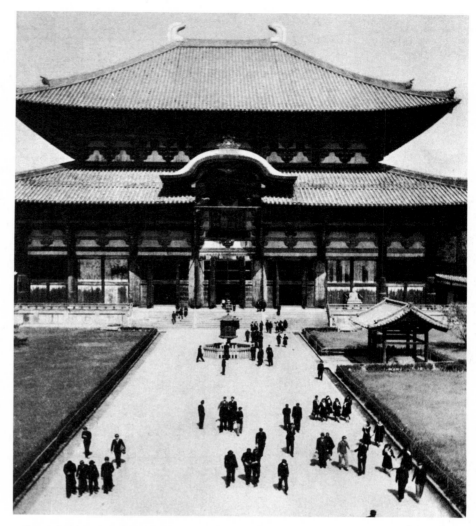

The Tōdai-ji temple in Nara.

The Tōdai-ji is the biggest wooden building in the world, and the Vairocana Tathāgata inside is the largest existing bronze.
The ticket of admission gives the following measurements:
Height of body: 16.212 m. (53' 28")
Height of face: 4.844 m. (15' 91")
Length of eye: 1.181 m. (3' 88")
Length of nose: 0.485 m. (1' 59")
Height of ear: 2.575 m. (8' 46")
Length of thumb: 1.636 m. (5' 37")

The Vairocana Tathāgata in the Tōdai-ji in Nara. The bronze statue was begun in 745. It is 16 metres tall, and the height of the temple housing it is 49 metres.

SAICHŌ, MASTER OF TENDAI

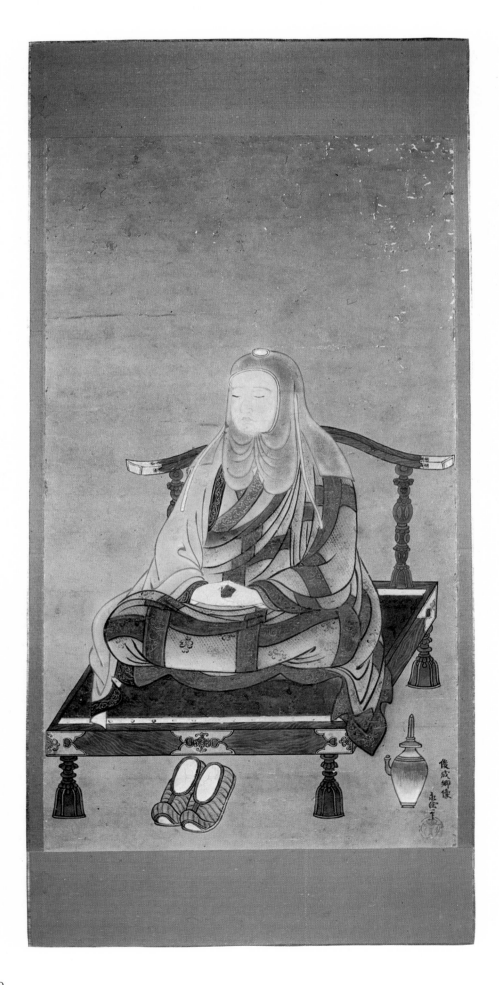

Saichō was born in 767, seven years before Kūkai. When he was twelve he left his family to go and study Buddhism. At fourteen he was ordained priest, and at nineteen he was head of the Tōdai-ji, which had just been set up in Nara. But very soon he abandoned the world to go and live in a cabin on Mount Hiei, overlooking the future site of Kyōto, and here he spent his time in Buddhist studies and meditation. When he was twenty-two he founded the Hieizan-ji (temple of Mount Hiei—later the Enryaku-ji). By the time he was thirty-six he was teaching Tendai Buddhism, now well-known at the imperial court, which had established itself at the foot of Mount Hiei. The Emperor Kanmu took an interest in Saichō, and promoted his visit to the monasteries in China. Saichō travelled there in the same expedition as Kūkai. After his visit to Mount T'ien-t'ai he had to wait six weeks in a Chinese port for a ship to take him back to Japan. It was at this point that he met Shun-Hsiao, a grand master of esoteric Buddhism, and copied out a hundred and two esoteric texts. It was this chance encounter which led to the introduction of esoteric elements and rituals into the Tendai school. The Tendai was one of the seven schools of Buddhism belonging to the Nara period (the others were the Kegon, Ritsu, Sanron, Jōjitsu, Hossō and Kusha schools). The Tendai school was very "democratic" in aspect: beings and things were basically of the same nature and essence, and derived from the same origin. Thus everyone and everything was capable of attaining Buddhahood. Tendai also aimed at being highly eclectic, and did not reject the teaching of any other school. So it was not surprising that Saichō introduced into it the elements of tantrism which had been passed on to him by the master Shun-Hsiao. Nor was it to be wondered at that the emperor encouraged the Tendai school, which might develop into a state church incorporating all other sects. This being so, it is not difficult to see why the Emperor Heizei, on receiving Kūkai's letter, did not immediately invite him to Kyōto to found a new school of Buddhism. But in 809 Heizei retired, and Kūkai's pseudo-exile came to an end. The new emperor, Saga, summoned him to Kyōto and ordered him to go and live in the Takaosan-ji (later known as the Jingo-ji) on Mount Takao, to the north-west of the city. There Kūkai remained for fourteen years, freely teaching Shingon or the True Word (a translation of the Sanskrit word *mantra*).

The monk Saichō (Dengyō Daishi), founder of the Tendai School (767–822). Late sixteenth-century painting based on ancient models.

The Jingo-ji Temple at Takao, north-west of Kyōto.

Takao: print from The Book of the Gardens of Kyōto *(1830).*

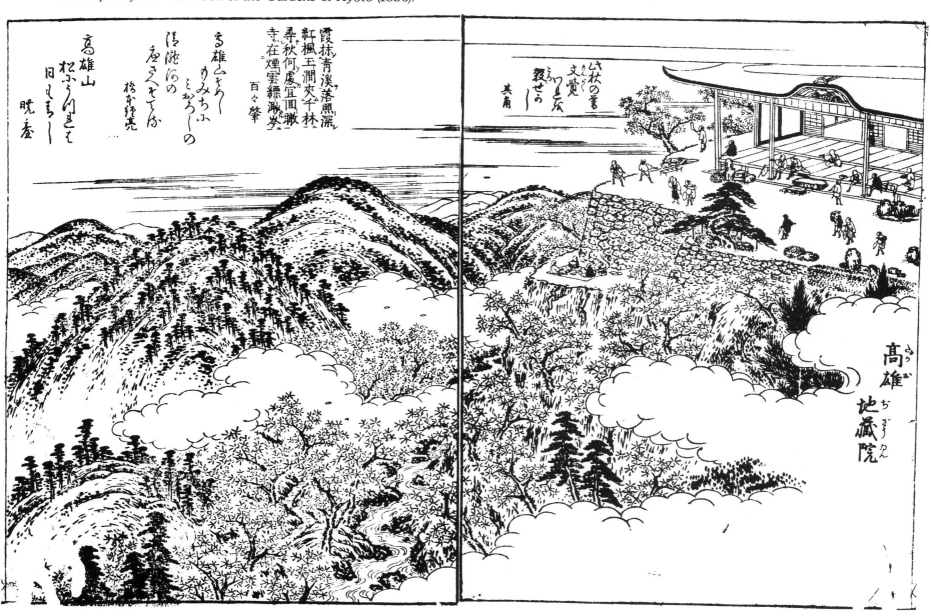

THE FOUNDING OF KŌYASAN

The Emperor Saga was a cultivated man and a poet. He is still regarded as one of Japan's three most famous calligraphists, another of the three being Kūkai himself. Saga and Kūkai exchanged poems, and the nobles of the court turned away from Saichō to follow the teaching of the one who enjoyed the emperor's favour. The Emperor Saga's patronage, the beginning of fame for Kūkai, signalled Saichō's decline. In 810 Kūkai was appointed administrative head of the Tōdai-ji in Nara, then the most important Buddhist temple in Japan. Two years later Saichō asked Kūkai to lend him certain texts which he had brought back from China. Kūkai refused, saying that the essence of esoteric Buddhism was transmitted from mind to mind and not through books. It was Kūkai who reinforced the Indian method of teaching in Japan, the transmission from master to disciple which played so important a part in the development of Japanese culture and is still practised in many contexts even today. The Takao temple soon became too small to hold all the disciples and believers. Moreover, Kūkai was inconvenienced by being so close to Kyōto. He was always being summoned to the imperial palace to perform ceremonies and recite prayers. He longed to create a centre for meditation and esoteric studies far away from the capital, on Mount Kōya, which he had come to know during his years as a wandering ascetic before his visit to China. The Emperor Saga granted his request for some land, and Kūkai found himself the owner of a small plateau four and a half kilometres long by two and a half wide, surrounded on all sides by steep cliffs covered with giant cryptomerias.

To build a monastery and temples in a spot so difficult of access was a challenge. The only local materials readily available were water and wood. But for Kūkai it was

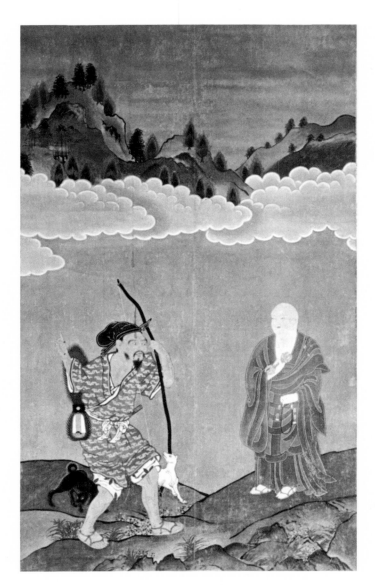

According to legend Kūkai, to find the site of his projected monastery, threw a vajra *into the air. It flew away, and here a hunter tells him he has found it hanging from the branch of a three-needle pine on the top of Mount Kōya.*

Kūkai, on Mount Kōya, is troubled in his meditations by evil spirits.

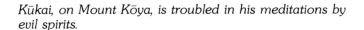

essential to build his tantric centre here and nowhere else. The summit of Mount Kōya, standing at an altitude of 860 metres, is surrounded by eight peaks about a thousand metres high and forming a kind of corona. Kūkai saw this formation as an image of the eight-petalled lotus, the central element of the Womb Mandala. He planned to build a temple in the middle of the plateau—the Kongōbu-ji or "Temple of the Diamond Peak," an image of the Diamond Mandala. Thus the whole mountain mass, with its central pagoda, would symbolize the non-duality of the two "king-doms." The work was slow and difficult, Kūkai supervised it personally, but was always being sent for from Kyōto. His universal efficiency was famed throughout Japan. One day the governor of his native province sent a plea to the capital for Kūkai to come and direct the repairing of a dam, a problem which had baffled all the engineers and other experts. Kūkai could not refuse. Three months later the dam had been repaired; today, after a thousand and sixty odd years, the lake still supplies the region with water. Kūkai's activities were many and various. He went on writing and teaching. He had copies made of the thirty-six paintings he had brought back from China. In the year 823, when he was forty-nine, the Emperor Saga, before retiring from power, put him in charge of the Tō-ji. When the emperors founded Kyōto in 794, they were determined not to build temples there, in order to avoid a repetition of what had happened in Nara, where the Buddhist clergy had kept interfering in affairs of state. But in Kyōto, as in both Nara and Ch'ang-an, the intention was to build two great temples, one on either side of the south gate of the city. These edifices, designed to afford the capital divine protection, were to be the Tō-ji or Eastern Temple and the Sai-ji or Western Temple. When Kūkai was appointed to finish the building of the Tō-ji, the *kondō* or central pavilion was already completed, but there was still time to modify the plans of the *kōdō* or assembly building so as to bring them into conformity with esoteric doctrine. Of the twenty-one sculptures which still survive today, fourteen date from this period. The Tō-ji is still one of the main centres of the Shingon sect. There Kūkai embark-ed on the construction of a five-storey pagoda for which he engaged the services of 3,490 workmen. The present pagoda is a seventeenth-century reconstruction (1644). Near the Tō-ji, Kūkai founded a school of art and science open to all, the first of its kind in Japan; he also compiled the first Japanese dictionary. In 831 he fell ill and asked permission to retire to Mount Kōya, which had just been recognized as a state monastery. He died on the twenty-first day of the third lunar month of the year 835, surrounded by his disciples. He was sixty-two. But for the million pilgrims who go every year to Kōyasan, the spirit of Kūkai, to whom they refer by his posthumous name of Kōbō-Daishi (the "Great Master who propagates the faith"), still lives on the summit of Mount Kōya. For them Kūkai has merely entered into *samādhi* (the last step on the Noble Eightfold Path), and remains on earth to save all beings from suffering. When I last went to Kōyasan in 1976, 1,141 years after his death, I met pilgrims who spoke of Kōbō-san quite familiarly, as if he were alive. Without Kōbō-Daishi, who introduced esotericism, and Dōgen (1200–1253), who spread Zen, Japan would have been quite different. Kōbō-Daishi's

Writing by Kūkai, one of Japan's three most famous calligraphers. Half-size.

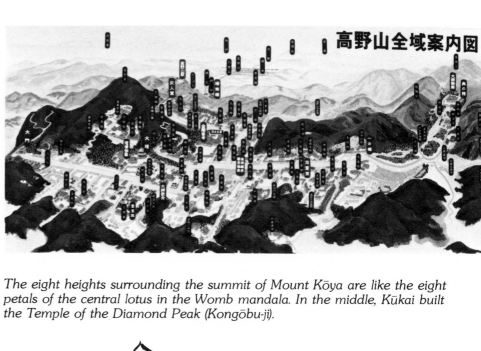

高野山全域案内図

The eight heights surrounding the summit of Mount Kōya are like the eight petals of the central lotus in the Womb mandala. In the middle, Kūkai built the Temple of the Diamond Peak (Kongōbu-ji).

雨空絶浄翔寥鶯覺慈

濁泓塵夢雨錦非

珠靈不為塞融廃

我懷と輩連佛如

如宮

罣聲指歸一巻

33

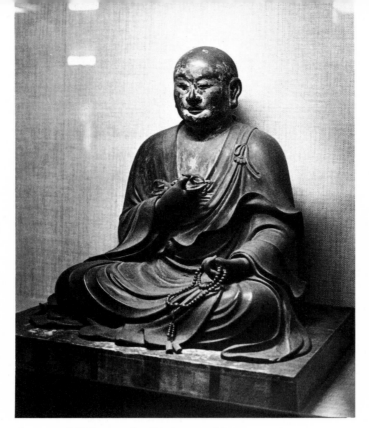

Statue of Kūkai in the Tōdai-ji in Nara.

THE MAN WHO BROUGHT ESOTERIC BUDDHISM TO JAPAN

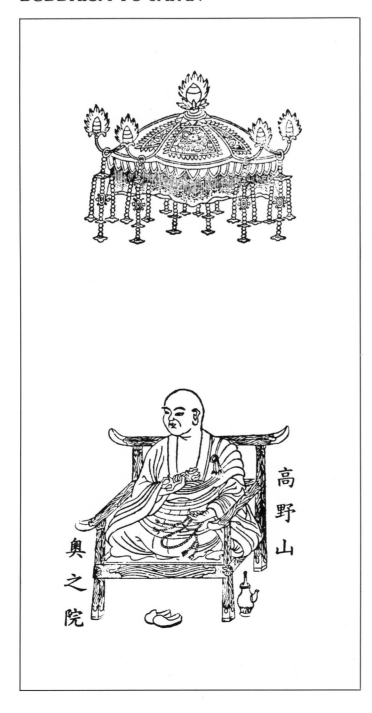

personality left its mark on all the Japanese arts of his time, and since after 894 the Japanese severed all contact with T'ang China and did not resume diplomatic relations until the end of the twelfth century, the arts of Japan developed in isolation for nearly three centuries under the impetus given them by Kūkai. Few men have exercised a deeper and more lasting influence. Traditionally, but incorrectly, he is credited with the invention of the *kana* syllabary, a system of phonetic transcription based on the Sanskrit alphabet which is still used today, and which made it possible for culture to spread through all classes of society.

Every age brings its own culture, its own art of living and thinking, its own style. In the West, one age is superimposed upon another, new cultures tread down those which have gone before. Under the accumulated weight of all these new layers, the old are reduced to dust. What is remarkable in Japan is that the imperial capitals, unlike those in the rest of the world, were not built one upon another, but side by side. Succeeding cultures, instead of being superimposed on one another, were juxtaposed. And so, instead of being crushed to death, they could go on living right up to the present day. During my first visit to Japan I was able to spend a month living in prehistory, attending the Shinto feasts and agrarian rites in the villages of Kyūshū; I spent some days in the seventeenth century, when I stayed in the Zen monastery at Obakusan Manpuku-ji; and a few hours in the fifteenth century, watching the Nō theatre. And so on.

Perhaps because the soil they live on is so unstable, the Japanese have a deep sense of impermanence. They have never tried to build for eternity, using the most durable materials. Instead they employ light and perishable ones. But these they tend day after day, rebuilding after every cataclysm—war, earthquake, typhoon, fire. The temples at Ise are even deliberately destroyed and rebuilt every thirty years—and have been since the fourth century! Paintings on fabric are copied before their colours have completely faded.

Kōbō-Daishi, from a ritual image in a monastery in Kōyasan.

Kōbō-Daishi, the Eighth Patriarch, is always represented, ▶ *like his predecessors, seated on a Chinese chair. In his right hand he holds a vajra, symbol of the Diamond pattern, and in his left hand a rosary, like Fudō-Myōō in the Womb mandala. The ewer, bottom right, symbolizes the "interpenetration" of the two patterns: the water of Wisdom (vajra) is contained in the vessel (garbha). Fifteenth-century painting (0.94 × 0.40 m.).*

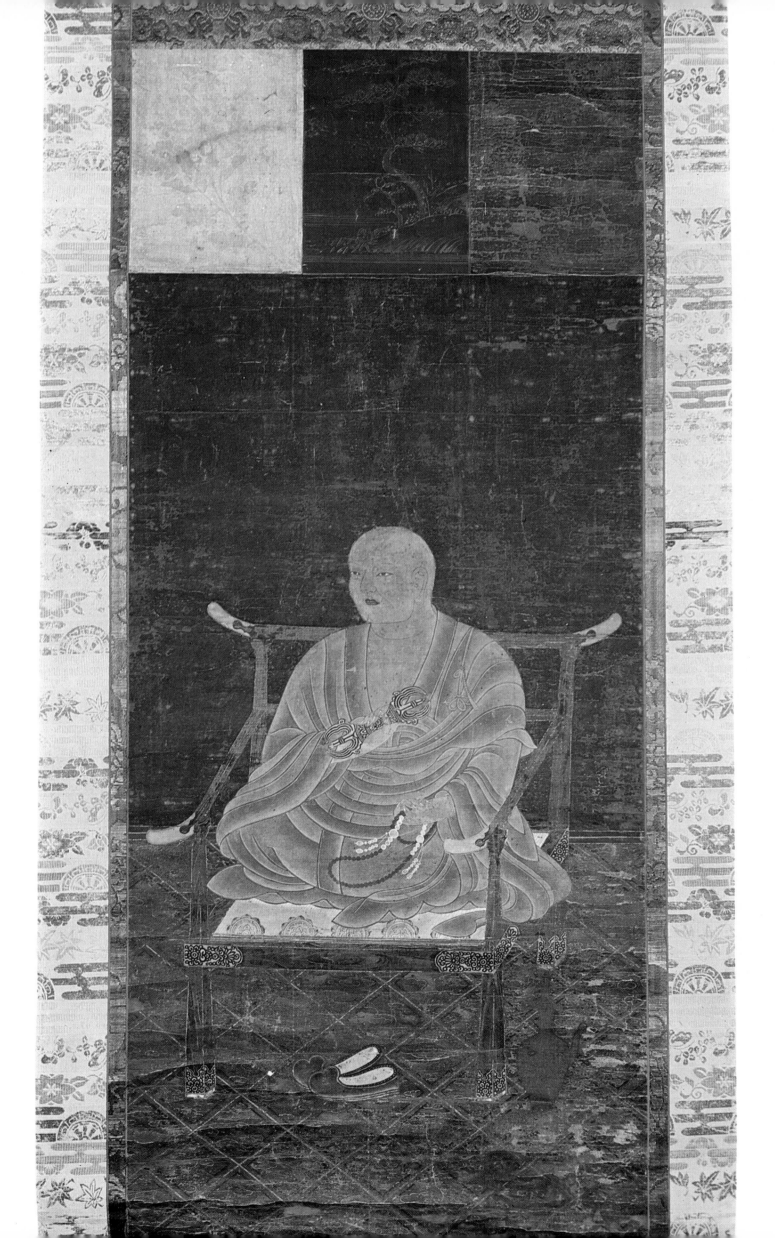

One of the three-tier pagodas at Taima-dera.

Main building (Kondō) at Taima-dera.

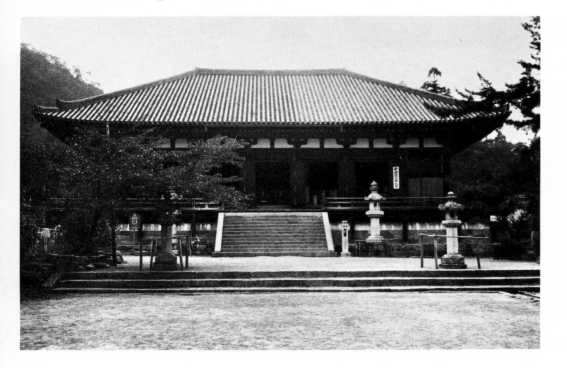

ESOTERIC TEMPLES

For all these reasons, and for others besides, the arts and cultures of past ages have remained living and accessible. Twenty-seven years ago, in India, I found only silent ruins of the seventh century. But when I went back for the sixth time to Japan in 1976, in quest of the ninth century, I found it quite easily: it still lives on in certain monasteries in Kyōto. Today, the only place where one can still encounter the atmosphere of the Indian monasteries of Nālanda in the seventh century, or of those of Ch'ang-an in the eighth century, is in the monasteries of the Shingon School in Japan.

With more than seven and a half million adherents in 1957, the Shingon sect is the fourth largest, numerically, in the country, after Shin-shū, Zen and Nichiren. As regards the number of temples, it comes third with 12,282. The chief temples are in the Kyōto-Nara area. They usually consist of large groups of buildings made up of the monastery as such, the temple (kondō), the assembly hall (kōdō), pagodas of from three to five storeys, gardens, and buildings for the storing and exhibition—for a few days every year—of treasures: statues, paintings, mandalas, items of calligraphy, iconographic drawings, ritual objects, and so on. Some of the groups of temples are old, but most have been rebuilt several times, after each fire. They are all in an excellent state of preservation and kept in perfect repair. In Kyōto itself we should mention the Tō-ji, of which Kūkai was the head from the year 823, and which contains ninth-century sculptures including some attributed to him; also the Ninna-ji, headquarters of one of Shingon's two branches, with its large collection of iconographic drawings; and the Sennyū-ji, the Daikaku-ji and the Chishaku-in. North-west of the city, on the Takao hills, is the Jingo-ji, the first teaching centre of esoteric Buddhism. South of Kyōto is the Daigo-ji, with its remarkable treasure chamber and its five-storey pagoda containing mandalas painted on wood and dating from the building of the temple in 951. On top of the mountain which overlooks the Daigo-ji, on a site which can be reached only by an hour's climb up a steep path which sometimes becomes flights of steps, is the astonishing tantric centre of Kami-Daigo. The great Shingon monasteries were often built on extraordinary sites difficult of access, as in the case of the great Taima-dera group and the famous Murō-ji, both in the Nara region.

室生寺

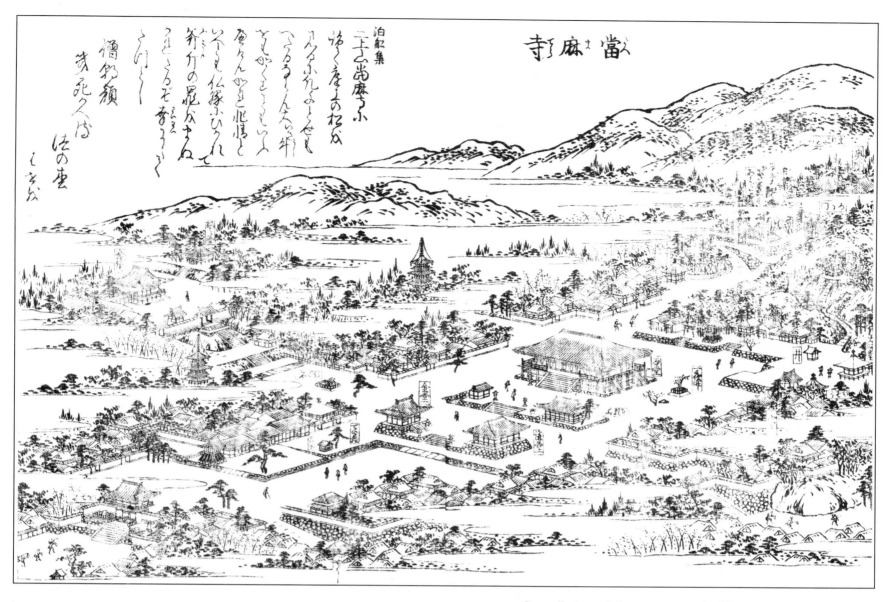

Overall view of the monastery buildings at Taima-dera, 1791.

Overall view of the monastery buildings at Murō-ji, 1954.

The parasol shelters the daisōjo, *highest-ranking priest of the Kogi branch of Shingon at the Ninna-ji Temple in Kyōto.*

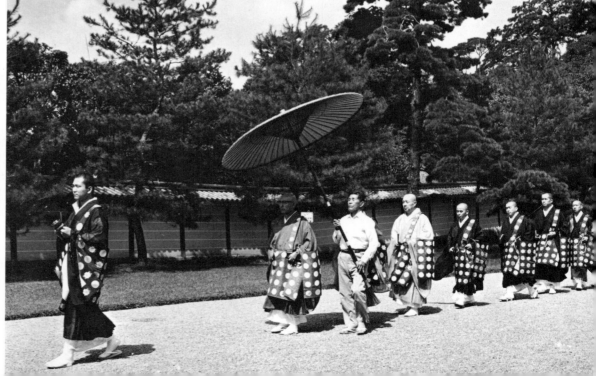

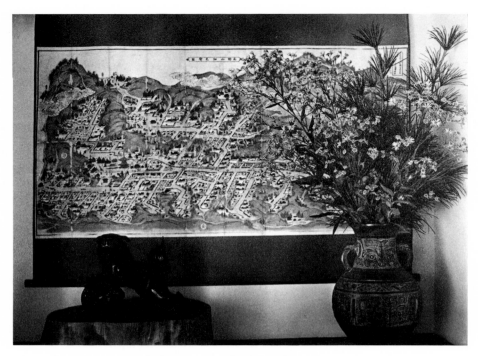

Plan of Kōyasan on a kakemono in the Tentoku-in at Kōyasan.

A small pagoda with a mobile section one metre above the ground. Pilgrims make it turn by harnessing themselves to projecting pieces of wood, thus performing the Indian rite of circumambulation around the stūpas (pradakśina), a rite over two thousand years old.

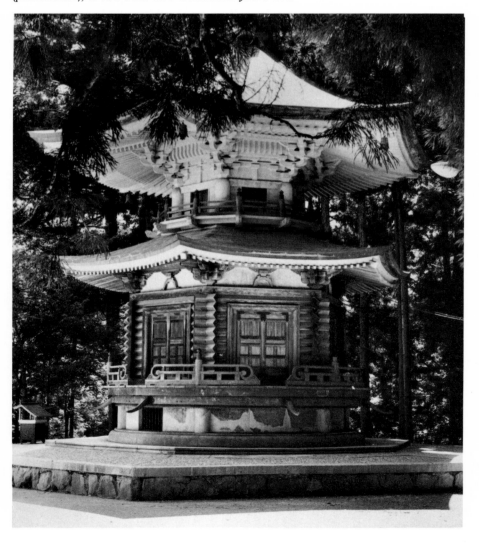

THE MONASTERIES ON MOUNT KŌYA

The most important centre of esoteric Buddhism is of course the Kōyasan, founded by Kūkai on Mount Kōya and consisting of some hundred and twenty temples and monasteries. Until 1873 it was forbidden to women, and could be reached only by mountain paths. Today visitors can go there by motorway, or by a funicular which meets the railway line at Osaka. After a thousand years as a solitary centre for meditation, Kōyasan has become a little commercial city capable of accommodating over a million visitors each year. There are no inns or hotels, but the fifty or so monasteries equipped to receive guests rival the best hotels in Japan for beauty, comfort and food (vegetarian). Kōyasan has a large resident population of young people: monks, novices, and students at the Buddhist University, which with its famous library and museum is an important centre of Buddhological research, probably the greatest of all for esoteric studies. But in the Japan of today, with its rapid industrial expansion, Buddhism as a whole is experiencing a marked decline. The pilgrims one encounters on the paths at Kami-Daigo or Kōyasan are all very old. The younger people are especially unenthusiastic about esotericism, which they regard as too difficult. Are we then to conclude that Shingon is a thing of the past, no longer able to supply satisfactory answers to the questions people ask themselves today? Will it soon disappear? Most unlikely. I would say there are certain signs which suggest just the opposite. There has been a sudden surge of interest in esoteric Buddhism in the West, comparable to the wave which made Zen popular some twenty years ago. It is not impossible that this movement might spread from the United States to Europe, and revive interest even in Japan itself in a school of thought which has influenced all aspects of Japanese culture just as much as Zen. It seems quite credible to me that the achievements of the most highly developed forms of oriental wisdom might fill the gaps left by the calling in question of Western "values." Moreover, certain recent discoveries in the fields of physics, neurology, psychiatry, etc., lend a sudden immediacy to the knowledge handed down by the esoteric tradition.

Western Pagoda at Kōyasan, rebuilt in 1835.

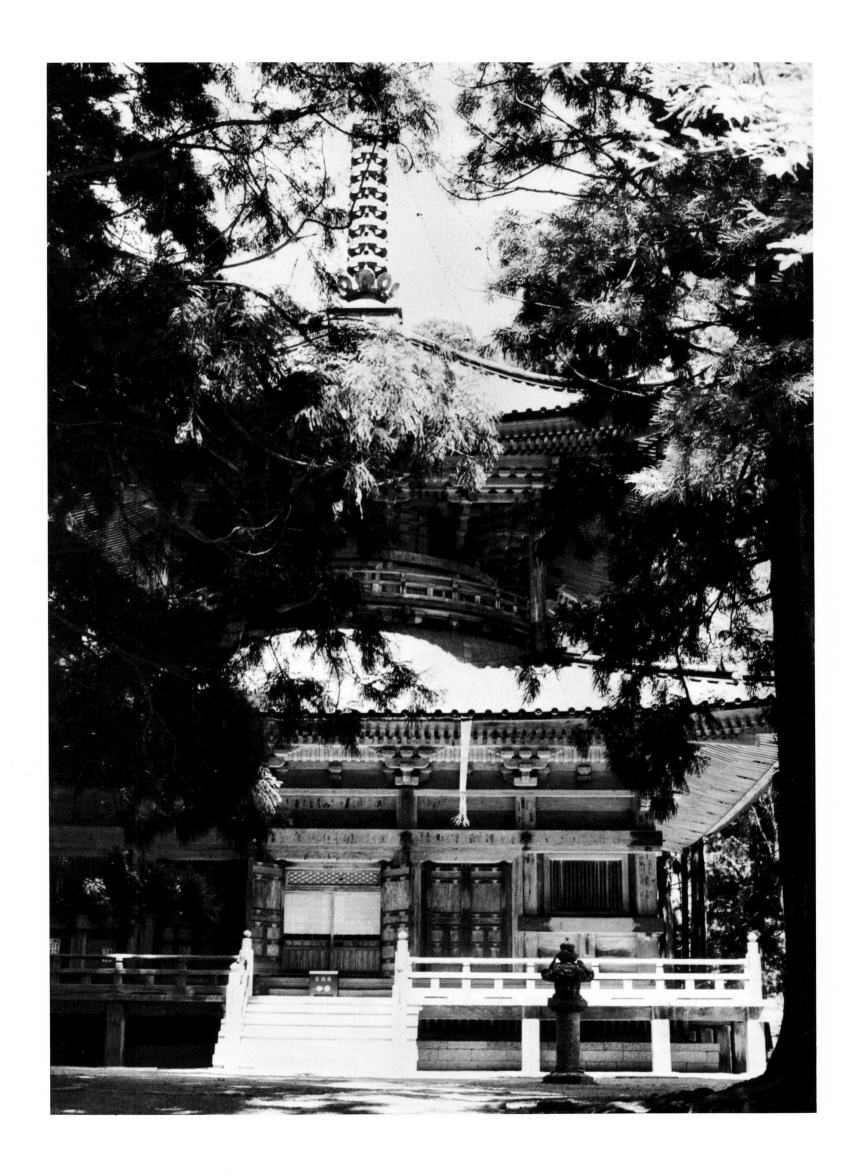

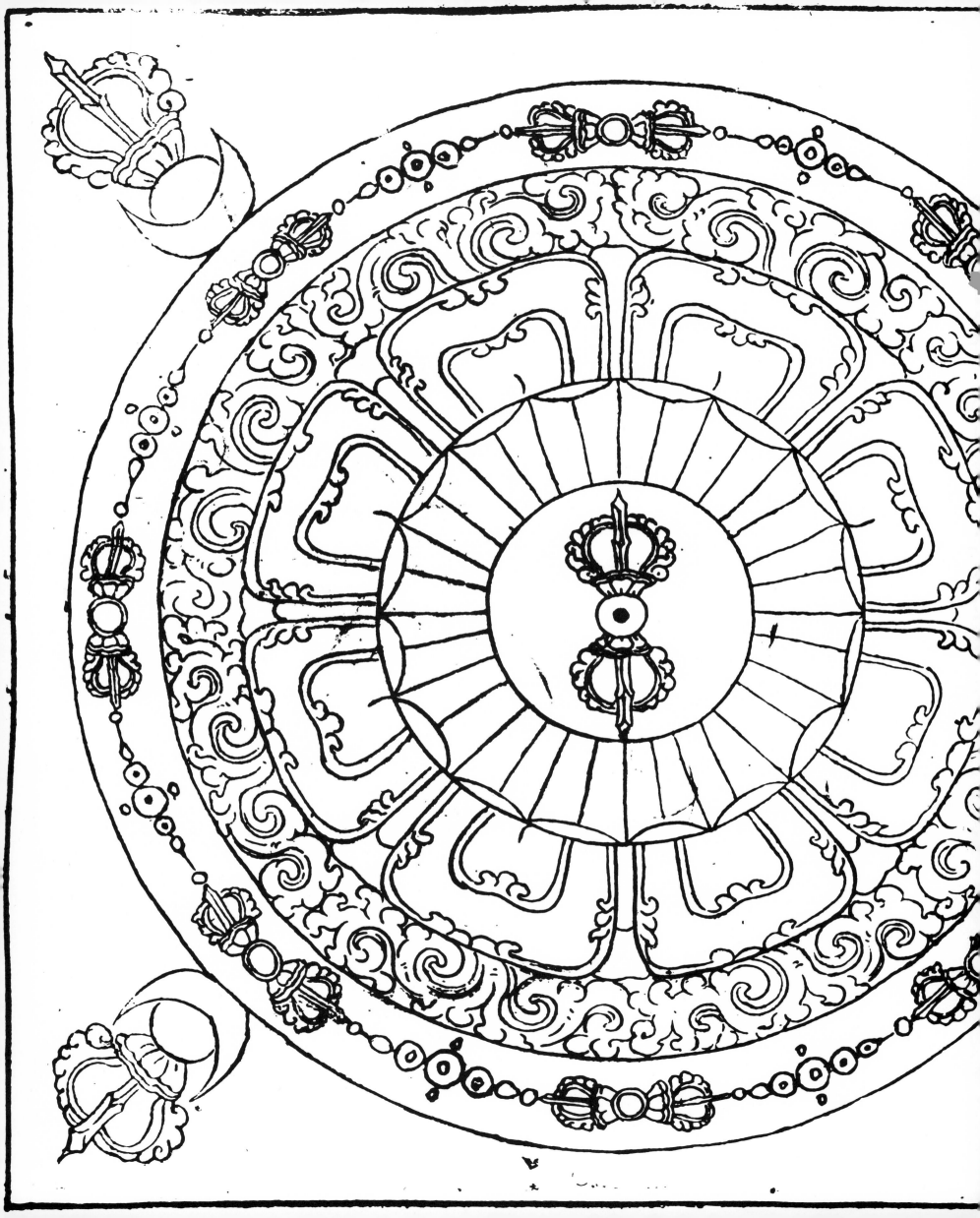

The way of the mandalas
and of the ritual of initiation

The Shingon School
of the "True Word"

Tibetan print: the Diamond in the lotus, the circle in the square.

*The esoteric doctrines are so profound
as to defy their enunciation in writing.
With the help of painting, however,
their obscurities may be understood*

thus wrote Kūkai on his return from China. (Translation from *Sources of Japanese Tradition.*)

The teaching of esoteric Buddhism is not opposed to that of the other schools of Buddhism: it complements, explains and incorporates them. The aim of those who practise Shingon is the same as that of the followers of other schools: the attaining of Enlightenment. It is not only those who practise Shingon who say it is possible for all of us to reach the state of Enlightenment in our present life: the same thing is taught by the Zen monks, who in the past only broke away on the question of whether Enlightenment was sudden or gradual. In fact, the fundamental difference between Shingon and Zen occurs at the level of method. The former prefers ritual, the latter a certain form of seated meditation *(zazen)*. Both are based on the idea of the Ultimate Reality of the Universe as a Void, an idea clearly expressed in the "Sūtra of the Essence of Perfect Wisdom" *(the Prajñā-Pāramitā-Hṛdaya-Sūtra).*

> *Emptiness does not differ from form,*
> *form does not differ from emptiness;*
> *whatever is form, that is emptiness,*
> *whatever is emptiness, that is form.*

(Translation by Edward Conze, *Buddhist Scriptures,* Penguin Books.)

The Zen monks sought to express the emptiness of the phenomenal world; hence the predilection for abstraction, monochrome painting, and compositions centred on a void, as for instance in gardens. Zen art aims at directness. It uses few symbols, does not need decoding, operates beyond the intellect. For this reason it can be appreciated by observers who have not followed the teaching either of Bodhidharma or of the Buddha himself. Shingon art, on the other hand, focuses on "Form" in its endeavour to help man apprehend the void. Instead of, as in Zen, meditating on the Void, eyes closed in the half-darkness of a bare and empty room, the Shingon novice meditates in a richly decorated temple, surrounded by statues and paintings full of symbols, performing gestures with hands and fingers *(mudrās)*, reciting Sanskrit incantations *(mantras)*, and keeping his mind from wandering by focusing it on coloured images. All the arts —architecture, sculpture, painting, music, singing, gesture— are drawn upon to help the monk progress along the path to Deliverance. Zen monks consider the studying of texts to be an obstacle on the way to Enlightenment. Shingon monks agree.

The secret teaching which spread from India to China no longer exists today in either of those countries, but it is still preserved in its original state in Japan. There are three ways of finding out what it consisted of. The first is to read Kūkai's numerous writings (see Kūkai, *Major Works,* translated by Y. S. Hakeda, New York and London, 1972). The second is to follow a ritual initiation in a monastery in Japan. The third is to make the images speak. For the two mandalas which Kūkai brought back from China contain the whole of the teaching. We are going to adopt this third method, but we can only make a beginning, for to be fully effective it needs to be complemented by the first two methods, and they do not come within the scope of this book. In any case, my object in writing it was not to expound Shingon doctrine as such, but to help the reader make contact with its iconography. However, since it seems to me one cannot appreciate a work of art without understanding the message it contains, the reader needs to know something about the doctrine which in this case is present in its entirety in the iconography. To understand a statue I need to know what it teaches; but the teaching is to be found only in the statue. How can this paradox be resolved? We might as well admit at once that it cannot be resolved. Buddhism, as I said at the very beginning, is based on a paradox, and Buddhist art, and the art of esoteric Buddhism in particular, is therefore entirely made up of paradoxes. Let us review the main ones.

— Every detail of a painting or sculpture, itself an expression of the Relative—or, as Buddhists would say, of "Form"— is at the same time an image of the "Absolute," and thus also of the "Void."

— The most abstract ideas are expressed by the most concrete means.

— Every painting or sculpture, itself an image of the Relative, is only a part of the All, an aspect of one of its aspects, an emanation of one of its emanations; but at the same time it is an image of this same Absolute.

— Every detail of a painting or sculpture of a deity has a precise meaning: its size, attitude, gestures, attributes, jewels, garments, the Sanskrit letters decorating its headdress, its location and orientation within the temple, are all messages directed at the beholder. It might seem necessary, therefore, in order to decode the message, to know the cipher, to understand the alphabet and the grammar of the language used. But in fact that is in a sense harmful, for the painting or sculpture was not designed to address our rational mind, and the symbols would lose their effectiveness if they were transformed into signs. It is obvious that reading a dictionary of symbols would not help us to emerge from the realm of the Relative, to advance along the path to Enlightenment. Such deciphering of symbolic images as there is in this book

can at the most only enable the reader to understand the meaning, the raison d'être of a painting, sculpture or sign, and thus to appreciate it more fully.

— Another paradox of esoteric art is that even if its meaning remains impenetrable, it still touches our subconscious. How else can one explain the fact that we may be moved by works which are completely stereotyped, their shapes and colours codified in written texts? It is this mystery, this mystical aspect of tantric art which is beginning to fascinate the West. Curiously enough, this interest has so far been directed only towards Indian and Tibetan tantrism, perhaps because of the very erotic aspect of their symbolism. The interest which has recently grown up in mandalas can similarly be related to Western developments in psychoanalysis and psychology.

— For, and this is the last paradox, there is an as yet unexplained link between the esoteric mandalas—the result of several centuries of learned research by Indian thinkers endeavouring to express at one and the same time the process by which the Absolute is made manifest in the world of phenomena, and the functioning of human thought—and the sort of painting known as "art brut," the work of people who, with no cultural equipment whatever, put into concrete form their own subconscious visions and fantasies.

If the Patriarchs of esoteric Buddhism declared that their teaching could only be retransmitted through the medium of images, it was because, in their view, only images can communicate with us without using the misleading language of words, without appealing to our intellect. So I am not going to try to "explain" these images, but only to bring them out of the darkness and shed some light on them. Literally, in the first place, because esoteric paintings, sculptures and drawings are kept safe in Japanese temples and monasteries both from the light and from the eyes of the profane. Figuratively too, because the works in question stir us to the depths of our being by using a symbolic language which was familiar to our ancestors but which we today have largely forgotten. Fortunately these images were created not by beings from another planet but by people like ourselves, and most of the symbols, while they originated in India, form part of all mankind's common heritage. When I showed a young Hindu monk in a monastery in Bhubaneśvar a picture postcard of Notre-Dame, he was surprised that the temples in my country were so much like those in India. Hindu temples and tantric mandalas are no further away from us than a painting by Hieronymus Bosch. Both the temple and the mandala represent the Universe, and the Universe they represent is my Universe. For me, Japanese art is not "exotic." But my approach to esoteric art is bound to remain a quite external one. The only internal approach is through ritual initiation in a temple under the direction of a master. Even the external approach is not easy. Perhaps that is why it has never been attempted before. It is true that the temples are open to all, the paintings are visible, and some religious services are public. But the books containing the "instructions for use" are reserved for the initiate. Those who know a little (like me) speak; there are very few who know a lot and write; the initiate are bound to secrecy on many points; the Enlightened are silent. In Western languages, sources of information about Shingon are rare. Worth quoting here are Ryūjun Tajima's *Les deux grands mandalas et la doctrine de l'ésotérisme Shingon* (1959) and Yoshito S. Hakeda's *Kūkai, Major Works, translated, with an account of his life and a study of his thought* (1972). It is from the latter that I have taken the information about Kūkai's life. The copious documentation on Shingon which exists in Japanese has not fully been translated. Ryūjun Tajima, although he was a *daisōjo* or priest of the highest rank in the Shingon sect, offers only a detached scientific description of the deities in the two mandalas, and is careful not to give away the "instructions for use." Of course, one reason is that tantric images are merely means, stratagems (*upāya*), tools to be rejected once the goal is reached; but in fact the goal, Enlightenment, is never reached once and for all. At the end of the ritual initiation, the monk concerned, crowned by the ceremonies of *abhiṣeka* or "entry" into the mandala, identifies with the Tathāgata. But this is not a permanent state, only a brief flash which occurs when he succeeds in changing his rigid mental structures, a flash of awareness, a sudden illumination. Very soon other structures form in his brain, which he will have to destructure in their turn. Enlightenment is thus a process rather than a stable state. Similarly, Liberty is only experienced at the moment of revolution. Thereafter, new institutional structures are established and the revolution has to begin all over again. The process of Enlightenment is active, and should be continuous and permanent, like revolution, like love. In exoteric Buddhism, the sculptures are silent, and it is the scriptures which speak. In esoterism, everything speaks to us directly, nothing is hidden, but understanding of this teaching is not given to us directly: we have to pass first through the action of symbols. It is in this sense that the teaching may be said to be reserved for experts. It is the manipulation of symbols which will enable us to leave the rational plane and attain a new depth of consciousness. So a symbol is not a sign, an arbitrary convention, but rather a cipher in a mystery never explained and for ever needing to be redeciphered. The symbols used by esoteric Buddhism possess a quasi-magical power which can stir our whole being, lead it to a transformation in depth, and enable it to leap from the rational level to the plane above. A symbolic image is a work tool, and needs to be re-experienced every time if it is to perform its function. The raison d'être of an esoteric painting or sculpture is not to please us, but to change us. That is why it does not address itself to our reason. Each detail has not only a special significance but also a role to play; it is "functional."

Instructions on how to use the images are contained in the initiation ritual. Tajima says nothing about this. My information about rituals comes from lectures delivered in 1976–1978 at the University of Geneva by Professor Robert Heinemann, who studied Buddhology at Tōdai University in Tōkyō. There are no books on the subject.

There were two methods open to me for approaching Shingon art. I could start from the mandalas and then branch out to other aspects, or I could start with the whole range of art and ritual and then converge on the mandalas. But before I go any farther it is necessary to define the exact meaning, or rather meanings, of the word *maṇḍala*.

THE MANDALA

The Sanskrit word *maṇḍala* (in Japanese, *mandara*) has a dual origin. In the most ancient texts it is a disc—of the sun or the moon—, a circle; the circular arrangement of troops, the circle of neighbouring kingdoms in relation to a central state. But *maṇḍa* is the water in which rice has been boiled, the precipitate which forms during cooking, cream, alcohol. *Maṇḍa* is essence, and *la* means completion. For a Tibetan sage of the eighth century, *maṇḍa*, essence, is *bodhi*, Enlightenment, Illumination, and the state in which *bodhi* is completed is *maṇḍala*. An Indian missionary in China in the seventh century explains: "This word means: to have attained perfect and unsurpassable illumination." Śubhakarasiṃha, in one of his commentaries, writes: "*Maṇḍala* means circle: thus all the virtues are joined together in a ring and absolutely all of them are there; it is in this sense that one speaks of a *maṇḍala*." "What is important to note here is that the mandala represents the All, an All from which nothing, absolutely nothing, is missing. The mandala represents the All, and in both its aspects: as the All-One and the All-Many. The Tathāgata, or All-One, exists only by virtue of the Enlightenment of Beings; the mandala is a graphic representation of Enlightenment when all the virtues (the All-Many) are united" (Robert Heinemann).

Thus, by definition, a mandala is a representation of the All, of Enlightenment, of the Ultimate Reality of the Universe, and so on, in the form of a circular design. The term also has a connotation concerning place: it is the site of Enlightenment, the place where Gotama attained Enlightenment, and the precincts of practice. Mandalas can be made in all sizes and the widest variety of materials. In his book, *La Théorie et la pratique du mandala*, Professor Giuseppe Tucci describes mandalas drawn on the ground in Tibet with coloured rice paste. These short-lived mandalas are used only once, for an initiation ceremony. In the centre, in symbolic form, is the Tathāgata, and in the surrounding circles or squares are the different aspects of the Absolute. In the course of the ritual, the subject enters physically into the mandala and tries to identify mentally with the deity on which he is standing. The aim of this magical ceremony is to lead the person concerned to Illumination. Some tantric manuscripts have been found in India consisting of palm leaves with sketches of mandalas drawn on them—a kind of aide-mémoire for architects. It can be said that all the Hindu temples built between the fifth and thirteenth centuries were built on the pattern of a mandala, usually square with a "door" in the middle of each side.

While it is possible, when we examine a temple, to find the geometrical key to its construction and the guide-lines on which it was based, we are unfortunately reduced to hypothesis when it comes to the esoteric content of the design. Indian treatises on architecture themselves insist on the need to keep the mandalas secret, for only an architect who is also an initiate can properly use the magic power inherent in them. Whether implemented in three dimensions in the form of temples, or painted on a flat surface, mandalas are, to use Professor Renou's phrase, "a figurative translation of a religious system." Paradoxically, the great Hindu temple-mandalas, which the Brahmans executed in stone that they might defy time and perpetuate the teaching, cannot yield up all their secrets, whereas the frail Japanese mandalas painted on fabric remain perfectly intelligible. This is because the texts worked out by the Buddhist monks to help in their execution have survived into the present; only partly in their Sanskrit version, but in their entirety in their Chinese and Tibetan translations.

The Garbhadhātu maṇḍala *(Taizo-kai mandara), the Womb pattern. A mandala of medium size (height 1.79 m.).*

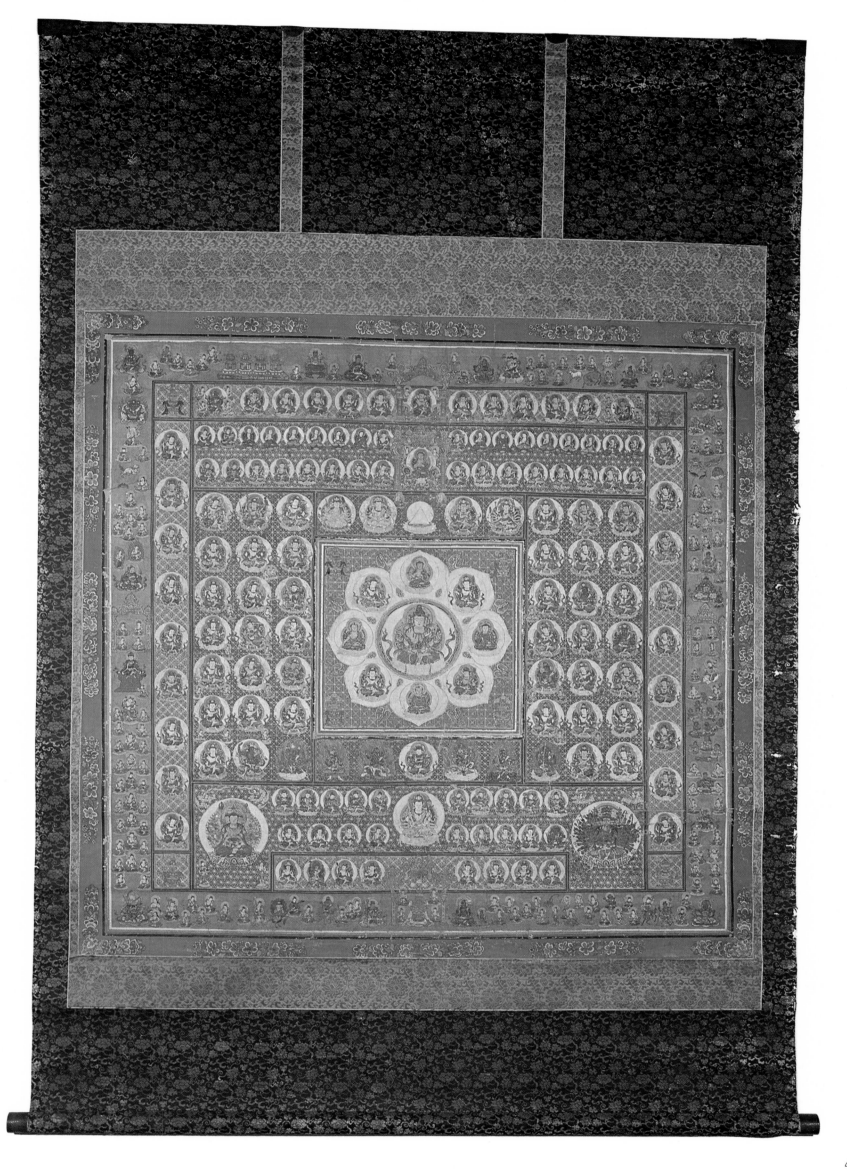

45

The Wisdom School was responsible in the second half of the seventh century for producing the *Mahāvairocana-sūtra,* the Sūtra of the Great Illuminator, a Sanskrit text which gives minute instructions on how to draw the *Garbhadhātu maṇḍala,* the "Womb-pattern mandala." In this *sūtra* all the Buddhist divinities are classified and grouped in relation to the Mahāvairocana Buddha, the Great Solar or Cosmic Buddha. The Mind-Only School made use of the *Vajraśekhara-sūtra,* whose graphic counterpart was the *Vajradhātu maṇḍala* or "Diamond-pattern mandala."

We know that the early Indian patriarchs who preached the "True Word School" in China produced mandalas, or commissioned Chinese artists to produce them under their supervision, but these mandalas have not come down to us. The originals of the two coloured mandalas which Kūkai brought back in 806 have also disappeared, but excellent copies were made as early as the ninth century. The copy which now survives dates from 1693. The oldest originally Japanese mandala, produced between 824 and 833, is known as the Takao *mandara,* and is preserved in the Jingo Temple in the Takao hills. Both these examples are of considerable size (4 by 3.7 metres, and 4.5 metres by 4), and they are drawn in silver lines on a blue-black background.

In the Eastern Temple (Tō-ji) in Kyōto, on a few days every year, visitors may see the oldest pair of coloured mandalas in Japan. As their style, though showing slight differences, recalls that of central Asia, experts think they are late ninth-century copies of an original brought back from T'ang China not by Kūkai, as tradition would have it, but by one of his disciples. The two may be regarded as the prototypes for all the mandalas made for the Shingon sect from the year 823, when the sect was officially recognized in Japan, up to the present day. Every Shingon temple had to have a pair of these mandalas, which play an essential part in the ritual.

Vajradhātu maṇḍala *(Kongō-kai mandara) in the Jingo-ji Temple at Takao.*

POSITIONING OF THE MANDALAS IN THE TEMPLE

To begin with, in the already existing temples, the mandalas were placed on either side of the altar. But when Kūkai decided to found the centre of the new School on Mount Kōya, he designed the central pagoda especially to contain a pair of mandalas. The original pagoda was destroyed by fire, and all those built to replace it met the same fate. The last reconstruction, in reinforced concrete, dates from 1934. But it is built according to the original plan. It is a square open to the south. At the other end of the main

Vajradhātu maṇḍala *in a minor temple in the Murō-ji.*

hall, to the north, one can see the altar, with the two mandalas facing each other on either side. Looking towards the altar, the *Vajradhātu* is on the left and the *Garbhadhātu* on the right. These positions correspond to the orientation proper to each mandala. The Vajradhātu, placed to the west, has its upper edge oriented towards the west, so to speak; the Garbhadhātu, placed to the east, has its upper edge oriented towards the east. There is nothing surprising about this if we remember that mandalas were originally drawn on the ground. Let us imagine the mandalas we now see hanging up in the temples placed flat on the ground like carpets in front of the central altar, where a statue of Amida or Fudō or Kannon is enthroned. The person performing the ritual faces the altar, but we should not forget that his aim, Enlightenment, is identification with the "Noble Principal" facing him. When I become one with the Tathāgata, the Garbhadhātu, which was on my right, will now be on my left, and the Vajradhātu will be on my right. This is very important for understanding the symbolism of the two mandalas. In fact the Garbhadhātu corresponds to the left hand, and the Vajradhātu to the right hand, of the Buddha facing me, but of course this Buddha is me, can be me, will be me when I am Enlightened. But then there will be neither right nor left, east nor west, because I shall be in the realm where all oppositions cease. Meanwhile I live in the Relative, and if the Absolute is to be manifest there and perceptible by my mental structures, it has to make use of the illusory opposition between contraries, and can only be represented through dichotomy. The two mandalas express, from two angles, according to two aspects, according to two "patterns of existence"—the exact meaning of *dhātu*—the Ultimate Reality of the Universe. For me, entering the temple and contemplating the image of the Absolute there on the altar, the pair of mandalas enclosing me on either side is at once a manifestation, made accessible through the action of the symbols, of that same Unutterable, and at the same time an instrument which will enable me, if I perform the magic ritual correctly, to attain Enlightenment. For I am a Being (Sattva) which like all other Beings possesses *bodhi* in a state of latency, and thus I am potentially a bodhisattva, an "Enlightenment-Being," a "Being whose essence is Illumination," a "Buddha-Being."

In tantric Buddhism, every figurative representation may and should be regarded from this dual point of view: as one of the countless different manifestations of Ultimate Reality, and as an instrument which may lead to Enlightenment. Each one is a medium between the Absolute and the Relative, between the Enlightened One I may become and the I who exists in ignorance. Moreover—and this applies to all the Shingon works of art reproduced in this book—every figurative representation of the Absolute appears in one of these dual forms, a form corresponding either to the pattern of the Womb or to the pattern of the Diamond. It is because these two mandalas are an image of the All from which "absolutely nothing is missing" that I have chosen them as a basis for classification and as keys to the whole iconography.

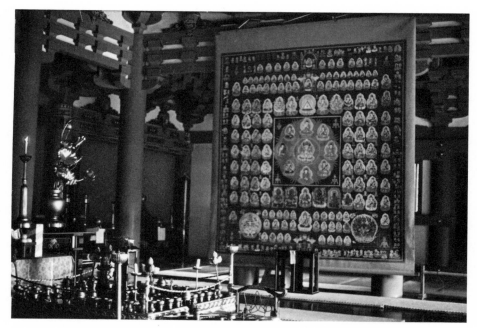

Garbhadhātu maṇḍala *(Taizo-kai mandara) in the Jingo-ji Temple in Takao.*

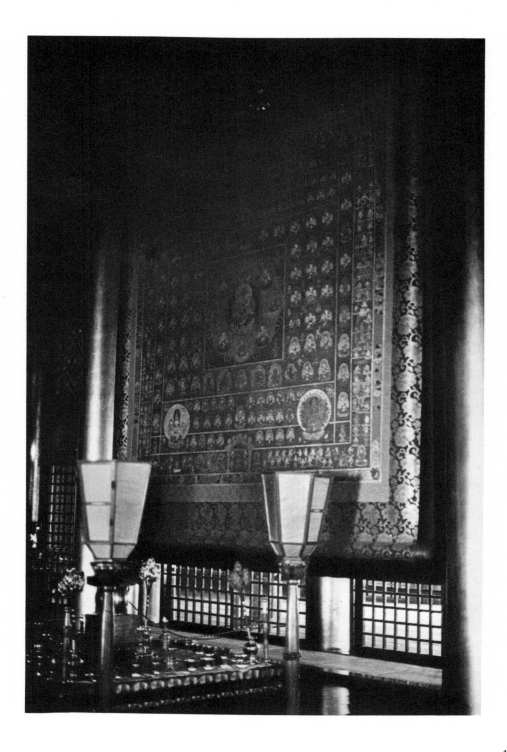

Womb mandala in a temple at Kōyasan.

EAST

NORTH

SOUTH

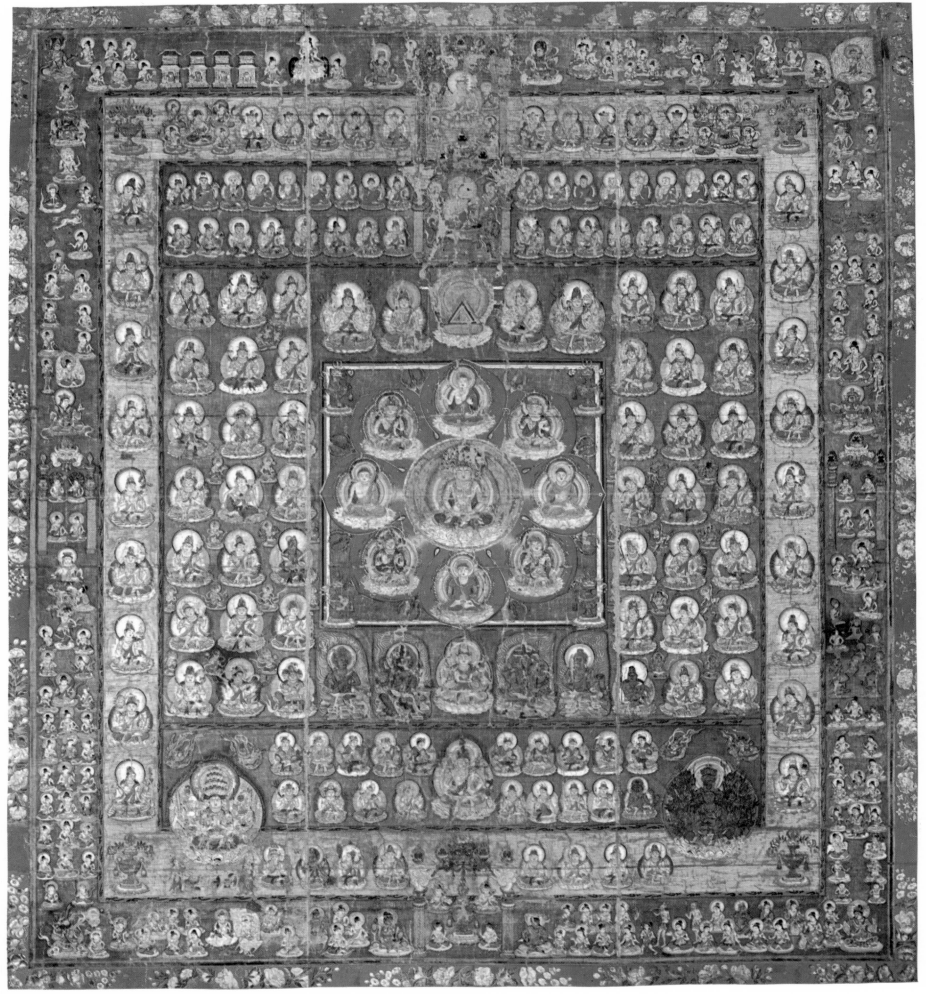

WEST

Position of the two mandalas in the temple.

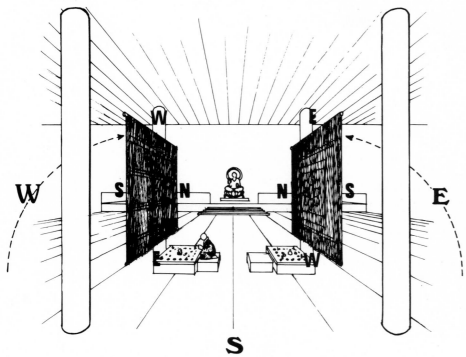

Through the Garbhadhātu, the Womb mandala, the mandala of Innate Reason and of Original Enlightenment, which always exists within us, we try to apprehend the Absolute Value of all things. But the great variety of the Universe's manifestations is caused by the phenomenon of "conditioned production": things exist only in relation to other things. The irreducible factors are six. The first five, symbolized by Earth, Water, Fire, Air and Ether are material; the sixth, Consciousness, is spiritual. The Garbhadhātu is centrally concerned with the first five elements. This is the point of view of things contemplated objectively, the point of view of Form, of RI, the Principle which must be known. Reason, being immutable, is expressed graphically by means of square figures. We see here the central square, known as the "zone of the eight-petalled lotus." In the middle of the square is Ultimate Reality, which radiates outwards and manifests itself in the Universe through the surrounding rectangles, as far as the outside border which includes all Beings. Conversely, by working inwards from the outside towards the centre, we may use this mandala to recognize Ultimate Reality through the world of phenomena.

When, having entered the temple by the great South Door, I stop in the middle facing the main deity, the Vajradhātu, to the west, is on my left, and the Garbhadhātu, to the east, is on my right. But they represent the right and left respectively for the deity facing me on the altar. Since in Japanese temples the mandalas are placed vertically and not flat on the ground, the top of the Vajradhātu represents the west, and the top of the Garbhadhātu the east.

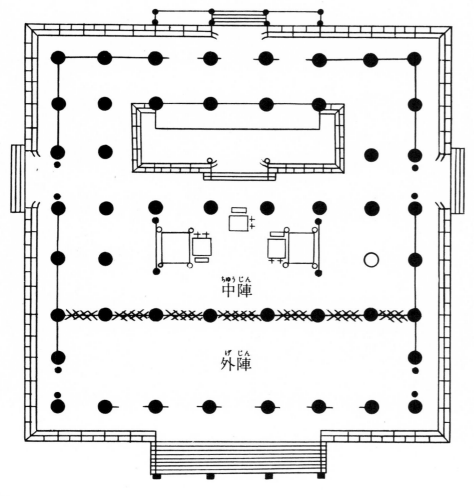

中陣（ちゅうじん）

外陣（げじん）

Plan of the main temple (kondō) at Kōyasan. Both to the left and right of centre are a large and a small square. These are the altar and the priest's dais at the foot of each mandala.

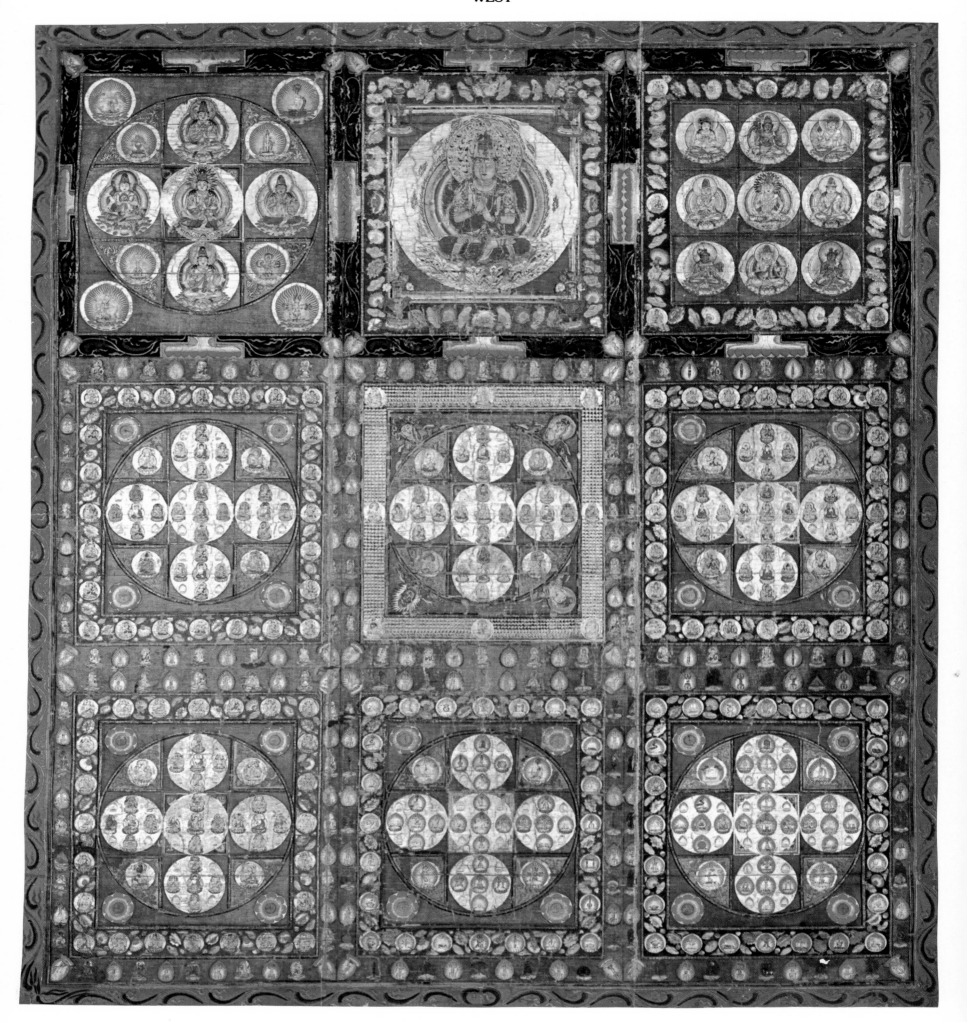

50

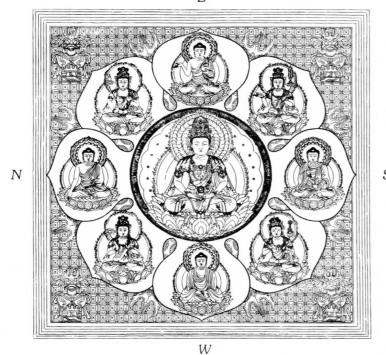

E

N

S

W

The central zone, or quarter of the eight-petal lotus, of the Garbhadhātu. The Hase Mandala.

THE WOMB PATTERN

In the centre of the lotus, an image of our deepest consciousness, is Mahāvairocana, the Absolute, whence there emanate, in the four directions of space, four Buddhas, each with a bodhisattva (Samantabhadra to the south-east, Mañjuśrī to the south-west, Avalokiteśvara to the north-west, and Maitreya to the north-east). The eight petals are the eight methods of salvation. According to esoteric Buddhism, the heart of Beings is like an as yet unopened lotus. Here the lotus is fully open, because it contains the virtues of the Buddha. According to the *sūtra*, he should be white, a symbol of the purification of the lotus of our own nature, but most often he is red, the colour of compassion, of love, an expression of the fact that our original nature contains the seeds of Enlightenment. Between each petal is a *vajra* with three branches. Thus is affirmed the union between Innate Reason (the lotus flower) and Knowledge (the *vajra*)—"Innate Reason and Knowledge are not two"– and the fundamental unity of the two mandalas. The same thing is also expressed by the four vases placed at the corners of the square, since an empty vase is the Womb, Innate Reason, the Garbhadhātu, and the water it contains is Knowledge, the Vajradhātu. From this union spring the virtues represented by the flowers. The central zone is framed by a five-fold border. According to the texts, this "limiting path of five colours" is made up, working from inside outwards, of a white band followed by a red, a yellow, a blue and a black (sometimes, in the mandalas themselves, the red and the yellow are reversed). These five colours correspond to the five Buddhas, the five wisdoms, the five cardinal points (including the centre), and the five elements. According to the cosmographical interpretation, white (water) is in the middle, red (fire) to the east, yellow (earth) to the south, blue (ether) to the west, and black (air) to the north. The order of the colours in the frame suggests a turning movement, suggested throughout this central zone. The point of departure, the east, the origin, the beginning, corresponds to the initial Enlightenment; to the south is the practice of ascesis; to the west, the obtaining of *bodhi*; to the north the entry into *nirvāṇa*. In some mandalas the vases in the corners are decorated with ribbons which are, successively, red, yellow, blue and black. It is through these bands of colour that the five natural elements are present everywhere in the Womb mandala. Thus it, and the central zone which epitomizes it, admirably express RI, Form, the World as it is.

The quarter of the eight-petal lotus in the middle of the ▶ Womb mandala. Above (to the east) is the quarter of Universal Knowledge, and below (to the west), that of the Five Great Ones, or quarter of the Wrathful Ones. Garbhadhātu mandala in the Musée de l'Homme, Paris.

If I imagine that I am on the altar, in the exact spot occupied
by the statue of the Enlightenment, looking towards the south:

On my left	On my right
To the EAST	To the WEST
The GARBHADHATU maṇḍala	*The VAJRADHATU maṇḍala*
In Japanese: The TAIZOKAI MANDARA	The KONGOKAI MANDARA
The mandala of INNATE REASON	The mandala of KNOWLEDGE
In Chinese: RI	CHI
The Principle which must be known	The Knower

"Reason RI and Knowledge CHI are not two."

Mandala of the ORIGINAL ENLIGHTENMENT	Mandala of the INITIAL ENLIGHTENMENT
Mandala of CAUSALITY	Mandala of RESULT
Mandala of the EAST	Mandala of the WEST
Pattern of the WOMB, the UTERUS	Pattern of the *VAJRA*, the DIAMOND, WISDOM
The open lotus	The *vajra*, the thunderbolt
FEMININE	MASCULINE
MATTER AT REST	The FUNCTIONING OF WISDOM (of ENERGY)
The FIVE ELEMENTS OF THE UNIVERSE	The ELEMENTS OF THE UNIVERSE "penetrated" by WISDOM
Acceptance, LISTENING, the PASSIVE, Receptive	ACTION, the Active, Creative
TO ACCEPT	NOT TO ACCEPT

Samadhi is
"Accepting all and not accepting,"
say the texts.

The MULTIPLE-ALL The ONE-ALL

In physics, the apparent duality between matter and energy.
Scientists, who previously adopted either the wave or the
particle theory of light, have now come to the conclusion
that both the wave theory AND the particle theory apply.
Here again the apparent duality is just the different
aspect taken on by Ultimate Reality according to the
plane it is viewed from. Both aspects exist
and each implies the other.

OBJECTIVE ASPECT SUBJECTIVE ASPECT

PRIMAL NATURE ACTIVE KNOWLEDGE

The two faces of Reality, like the two mandalas

The world considered from the point of view of its NATURE	The world considered from the point of view of its ACTION
SUBSTANCE	FUNCTION
The first five elements (Earth, Water, Fire, Air, Ether)	The sixth element (Consciousness)

YES NO
Emptiness, Identity of Yes and No
What stands between affirmation and negation
ZERO

The WORLD AS IT IS The WORLD AS IT APPEARS through the working of the mind

The two are complementary and inseparable
The union of the two leads to Illumination
The one is the principle of the other
Two sides of the same reality

◀ *The Garbhadhātu maṇḍala in the To-ji in Kyōto.*
Height 1.83 m., width 1.54 m. Late ninth century.

The Vajradhātu maṇḍala in the To-ji in Kyōto. ▶
Height 1.83 m., width 1.54 m. Late ninth century.

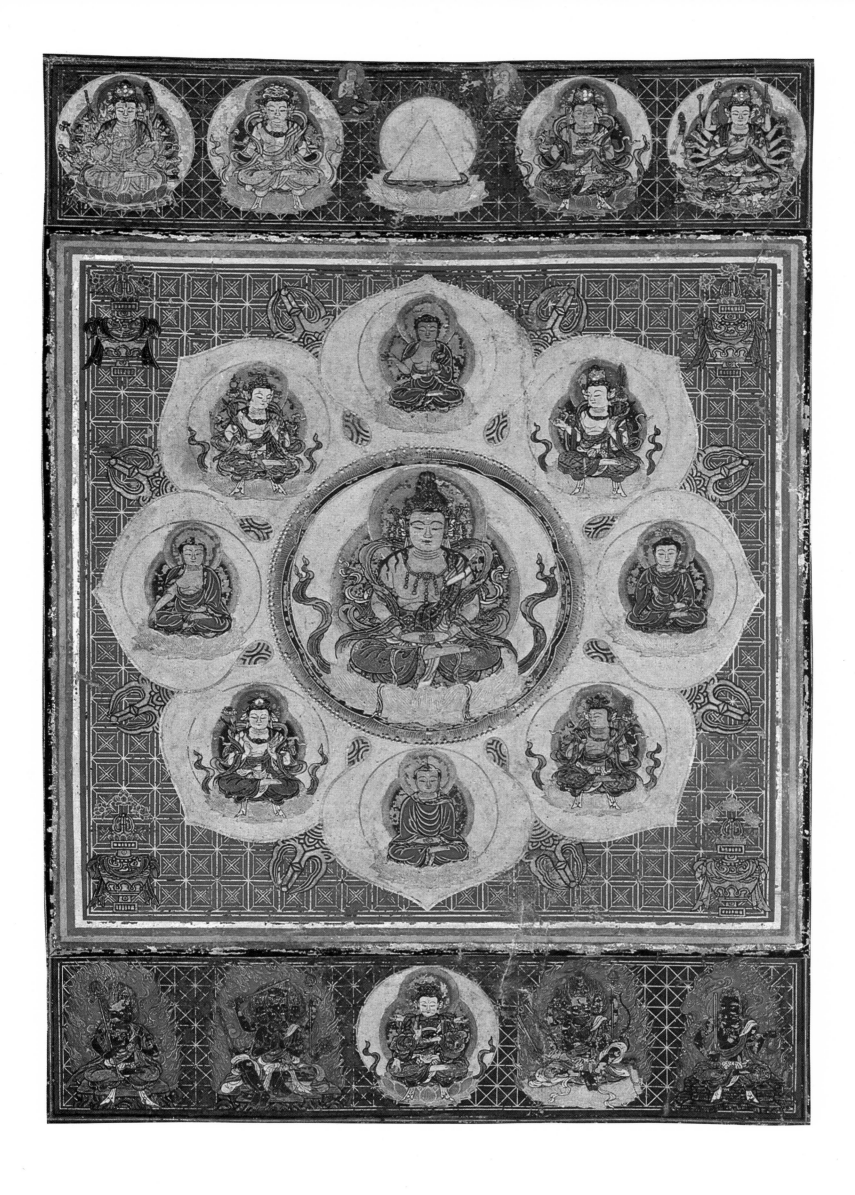

W

S 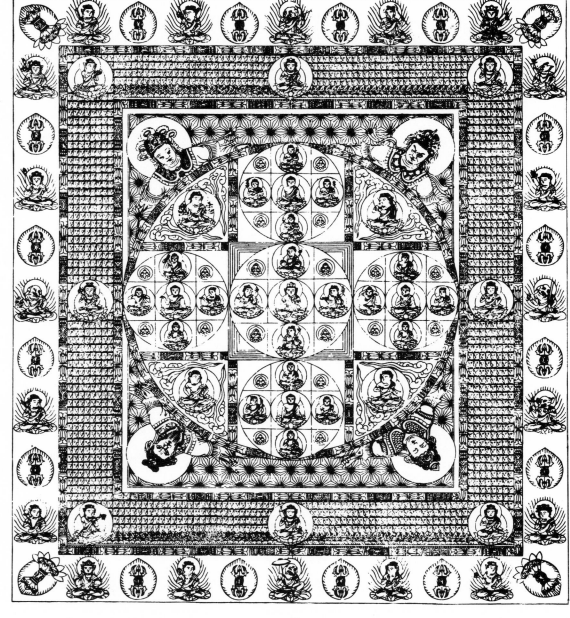 N

E

Central mandala, known as the Great Mandala
(Mahāmaṇḍala) of the Vajradhātu. Hase Mandala, 1834.
Quarter-size.

THE DIAMOND PATTERN

At first glance the checkerboard appearance of the Vajradhātu seems in direct contrast to the concentric structure of the Garbhadhātu. But once one realizes that the Diamond mandala is really an assemblage of nine mandalas, it becomes plain that each of the nine has a radial structure, as in the Womb mandala, though in the Diamond mandala the central disc is surrounded by circles instead of rectangles. While the square symbolizes the stability of Reason, the circle suggests the freedom of movement belonging to Knowledge. This is because the Vajradhātu is the mandala which expresses CHI, Knowledge, which will "apprehend" Reason in order to lead to Wisdom. Despite appearances, the checkerboard structure of the mandala as a whole is not static; it too expresses movement, a spiral movement from the centre to the periphery, as one sees if one reads the nine mandalas in their ritual order. The central mandala, which is the point of departure (or arrival), is the most important. The eight others, as we shall see, merely express the same message in the form of variation or résumé. In the centre, of course, is the Tathāgata, the Absolute, Enlightenment, but this time in its active aspect. The disc in which he sits manifests itself outwards in the four directions of space, in the four slightly smaller discs which are tangential to it. In the centre of each disc is one of the five Buddhas. Each of these in turn manifests himself in the

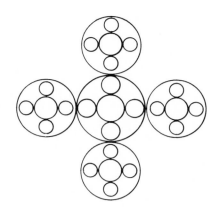

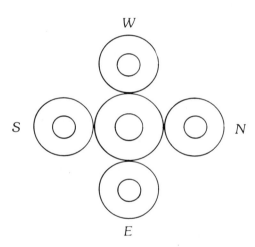

four directions, in four slightly smaller discs in each of which is seated one of the sixteen bodhisattvas. The group of five larger discs containing the twenty-one smaller ones is itself contained in a single circle made up of vajras set end to end to limit the first enclosure; this is the lunar circle, an image of the fifth element, ether. This circle is supported at the four cardinal points by the four Indian deities of the elements: in the north-east, Pṛthivī, Earth; in the south-west Varuṇa, Water; in the south-east Agni, Fire; and in the north-west Vāyu, Air. So much for the first five or material elements. The sixth element, Consciousness, is never depicted as such, since it is contained in the first five, and is the lunar disc itself. Thus our consciousness, an image of the Universe, is represented as containing the five sapiences of Vairocana and all their virtues in the form of the sixteen bodhisattvas. Outside the rectangular wall of the second enclosure, also made up of vajras end to end, there are innumerable

Buddhas: the thousand Buddhas of the present, which also represent the thousand Buddhas of the past and the thousand Buddhas of the future, since only the present exists, the past being the memory of the present and the future its anticipation. In the middle of each side of this enclosure is a bodhisattva. These are the four most important bodhisattvas, since they are at once in the world of the Buddhas, and in touch on the one hand with the world of Vairocana and on the other with "the quarter outside the vajras," the third enclosure which contains the twenty devas (ten in Japanese) who are close to us human beings and who are protectors of the Shingon doctrine. The four bodhisattvas represent the means of salvation by means of which Vairocana attracts Beings. The bodhisattva of the East holds a hook, to draw Beings back out of the evil spheres of existence; the bodhisattva of the South has a rope to draw to the state of Buddhahood those Beings who are caught in the "rope of ascetic practices"; the bodhisattva of the West holds a chain with which to keep Beings in Enlightenment; and the bodhisattva of the North has a bell, whose piercing sound delights those whom he has caused to enter into Nirvāṇa. Here, as in the central quarter of the Garbhadhātu, we have the movement east-south-west-north: from initial Awakening through the Practice of ascesis and the obtaining of bodhi to Nirvāṇa. The four deities situated at the four cardinal points, the only points of contact between the three enclosures, may be regarded as guardians of the "gates." The four gates are depicted as such in Tibetan and Nepalese mandalas.

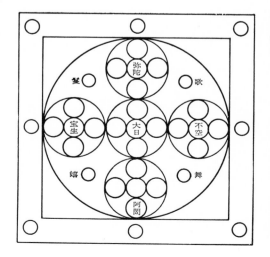

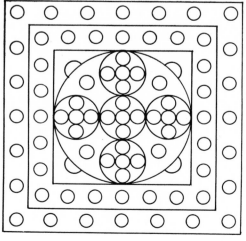

The pure geometry of the five elements is more easily seen in a diagram than when transposed into stone (steles), wood (pagodas) or bronze (ritual objects). If we superimpose one upon the other the square, the circle, the triangle, the half-circle and the composite cintāmaṇi, we can see that the square, Earth, form of the Garbhadhātu, is RI, the Principle, Innate Reason; the circle, Water, form of the Vajradhātu, is CHI, is Knowledge. Knowledge placed upon Principle (the Spiritual World inseparable from Innate Reason, rooted in it and surmounting it) form the Real World, the un-born (and therefore not subject to death).

The triangle, Fire, surmounted by the half-circle, Air, is the same image of the RI-CHI duality. They represent the inanimate beings of the phenomenal world: their forms, being born of the square and the circle, are subject to death. The topmost element, Ether, with its composite form of a triangle joined to a half-circle, also belongs to the phenomenal world. It is at once an image of animate beings and of the non-duality of the two patterns expressed by the two mandalas.

Great stūpa of the five elements in the cemetery at Kōyasan. Below, statuettes of Jizō dressed up in coloured aprons.

THE FIVE ELEMENTS OF THE UNIVERSE

As we shall see, in some cases the Vairocana Tathāgata sitting in the centre of the mandala is replaced by an object in the shape of a pagoda—the "stūpa of the five circles," symbolizing the five elements. This is because the five elements—six if one includes consciousness—are not phenomena appertaining to something, but, according to the theory of "conditioned production," *are* Ultimate Reality. In Japan one comes across innumerable examples of these *stūpas* of the five elements, either in the form of funeral monuments or as religious statues near Shingon temples. In the big cemetery on Mount Kōya, amid a forest of giant cryptomerias, there are thousands of such *stūpas*, covered with moss and lichen. The tallest are up to five metres high. The five elements—Earth, Water, Fire, Air and Ether—are here suggested by forms, not by colours as in the mandalas.

The Earth, the image of solidity, strength, immobility, inertia, of what supports all, is represented by a cube.

Water, like Life, subject to change, quivering like a droplet, is a sphere.

Fire has the pyramid shape of flame.

The fourth element, Air or Wind, a half sphere with its curved surface resting on the top of the pyramid of Fire, suggests instability, motion.

Ether, which fills all space, penetrating everywhere, is shaped, by association with the brightness of the sky, like a ball with a burning point on top—the *cintāmaṇi*.

Thus assembled, the five elements are also an image of Man. What we have here is not a microcosm and a macrocosm side by side, but the Universe incarnate in Man: an Anthropocosm. In the course of the initiation rituals, the high points for the subject are the moments at which he realizes fully first that the *stūpa* IS the Universe, then that he himself is the *stūpa*, and thus may realize the identity of Absolute and Relative in his own existence.

Stūpa *near Murō-ji: the five elements are marked with the ideograms for Earth, Water, Fire, Wind and Void.*

Stūpa *in the cemetery at Kōyasan marked with the Sanskrit letters A* 𑖀 *Va* 𑖪 *Ra* 𑖨 *Ha* 𑖮 *and Kha* 𑖏 *.*

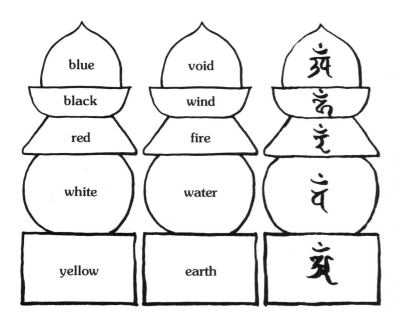

THE TWO-STOREY PAGODA

The "two-storey pagodas" found in many of the centres belonging to the Shingon School are of course *stūpas*. The lower roof has only a utilitarian function: it is there to protect the cubic element which represents Earth, while the upper roof and the mast or post rising out of it represent Fire. At the top of the mast is Ether, in the form of a *cintāmaṇi* or flaming ball. A cross-section of one of these pagodas shows how the architects and carpenters managed to solve the difficult problems involved in the transition from the square representation of Earth up to the circular representation of Water and thence up to the square base of the pyramidal roof complex representing Fire. The central mast passes through all five elements, both assisting in their interpretation and consolidating the structure. In the middle of the shrine, directly below the central mast, is an effigy of the Vairocana of the Diamond World, performing the manual gesture known as the "Knowledge Fist" or "gesture of the Six Elements." The sixth element (consciousness) which is not represented in the architecture, is thus to be found in the effigy. The two-storey pagodas found all over Japan are therefore, like the *stūpas*, representations of the Ultimate Reality of the Universe, of Enlightenment, and of Man.

宝珠
八葉
六葉
九葉
九輪
相輪
受花
伏鉢
露盤
心柱
四手先組物
高欄
亀腹
面取角柱
丸柱
亀腹

Cross-section of a two-storey pagoda.

Two funeral steles in the cemetery of the Danko-ji at Nara. The one on the right shows the five elements of a two-storey pagoda.

Two-storey pagoda (Tahō-tō) in the Kongōsanmai-in, the oldest building in Kōyasan (1223).

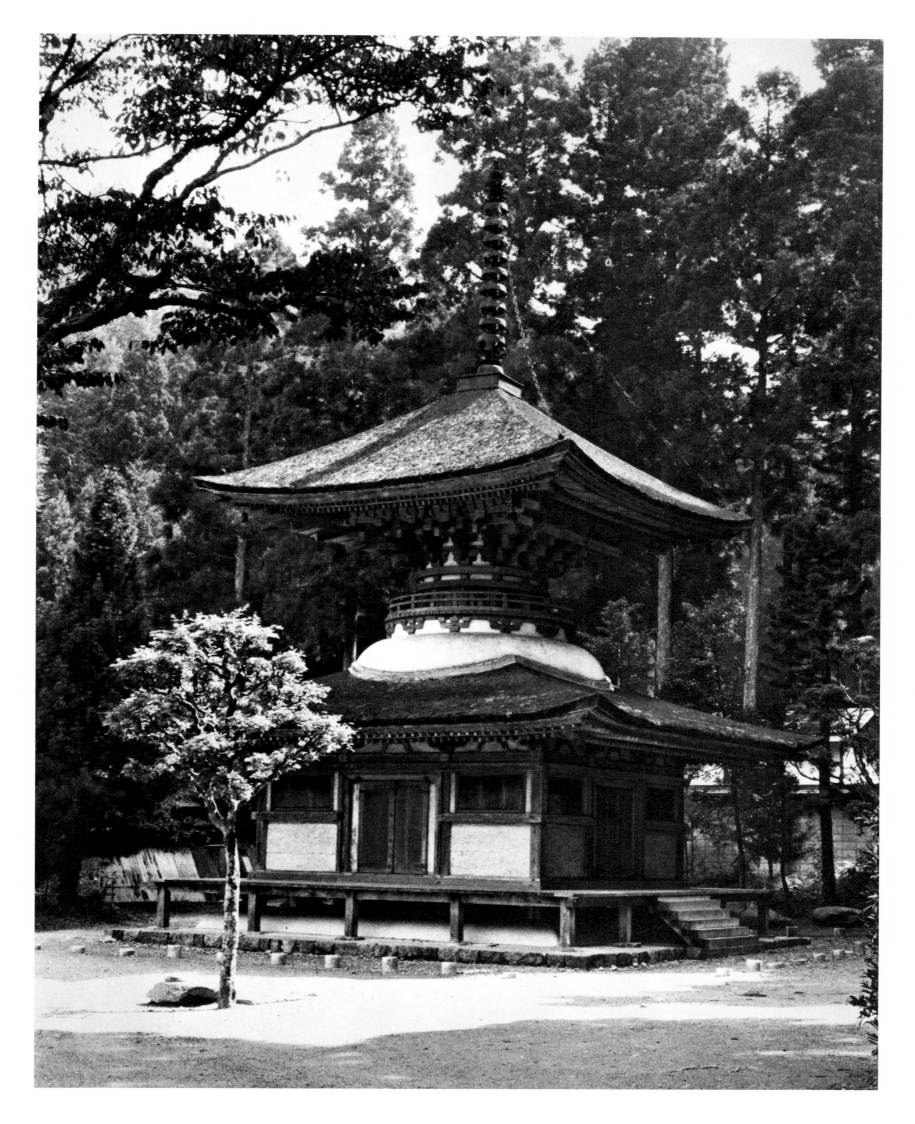

59

Wooden pillar carved in the shape of a stūpa *of the five elements, in front of the Enryaku-ji, centre of the Tendai School on Mount Hiei, north-east of Kyōto.*

THE SYMBOLISM OF
SANSKRIT LETTERS: THE BĪJAS

The illustration shows a rather rare kind of *stūpa* inscribed with the five Sino-Japanese ideograms: Earth, Water, Fire, Air and Ether. In most cases the *stūpa* has five letters of an ancient Sanskrit alphabet engraved on it. These are *bījas*—literally "seeds." They play a very important part in the practice of esoteric ritual, and their fundamental meaning is divulged only to initiates. *Bījas*, unlike ideograms, suggest not concepts but sounds. In one of the oldest Indian schools of thought, sound is regarded as eternal, and has always existed in the form of the letters of the alphabet. The meaning of a word is independent of human will, and is something belonging to the world. Words are eternal, but in order to become intelligible they have to be pronounced. According to the Tantrists, the process of producing sound epitomizes the process of creating the Universe. An abstract idea or cosmic principle may be represented in the form of an anthropomorphic deity or a symbolic object. But according to the Shingon school of Buddhism the first tangible manifestation of the Absolute was made in the form of sounds. These *bījas* are not letters of the present Sanskrit alphabet (known as *devanāgari*); they are the letters used during the Gupta dynasty, which ruled in India from 320 to 500 AD. It was this style of writing, *siddhaṃ*, still in use in the eighth century, which was introduced into China by the early Patriarchs for the writing of tantric formulas, and subsequently into Japan by Kūkai at the beginning of the ninth century.

When we open our mouths and breathe out, we produce the sound A. It is *the* sound par excellence. Without A there would be no language. The sound A expresses that which is not born, Ultimate Reality, the content of the Buddha's Illumination, the Absolute, the unthinkable, the unspeakable. The ultimate meaning of the letter A is the origin of all things. Its *bija* 𑂃 —initial letter of the word *ādyanutpāda*: not having been produced originally, not born of a first cause and therefore not subject to birth and death—is the *bija* of the first element, Earth. Water, which epitomizes the functions of life, is symbolized by the letter VA 𑂫 , from the Sanskrit *Vāri*, water. There is an association of ideas here with *Vāc*, speech, for the nature of water is inexpressible, and incompatible with speech.

Fire purifies by burning away impurities *(rajas)*. The fire of Wisdom burns away all stains; its *bija* is the syllable RA 𑂩 .

The *bija* of the wind, Ha 𑂩 , comes from the Sanskrit word *Hetu*, meaning "cause." Ignorance, the cause of our suffering, is here assimilated to the darkness of the sky which the wind drives away. The origin of the *bija* Kha 𑂍 for the ether is more obvious: the ether is represented by a jewel in the form of a flaming ball or *cintāmaṇi*, an image of the sky, which is called *Kha*.

A, Va, Ra, Ha and Kha 𑂃 𑂫 𑂩 𑂩 𑂍 , the *bijas* of the five elements, are at the same time those of the five Buddhas of the Vajradhātu. On the rear face of the *stūpa* is engraved the single syllable Vam 𑂫̇ , made up of Va 𑂫 , with the mark over the top which produces the nasal sound "m." This is an image of the Void. Vam is the "water of Wisdom," the *bija*

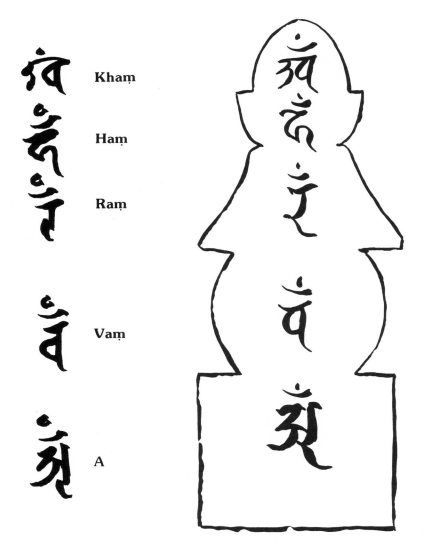

Khaṃ

Haṃ

Raṃ

Vaṃ

A

Stūpa of the five circles, after a print of the fourteenth-sixteenth century, in the Murō-ji, Nara.

symbolizing the Vajradhātu. As we can see from the diagram, this 𑀩 extends over the whole height of the *stūpa* from Ether to Earth, in order to express fully the complete interpenetration between the five elements, among themselves and with the sixth element, consciousness-wisdom. And as 𑀩 is at the same time the *bija* of the Vairocana of the Vajradhātu, the *stūpa* of the five elements in itself symbolizes the fundamental unity of the two mandalas, of "Innate Reason" and of Knowledge.

The term *bija* (semen, seed) applied to these Sanskrit letters is very suggestive of the role allotted to them in esoteric Buddhism. The *bijas* are eternal sounds, uncreated, preceding in time all earthly creation and manifestations. Sounds organized in the Sanskrit language (Sanskrit means that which is composed) are in words which are eternal, and will form the language of the Absolute. Since anything that may be said about the Absolute is false, the Enlightened Ones, in order to be understood by men, had to use parables, metaphors, the languages of forms, images, colours and allegories—and the language of *bijas*. Ultimate Reality may be represented in the form of drawings and diagrams, the only means our minds possess for representing what is beyond our understanding. When I was young, the structure of the atom was depicted as a miniature solar system made up of coloured marbles. Nowadays people prefer to imagine it as a diagram made up of conventional Greek letters. Each of these methods of representing Reality is equally false and approximate. The diagram here is very interesting in the present context, because it is perfectly symmetrical, like a mandala: the particles and anti-particles, the pluses and minuses, balance, and in the middle are the mesons and photons of charge. Western scientists try to formularize and tabulate the laws which govern the Universe (including men) by means of dead symbols. The Indians tried to do the same thing by means of the living and audible symbols called *bijas*. We should not forget that it was the Indians who, as a result of their metaphysical speculations, succeeded in inventing the concept of the Void, an image of the Absolute—not emptiness or nothingness, but the *point* where plus and minus, yes and no meet. The philosophical concept of the Void was brought back from India by the Arabs, who introduced it into the Mediterranean region under the name of *Sifr*, which means "void" in Arabic. *Sifr* became *cifre*, *chiffre* (cipher) in French, and in Italian first *Zefiro*, then *Zero*, and came to represent, in the form of a circle (though not yet a dot in Arabic), the number which itself represents an empty set, the point of departure for algebra and all subsequent scientific progress.

Table showing the structure of matter.

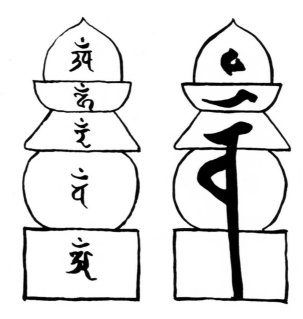

On the front of the *stūpa* are written the bījas of the five elements, A, Va, Ra, Ha and Kha, which are the bījas of the five Tathāgatas of the Womb pattern. On the back of the *stūpa* is the one syllable Vaṃ, bīja of the sixth element, consciousness, and of the Tathāgata of the Diamond pattern. Thus the *stūpa* symbolizes the unity of the two patterns.

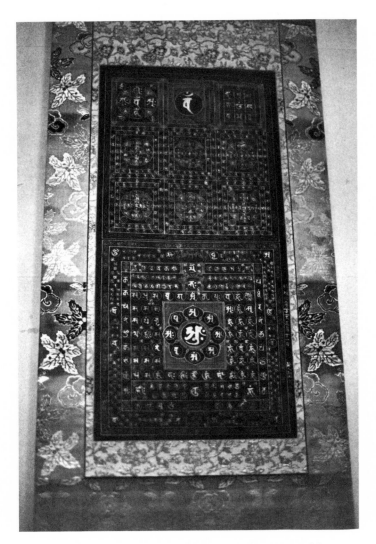

In these two mandalas the deities are represented by their bījas in gold on a black ground (shūji mandara).

This zero point, circle or lunar disc, a symbol of the Mind and of Thought, represented in Sanskrit by the word *citta* and in Chinese by the ideogram Heart, lies at the centre of the two mandalas. We have already seen how in the Vajradhātu the central disc radiates four others. Thus, through successive radiations, the unspeakable Absolute can express itself in terms of the Relative, in terms belonging to our world. Any concept may thus be represented in a figurative form accessible to our apprehension. *Bījas* occupy a special place in the scale of symbols used in this way. When we pronounce them our whole being is stirred by the same vibrations as created the Universe. The vibration "m" which changes Ra 𝗿 , the *bīja* for Fire, into Ram 𝗿̇ , the fire of Wisdom which burns away all stains; which changes Va 𝗏 into Vam 𝗏̇ , the water which purifies that which is defiled—this vibration is the zero point, symbol of the Absolute, of the Void, the Ultimate Reality of the Universe. A 𝗮 is the *bīja* of the Earth; Am 𝗮̇ , that of the Vairocana of the Garbhadhātu; Vam 𝗏̇ , that of the Vairocana of the Vajradhātu. The evocative power of a *bīja*, its "magic," is such that the mere fact of pronouncing it correctly, in an appropriate state of mind, both relaxed and concentrated, enables the person concerned to rise to a higher state of consciousness, and even to attain Enlightenment. Graphically, Enlightenment may be represented by a circle (see certain Zen paintings), a *vajra* standing on an open lotus, the letter A on a lotus (this especially in the Tendai sect), or by a diagram made up of *bījas*. In Tibet the most common and therefore the best known representation, which is also one of the most condensed and powerful, is the one which corresponds to the sound *ôm*, a sound image of the Absolute.

The Vairocana of the Vajradhātu is represented by the letter Vam.

The Vairocana of the Garbhadhātu is represented by the letter A, and the four bodhisattvas of the eight petals of the lotus by their respective bījas.

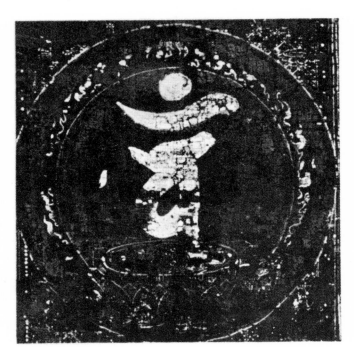

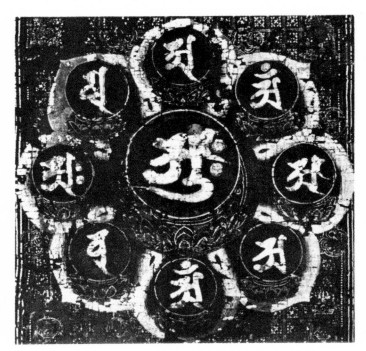

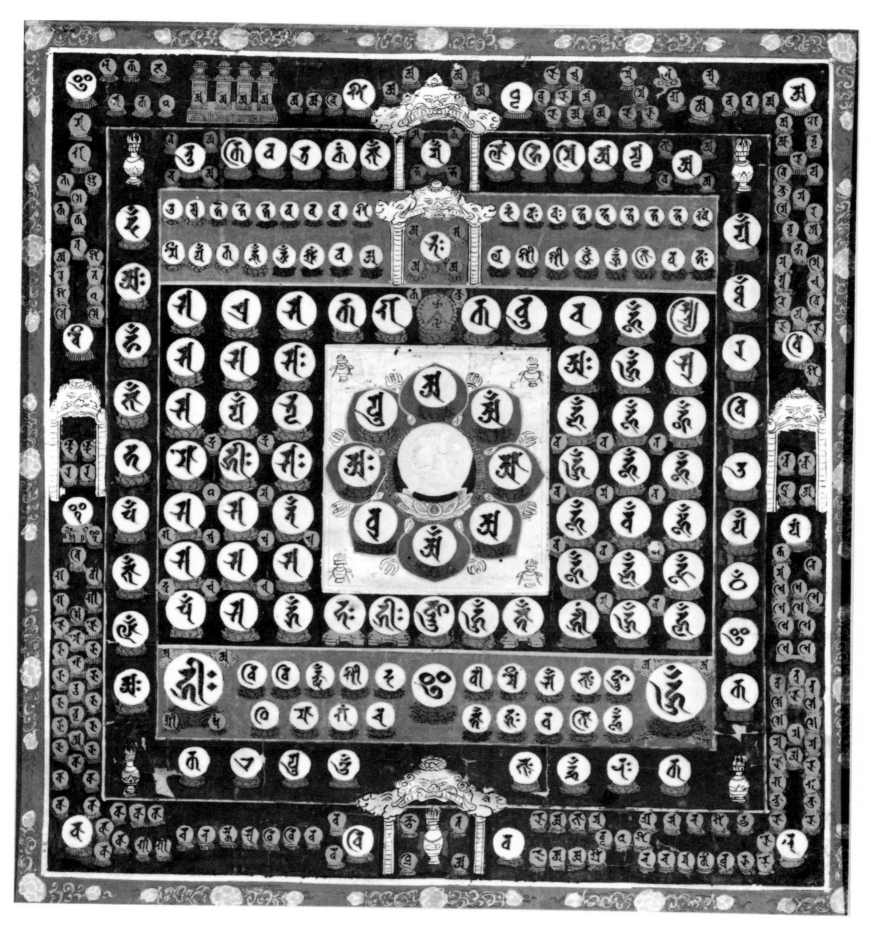

The Garbhadhātu with Sanskrit letters. Seventeenth-century woodcut.

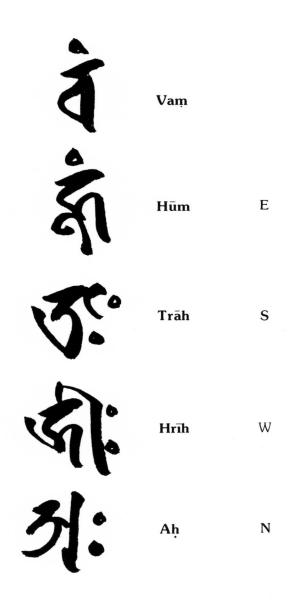

Vaṃ	
Hūm	E
Trāh	S
Hrīh	W
Aḥ	N

Vaṃ, Hūm, Trāh, Hrih and Ah, the Five Buddhas of the Vajradhātu.

There are four types of mandala, divided up according to the aspect of the deity which is represented.
The Mahā maṇḍalas *show the Buddhas and the bodhisattvas in human form, sitting in silent meditation.*
The Karma maṇḍalas *are those in which Buddhas and bodhisattvas perform gestures expressing their functions and actions* (Karma).
In the Samaya maṇḍalas *the figures are replaced by objects symbolizing their true nature and role.*
The Dharma maṇḍalas *are those in which Buddhas and bodhisattvas are represented in the form of* bījas. *These mandalas, made up entirely of Sanskrit letters, are supposed to show the Universe as it is perceived by someone who is totally awakened. It is a universe of sounds, sound being the first tangible manifestation of Ultimate Reality. In the Shingon School these* bīja *mandalas* (shūji mandara) *are regarded as the most sublime expression of the Absolute in the Relative.*

One of the Vajradhātu mandalas with Sanskrit letters. Fifteenth century.
In the centre is Vaṃ, the bīja *of the Mahāvairocana of the Diamond pattern. In the small circles surrounding him and in the middle of the large circles in the four directions are: Hūm,* bīja *of the Buddha of the East; Trāh,* bīja *of the Buddha of the South; Hrih,* bīja *of the Amida of the West; and Ah,* bīja *of the Buddha of the North.*

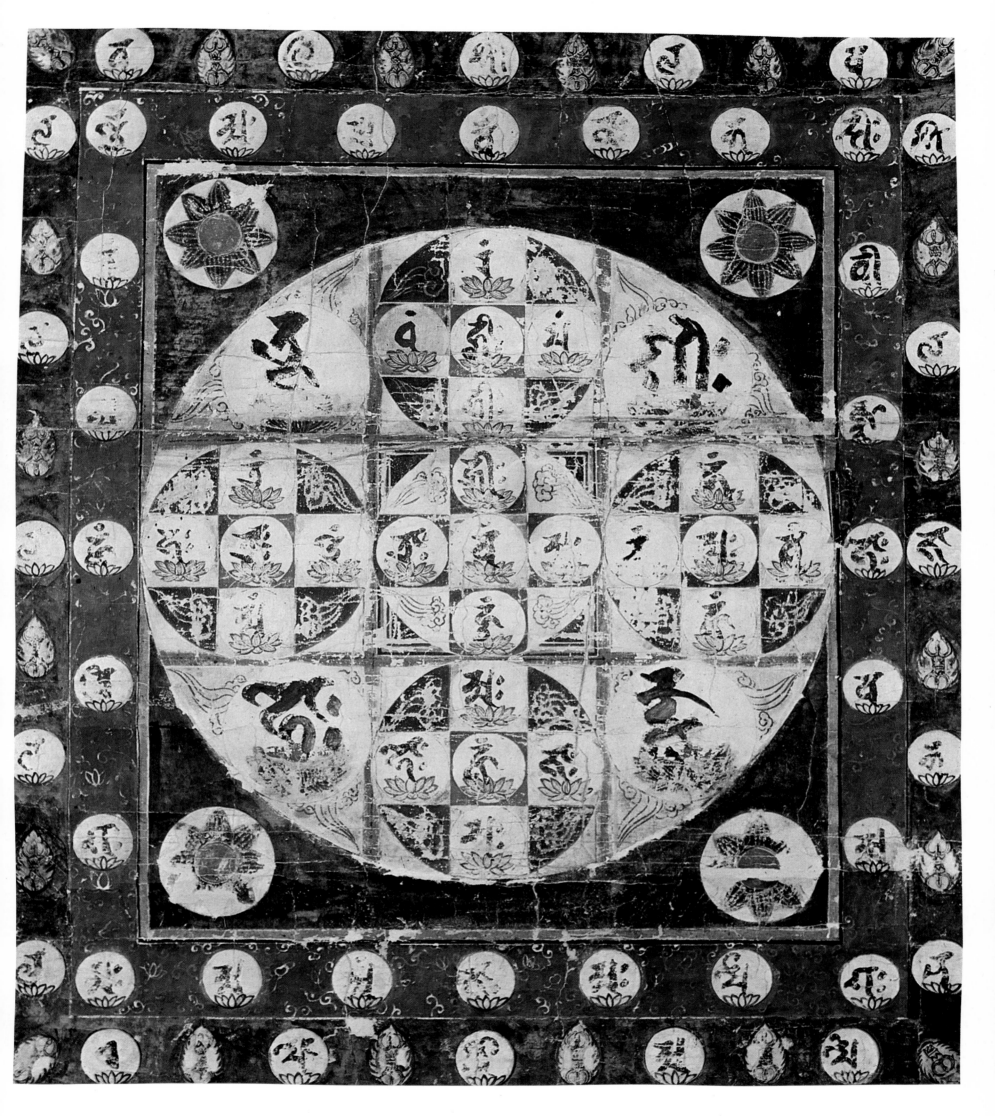

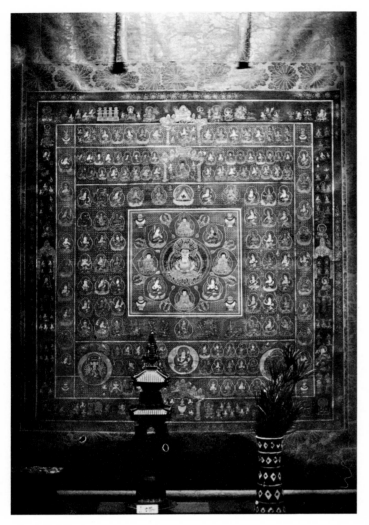

Womb mandala.

The Vairocana of the Garbhadhātu.

A 引 the left hand.

THE LEFT HAND:
THE WOMB PATTERN

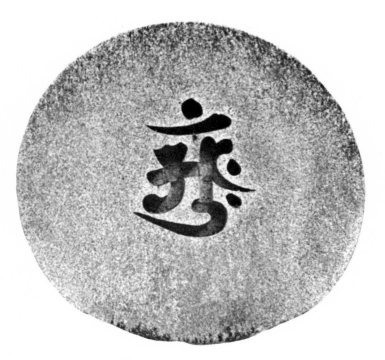

āṃh, bīja of the Vairocana of the Garbhadhātu.

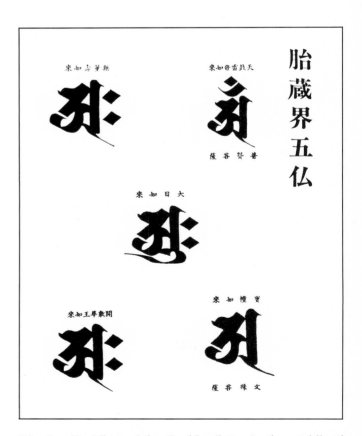

The five Buddhas of the Garbhadhātu. In the middle āḥ, to the east a, to the south ā, to the west aṃ, and to the north aḥ.

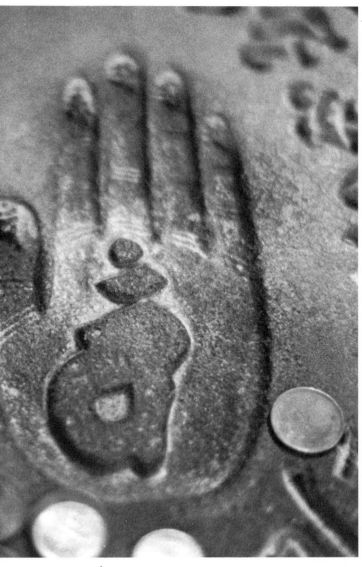

Vaṃ ई the right hand.

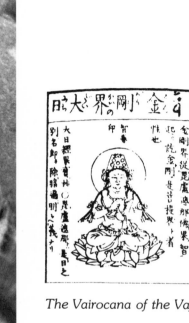

The Vairocana of the Vajradhātu.

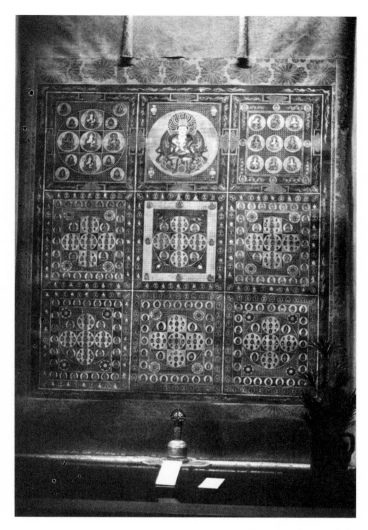

Diamond mandala.

The five Buddhas of the Vajradhātu. In the middle vaṃ, to the east hūṃ, to the south trāḥ, to the west hrīḥ and to the north aḥ.

THE RIGHT HAND: THE DIAMOND PATTERN

Vaṃ, bīja of the Vairocana of the Vajradhātu.

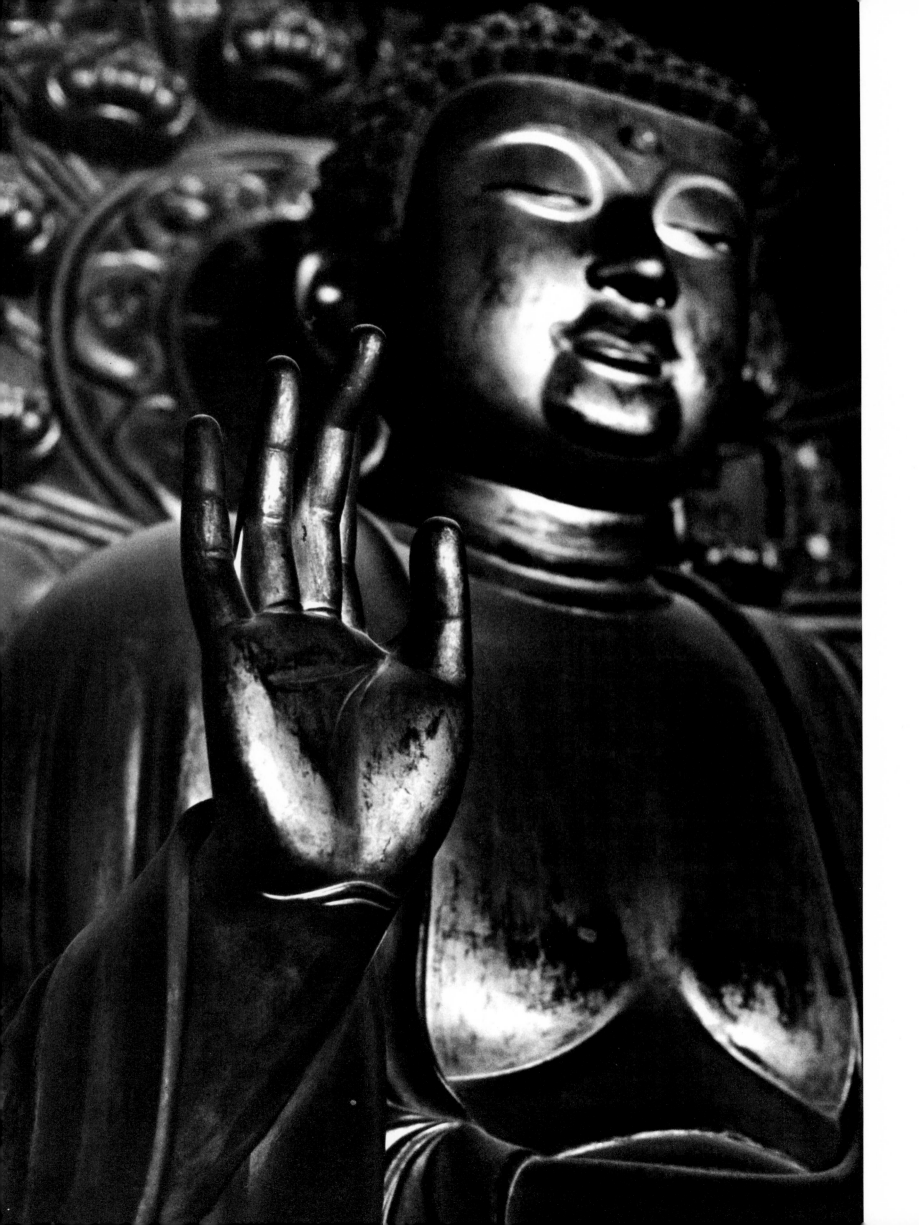

MUDRĀS: THE MOVEMENTS OF THE MIND

On the plane of the Absolute there is no longer any distinction between active and passive, right and left, male and female. In the statuary of tantric Hinduism, which appeared in central India in the fifth century, the active aspect was represented by the "spouse" of the god, his creative energy, his *śakti*. When the god Śiva assumed androgynous form, his left side was feminine. In the tantric Buddhism which spread to Tibet, strongly influenced by Hindu Shaktism, the Absolute is represented in the form of a sexual union in which the female element still plays the active part. On the other hand, in the Chinese and Japanese tantric Buddhism which concerns us here, the active element is male, though it still corresponds to the right side of the human body. The active male aspect of the Absolute is the pattern expressed by the Diamond mandala, the *bīja* Vam वं , the right hand of the Vairocana. The passive female aspect is the Womb mandala, the *bīja* A अ , the Vairocana's left hand. These two movements of the Buddha's hands are a figurative transposition of the movements of our mind which lead us to Enlightenment.

To interpret the movements of the hands correctly, we must always remember that they illustrate and express the movements of the mind. Men have always used not only words but also gestures of the arms and hands to express themselves. An advantage of these gestures is that they can be understood at a greater distance than the voice can carry, and by speakers of any language. Moreover, they make possible a direct or "magnetic" contact between beings, beyond discursive language.

I realized the importance of this language of gesture when I first came face to face with the world of India, with the "divine images" that cover the façades of Hindu temples. If one does not understand this language, the statues which were designed to speak to us remain dumb. Attitudes, movements of arms and legs, gestures of hands and fingers, are all parts of a vocabulary which seems esoteric, but does so only because of our ignorance. In fact, everything was said in plain language. Moreover, this language aimed at being universal, like the message it contained, and, in antiquity, not specifically Indian. This can be seen by the important part it played in the iconographies of Egypt, Sumer, Greece and Rome, and which it continued to play in the Christian world. The codification of the language of gesture was firmly established by the early centuries AD. It is certain that the sculptors of the Gandhāran school, descendants of Greeks soldiers who followed Alexander to India and credited with the first representations of the Buddha, chose to identify the main stages of the Buddha's life by means of gestures whose meaning was perfectly clear throughout the ancient world.

Right hand and left hand of the Buddha of Medicine in the Hōkō-ji at Kyōto.

右手 施無畏印　左手 与願印

来　迎　印

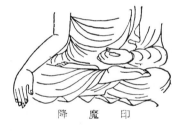

右手与願印（裂裟角ヲトル）

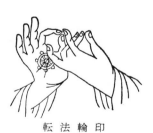

降　魔　印

転 法 輪 印

EXOTERIC *MUDRĀS*

The right hand performs the gesture which grants absence of fear: abhayamudrā (semui-in), the left hand that of charity: varamudrā (segan-in).

Gesture of argumentation: vitarkamudrā.

The right hand performs the gesture of charity: varamudrā (segan-in).

Gesture of taking the earth to witness: bhūmisparśamudrā (sokuchi-in).

Gesture of turning the wheel of the Law: dharmacakrāmudrā (tembōrin-in).

These manual gestures and twinings of fingers are known by the Sanskrit name of *mudrās*. *Mudrā* has a meaning at once wider and more precise than this. It means a writing, a sign language, a gesture of the hand, a seal. The Japanese word for *mudrā* is *in*, which means seal. *Mudrā* is also the calling of something by its name, authority, command. As symbols of authority, productive of power and efficiency, *mudrās* are naturally the attributes of the god, the king, the priest and the magician. In the Indian world, where man was a miniature image of the cosmos, the ritual gestures of a priest or a statue of a deity had the value of cosmic motion. In every ritual act, a *mudrā* was accompanied by the utterance of a sound, and by this dual act of magic, man entered into contact with the universe and could affect its workings.

These gestures, of which there are only seven, and which are found in all the Asian countries which received in turn the messages of the Lesser, the Great and the Diamond Vehicle, are not exclusively Buddhist. The *mudrā* of meditation is found earlier in the Jain religion, and in the art of the Indus (2500 to 1500 BC). The *mudrā* "which grants the absence of fear" is found frequently in representations of Śiva. The *mudrā* of argumentation is still used automatically in India and Italy to emphasize what is being said. The *mudrā* of "giving" or "pity," and that of "taking the earth to witness" are very expressive of the attitude to be conveyed. The seventh *mudrā*, in Sanskrit *dharmacakramudrā*, the *mudrā* of the Wheel of Dharma, represents the moment when the bodhisattva, having attained Buddhahood, sets the Wheel of the Law in motion. Long before Buddhism, the symbol of the wheel was used in Indian tradition to represent the perpetual motion of rebirth. The wheel is usually depicted as having eight spokes, and is linked to the symbolism of the sun and of the eight-petalled lotus, expressing the eight stages of spiritual rebirth. Originally these seven *mudrās* possessed no hidden meaning and were common to all forms of Buddhism. But when we meet them again in sculptures and paintings in India after the seventh century, in China and Tibet after the eighth century, and in Japan at the beginning of the ninth, they have taken on a quite different meaning; or rather, their original meaning has been reinforced by a hidden one which is much more complex and rich doctrinally, and has several levels of significance, some of which were restricted to initiates. In the rites of both Hindus and Buddhists, the performance of *mudrās*, accompanied by the reciting of *mantras*, was to play an important part in progress towards, in the first case, reintegration, and, in the second, Enlightenment. With the appearance and development of the *Tantrayāna*, the "third turn of the Wheel of the Law," the seven *mudrās* which contained and epitomized the teaching of the historical Buddha were supplemented by ten or so others and a large number of variants, transmitting the secret teaching of the Vairocana, of whom the Śākyamuni was but one earthly manifestation. But while there is a distinction to be made between exoteric and esoteric Buddhism, represented by the Buddhas Śākyamuni and Vairocana respectively, there is no doctrinal difference between them. The Law understood by Śākyamuni when he attained Illumination was Absolute Reality (Tathatā), and

exists, unchangeable, quite apart from Śākyamuni's Enlightenment. In the Buddhism of the Lesser Vehicle, the emphasis is on the Śākyamuni who preaches the Law; in the Great Vehicle, the historical Buddha, idealized and eternal, continues to manifest himself through the bodhisattvas (Enlightenment-beings); in the Third Vehicle, the Ultimate Reality of the Universe possesses form and action and can thus manifest itself without any intermediary and expound the Law directly.

Any man can therefore become a Buddha or Tathāgata —literally "He who has realized the nature of things as they are"—by making the three acts performed during ritual coincide with the three "mystery-acts" of the Secret Buddha. When the Buddha was asked what the expression "things as they are" meant, he answered: Śūnyatā—Emptiness. In esoteric Buddhism, every drawing, painting or sculpture was to be at the same time an image of that Emptiness and an image of our own fundamental nature. Emptiness, and our own nature, was by definition inexpressible, and could be apprehended only from two different points of view, two convergent angles.

EXOTERIC *MUDRĀS*

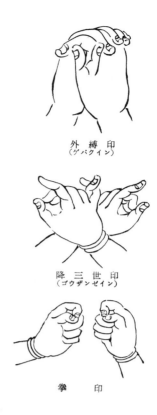

外 縛 印
（ゲバクイン）

降 三 世 印
（ゴウザンゼイン）

拳 印

Left hand of a bronze Buddha near the Shingon temple at Kurodani near Kyōto. Mudrā of joy, of luck: an-i-in.

THE SYMBOLISM OF THE FINGERS

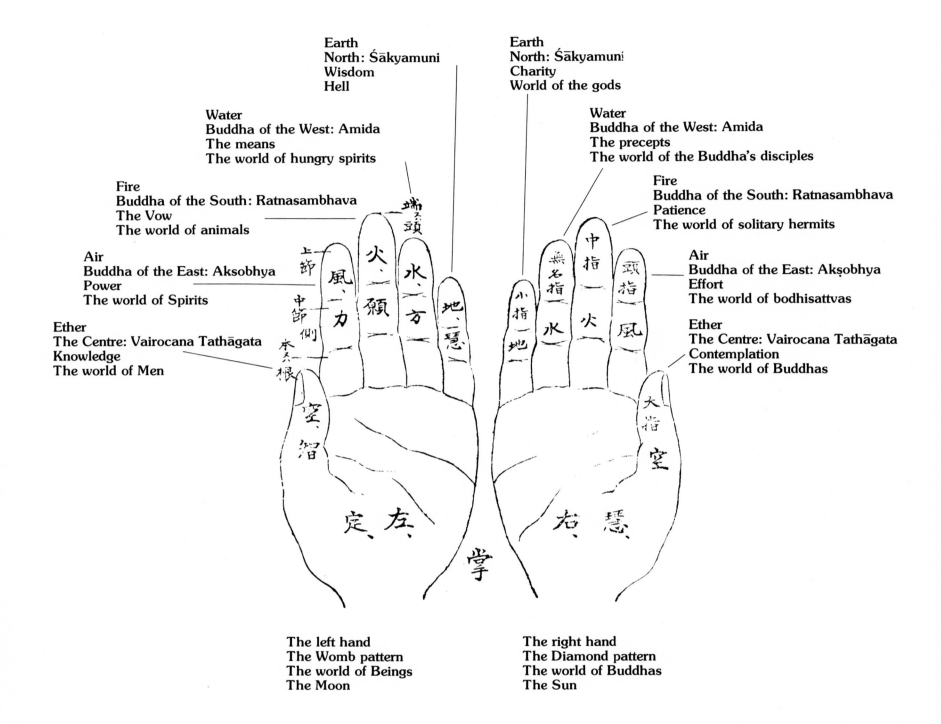

Earth
North: Śākyamuni
Wisdom
Hell

Earth
North: Śākyamuni
Charity
World of the gods

Water
Buddha of the West: Amida
The means
The world of hungry spirits

Water
Buddha of the West: Amida
The precepts
The world of the Buddha's disciples

Fire
Buddha of the South: Ratnasambhava
The Vow
The world of animals

Fire
Buddha of the South: Ratnasambhava
Patience
The world of solitary hermits

Air
Buddha of the East: Akṣobhya
Power
The world of Spirits

Air
Buddha of the East: Akṣobhya
Effort
The world of bodhisattvas

Ether
The Centre: Vairocana Tathāgata
Knowledge
The world of Men

Ether
The Centre: Vairocana Tathāgata
Contemplation
The world of Buddhas

The left hand
The Womb pattern
The world of Beings
The Moon

The right hand
The Diamond pattern
The world of Buddhas
The Sun

The five fingers represent the five elements, the five Buddhas,
the five constituent elements of consciousness, the five senses.
The ten fingers represent the ten virtues, the ten worlds.

We have already seen how the right hand, which is active, represented the Diamond pattern, while the left hand, which is passive, represented the pattern of the Womb. It should be added that in tantrism every finger was to take on a particular significance. Each hand was a mandala, and the five fingers represented the five elements, the five Buddhas, the five components of thought, and so on, Each finger was linked to an aspect of the Absolute, a colour, a *bīja*, etc. In the course of ritual, by living these symbols, we may apprehend the reality of our true nature. Statues of the Tathāgata, the personification of the Universe, may speak to us through esoteric *mudrās* and correspondences. As we sit before them, relaxed and in a posture of meditation, we shall be able to "listen to the *dharma*." By combining this passive mental attitude with the active practice of the three acts of body, word and thought, we may achieve *samādhi*, relaxed concentration, transcendence of our own rationality, Awakening.

There are no books on how to perform the ritual *mudrās* correctly. The teaching remains secret, confined within the Shingon and Tendai schools of Japan, handed down from master to disciple. But it is possible to obtain manuals containing drawings of the chief *mudrās* of the four great rites—the rites of the "eighteen paths," of the Vajradhātu of the Garbhadhātu, and of fire. These include no fewer than three hundred and ninety different *mudrās*. Up to 1868, Japan existed in almost complete isolation, and it was not until 1876 that Emile Guimet brought one of these manuals back to Paris. Esoteric Buddhism was then totally unknown in the West, and it was only after twenty-three years of research that the book was published and commented upon. Part of the Introduction to the 1899 Paris edition is reproduced overleaf.

Some ritual *mudrās* are found, with exactly the same meaning, in paintings and sculptures in which deities use them to express their action. They are also found in the form of separate drawings, usually surrounded by a halo of flames and standing on a fully opened lotus. The active role of the gesture is thus opposed to its passive, receptive counterpart in an act of fertilization.

Certain esoteric mudrās are performed secretly under the folds of the monk's robe.

Deities represented in the form of mudrās.

73

SI-DO-IN-DZOU

GESTES DE L'OFFICIANT

DANS LES CÉRÉMONIES MYSTIQUES

DES SECTES TENDAÏ ET SINGON

D'APRÈS LE COMMENTAIRE

DE

M. HORIOU TOKI

SUPÉRIEUR DU TEMPLE DE MITANI-DJI

TRADUIT DU JAPONAIS	AVEC INTRODUCTION
SOUS SA DIRECTION	ET ANNOTATIONS
PAR	PAR
S. KAWAMOURA	**L. DE MILLOUÉ**
	CONSERVATEUR DU MUSÉE GUIMET

PARIS

ERNEST LEROUX, ÉDITEUR

28, RUE BONAPARTE, 28

1899

INTRODUCTION

When M. Guimet visited the Buddhist temples of Japan, in the course of a mission entrusted to him in 1876 by the Ministère de l'Instruction publique et des Beaux-Arts, the ceremonies of the Shingon sect (an esoteric and mystical sect, as is well known) particularly attracted his attention. He noticed that when the priests recited or chanted their prayers their hands were constantly moving beneath the wide sleeves of their robes, sometimes rapidly emerging to take up or put down some sacred utensil, rosary, thunderbolt, bell or aspergillum, or to make a gesture resembling benediction. M. Guimet's curiosity was aroused, but his attempts to obtain information from the priests were vain. All he could find out was that these were ritual gestures known as *In*, i.e. "seals," and that their meaning and the way of performing them were part of the secret doctrines to which only initiates might be admitted. The most severe punishments, in both this world and the next, awaited any sacrilegious monk who delivered over to an uninitiated person the key to the mystery of the seals.

When, however, M. Guimet found that his guide at the Chi-shiku-in in Kyoto was a young novice who seemed lively and disposed to talk, he reintroduced the topic which had interested him so deeply. At first, like all the other priests, the monk took refuge in the secrecy of the doctrine. Then, attracted

Facsimile of title page of 1899 edition of the Shi-do-in-zu, compiled in 1272 in accordance with a tradition deriving from a ninth-century Master of the Tendai School.

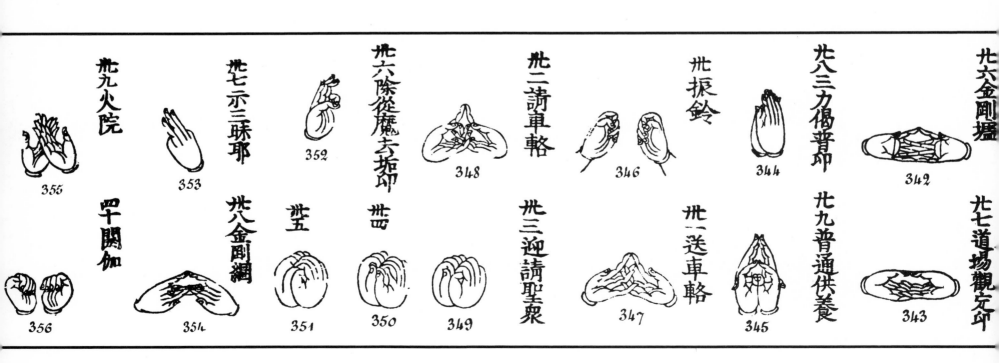

by the offer of having his portrait drawn by M. Félix Régamey, he objected that as a mere novice he had not yet been initiated into the depths of the mystery of the seals. Finally he promised to get M. Guimet the book containing all the cabalistic signs and their meanings, together with explanations of the ceremonies in which they were used.

What is published here is a commentary on that book.

It was a great step forward to have the book, but we still needed to understand its contents, and for a long time this proved an insurmountable difficulty. Among the Japanese members of staff attached to the Musée [Guimet] when it was founded in 1878 was M. Imaizumi, a most erudite scholar who had for some time been a novice in the Shingon sect. M. Guimet asked him to translate the mysterious book, but after long and fruitless efforts M. Imaizumi declared he could make nothing of it, either because, as he said, his degree of initiation was not sufficient to enable him to understand it, or perhaps for reasons of conscience.

The book was then shown to various Japanese and Chinese scholars. It was submitted to M. Fujishima Ryawon, a priest of the Shin-syo sect, when he visited Paris; to M. Hung-chou, head of the Annamite bonzes at the 1889 Exhibition; to MM. Ko Izumi Ryotai and Yoshitsura Hoguen, the two priests of the Shin-syo sect who celebrated the first Buddhist office in the Musée Guimet on February 21, 1891, and to M. Motoyoshi Saizo. No one could understand it. Only M. Hung-chou had been able to catch a part of what it said, but even he was unable to give its exact meaning.

We were beginning to despair of ever solving this tantalizing mystery when at the end of 1893 there arrived in Paris M. Horyo Toki, superior of the Shingon monastery of Mitani-ji. He was visiting Europe on his way back from the Congress of Religions which had been held a few months earlier in Chicago and to which he had been sent as a delegate by the chapter of his sect. At first M. Horyo Toki declined to tell us anything, because of the secret nature of the rites involved. But at our urgent request, and realizing from all he saw around him that we were motivated only by scientific curiosity and a great interest in the dogmas of Buddhism, he agreed to lift a corner of the veil for us, and to reveal in a brief commentary the meaning and raison d'être of the mysterious gestures. But he told us he would confine himself to those points which were revealed to novices. As for the prayers and invocations, the mantras and the dharanis, he absolutely refused not only to translate them but even to read them to us.

The writing and translation of the commentary, together with the necessary discussion, lasted five months, and unfortunately both M. Toki and M. Kawamura [the translator] had to leave for Japan before certain doubtful points could be completely elucidated and certain details made clear. These concerned chiefly the distortion of form due to the double transcription into Chinese and Japanese, and the special meaning of the many Sanskrit terms which occur in the work. Nevertheless, our labours as a whole were sufficiently advanced for me, even when left to my own resources, to...

THE *MUDRĀS* OF RITUAL

Some of the mudrās of the Fire ritual (Goma). From the Shi-do-in-zu.

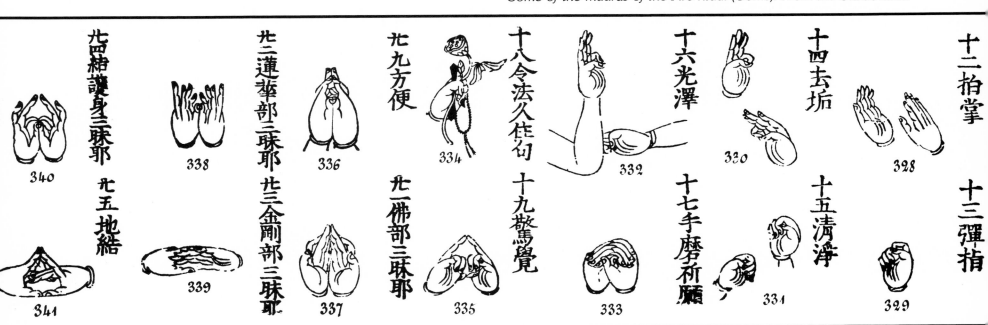

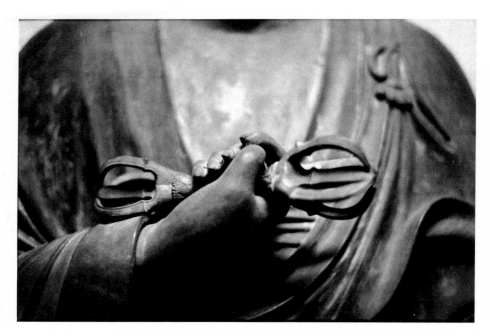

The vajra *is held in the right hand. Detail of a statue of Kōbō-Daishi in the Tōdai-ji at Nara.*

RITUAL OBJECTS

Eighteenth-century Tibetan ritual bell.
The bell, an image of the phenomenal world—the sound it emits is without substantial reality—is held in the left hand.

In the iconography, *mudrās* are often supplemented with attributes: lotus flowers, bows and arrows, ropes, etc. (There are between thirty and forty different attributes. Their meaning will be explained as we come to them.) *Mudrās* performed by the officiating priest are usually carried out with the hands alone, but sometimes they are performed with the aid of ritual objects laid out before the priest on the altar: these may include several kinds of bell and *vajra*. Iconography experts have no doubt that the *vajra* derives from the image of the thunderbolt. It is an attribute of Zeus and of Indra, the Hindu divinity of the atmosphere; an emblem of sovereignty and of the victory of light over darkness, knowledge over illusion. It is the force of Wisdom, which destroys the obstacles presented by the passions. The *vajra* is a symbol of irresistible and indestructible Truth. In Sanskrit, *vajra* (*kongō* in Japanese) is the thunderbolt and the diamond. In esoteric Buddhism (*Tantrayāna, Vajrayāna*, the Diamond Vehicle) it is an emblem of indestructible hardness, and as such stands for Wisdom; but it also stands for Buddhist Law, Emptiness, the nucleus of all things, the Absolute, Awakening. In Tibetan tantrism the *vajra* is a phallic symbol, the counterpart of the lotus. This aspect, though secondary in the two esoteric schools of Japan, is still present there, in particular as regards the single-point *vajra* (one point on each side, for in Japan the *vajra* is always symmetrical). This single-point *vajra*, the axis of the cosmos and symbol of the doctrine, is the only one a novice is allowed to use in the ritual. In the Shingon school the *vajra* is usually three-pointed, an image of the "threefold mystery," of the unity of the three acts. Two crossed *vajras* are related to the symbolism of the wheel. The four-pointed *vajra* recalls the form of an unopened lotus bud. The five-pointed *vajra*, which is restricted to initiates, symbolizes many things: for example, the five elements, the five Buddhas, the five Wisdoms. Its symmetry signifies that there is no difference between the Buddha World and the World of Beings. Its middle point, surrounded by four curved ones, with all five united at the base, suggests the central part of the two mandalas (with their central Tathāgatas radiating their four aspects) and their fundamental unity. Bells also play an important part in the ritual. The sound of a bell, which is perishable and may be perceived but not preserved, is a symbol of impermanence.

Like sound, things have no substantial reality. A bell represents the phenomenal world, the Garbhadhātu, the Womb pattern, just as the *vajra* represents the pattern of the Diamond. If the handle of the bell is in the shape of a *vajra*, this represents the oneness of the two patterns and, more markedly in Tibetan tantrism, the union of the male and female principles. To perform the ritual the officiating priest sits in the lotus posture on a small platform facing either the main altar of the temple with its statue of the "Honorable Principal" (the Amida Buddha, or one of the deities Fudō and Kannon), or one of the two mandalas. Just in front of the priest and on the same level is another dais about one metre square, an altar with numerous copper or bronze objects on it, arranged symmetrically in a way that suggests a mandala. And that is exactly what it is. In the

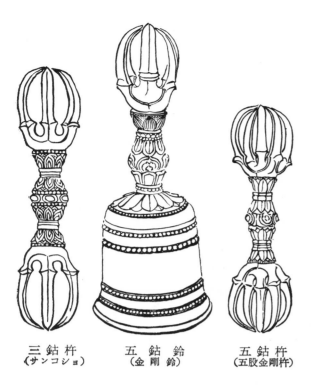

三鈷杵
（サンコショ）

五鈷鈴
（金剛鈴）

五鈷杵
（五股金剛杵）

In esoteric Buddhism the handle of the bell is in the shape of a vajra, so that the object as a whole symbolizes the indissociability of the Womb and Diamond patterns.

Ritual being performed in the Enryaku-ji, Mount Hiei, centre of the Tendai School.

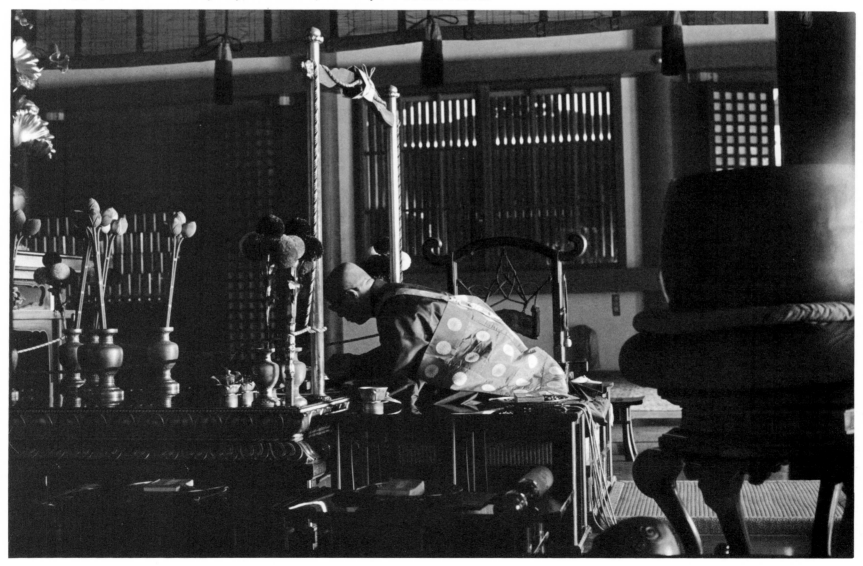

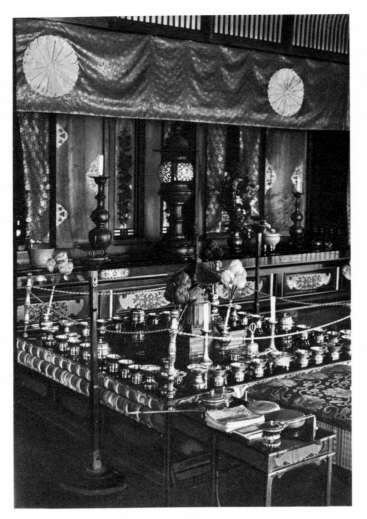

Shingon altar in the Ninna-ji, Kyōto.

middle there are a *vajra* and a bell, each in the shape of a tower, representing respectively the "Realization" and the "Teaching" of Mahāvairocana, the essential cosmic Wisdom. On either side, in all four directions, are four other pairs consisting of a *vajra* and a bell. To the east is a five-pointed *vajra* and a bell with a handle shaped like a five-pointed *vajra*. To the south is a *vajra* shaped like a *maṇi*, and a bell whose handle is surmounted by a *maṇi*. To the west are a single-point *vajra* and bell; to the north, a three-pointed *vajra* and bell. Each of these pairs of objects represents the "Realization" and the "Teaching" of one of the four Buddhas of the Vajradhātu Mandala, each pair being an image of one of his Wisdoms. All the surrounding ritual objects —vases, candlesticks, vessels containing water, rice, fruit and so on—help the priest, as he performs the three acts through the *mantras* he recites, the *mudrās* he performs, and his mental representations, to identify with the Tathāgata and, by living the symbols, to attain transcendence. It is not a god he is addressing, but himself. It is to himself he makes the offerings. By the quasi-magical power of ritual acts correctly performed, he will attain a higher level of consciousness, he will become aware that he is "He who has realized the Reality of Things (Tathāgata)," that there is no difference between the Buddha and himself.

> ***I am sitting, I am Buddha.***
> The Zen monk Dōgen (1200–1253)

1a vajra in the form of a tower: the "realization"
1b bell in the form of a tower: the teaching
— of Mahāvairocana (essential cosmic wisdom)

2a five-point vajra: the "realization"
2b bell surmounted by five-point vajra: the teaching
— of Akṣobhya (wisdom of the great round mirror)

3a vajra in the form of a maṇi: the "realization"
3b bell in the form of a maṇi: the teaching
— of Ratnasaṃbhava (wisdom of the natural equality of all beings)

4a one-point vajra: the "realization"
4b bell surmounted by one-point vajra: the teaching
— of Amitāyus (wisdom of marvellous discernment)

5a three-point vajra: the "realization"
5b bell surmounted by three-point vajra: the teaching
— of Amoghasiddhi (wisdom which produces acts)

6 cakra, wheel (symbol of the Buddha and his teaching)

7 karma-vajra, vajra-action (symbol of wisdom, the intrinsic function of the Buddha)

8 perfume-brazier

9 water

10 powdered incense

11 flowers (leaves)

12 rice

13 flower vases (symbolic)

14 soup (made of red beans)

15 rice paste

16 fruit

17 posts

18 candlesticks

19 streamers decorated with lines of precious stones or round metal beads. The four streamers at the four corners of the altar stand for the "virtue" of the officiant which is offered to the four Buddhas.

20 dais for officiating priest

21 aspergillum stick or rod

22 sprinkling water

23 incense

24 incense for swallowing (to purify the mouth)

25 perfume-brazier with handle

26 metal gong hanging at a gate

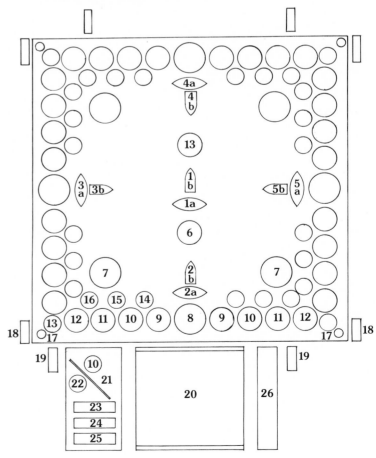

The whole ritual can be divided into four successive rites. The preliminary one is like the Hindu rite of hospitality. The priest is receiving a distinguished guest. He must first purify himself, and then prepare a place and build on it to receive the guest, decorate and protect the "site" (of Enlightenment), offer a meal, and then speed the parting guest. At the beginning of the rite, he is the host; at its end he is the guest. There is no fundamental difference between the two. The second *mantra* of the ritual—"ōm Tathāgatodbavāya svāha"—means "ōm! Birth of a Tathāgata, hail!" The ritual is a birth. There is no death and birth; only birth. The Tathāgata who is invited is none other than the officiant, the inviter, myself. When, at the end of the rite, I ask him, the Absolute, to depart, he does so, but he remains in me, the Relative, who have just become aware that in fact I am the Absolute. The Absolute contains the Relative. I am the Absolute, but I go on living in the Relative, in the world of phenomena. I have accomplished the rite of the eighteen paths (dō), of the eighteen awakenings (dō), I am the Enlightened One. The Tathāgata who was my guest has departed only for those who remain in the Relative; but in fact he has remained, in me. Indeed, he has always been there. This birth is bound to be an inexpressible experience. You cannot look on at it; you can only live it. It is a painless birth, a birth outside the realm of suffering: it is the goal of existence, the only goal, as Buddha said 2,400 years ago.

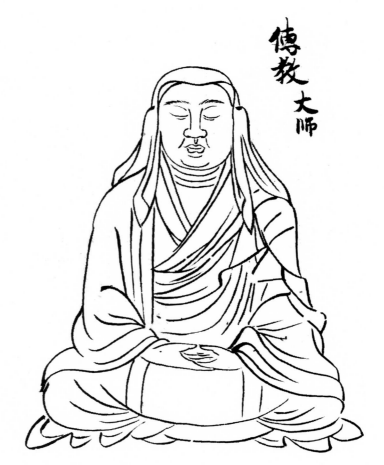

The monk Saichō.

ALTARS AND THE MANDALA OF RITUAL OBJECTS

Arrangement of ritual objects on the altar for the Fire ritual. Detail from the Shi-do-in-zu.

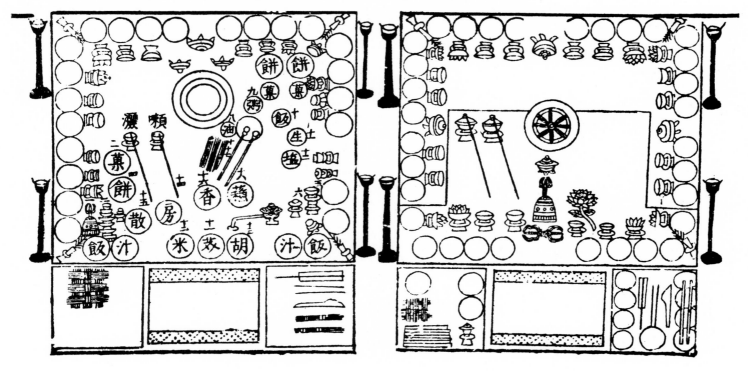

Esoteric ceremony in the Enryaku-ji, Mount Hiei, centre
of the Tendai School.

On the next two pages:

Main altar of the Chishaku-in in Kyōto.
In the middle, the Mahāvairocana of the Diamond pattern.
On his right the Vajradhātu, on his left the Garbhadhātu.

Vajradhātu maṇḍala in the Chishaku-in in Kyōto.

The Amida triad in the Sennyū-ji in Kyōto.

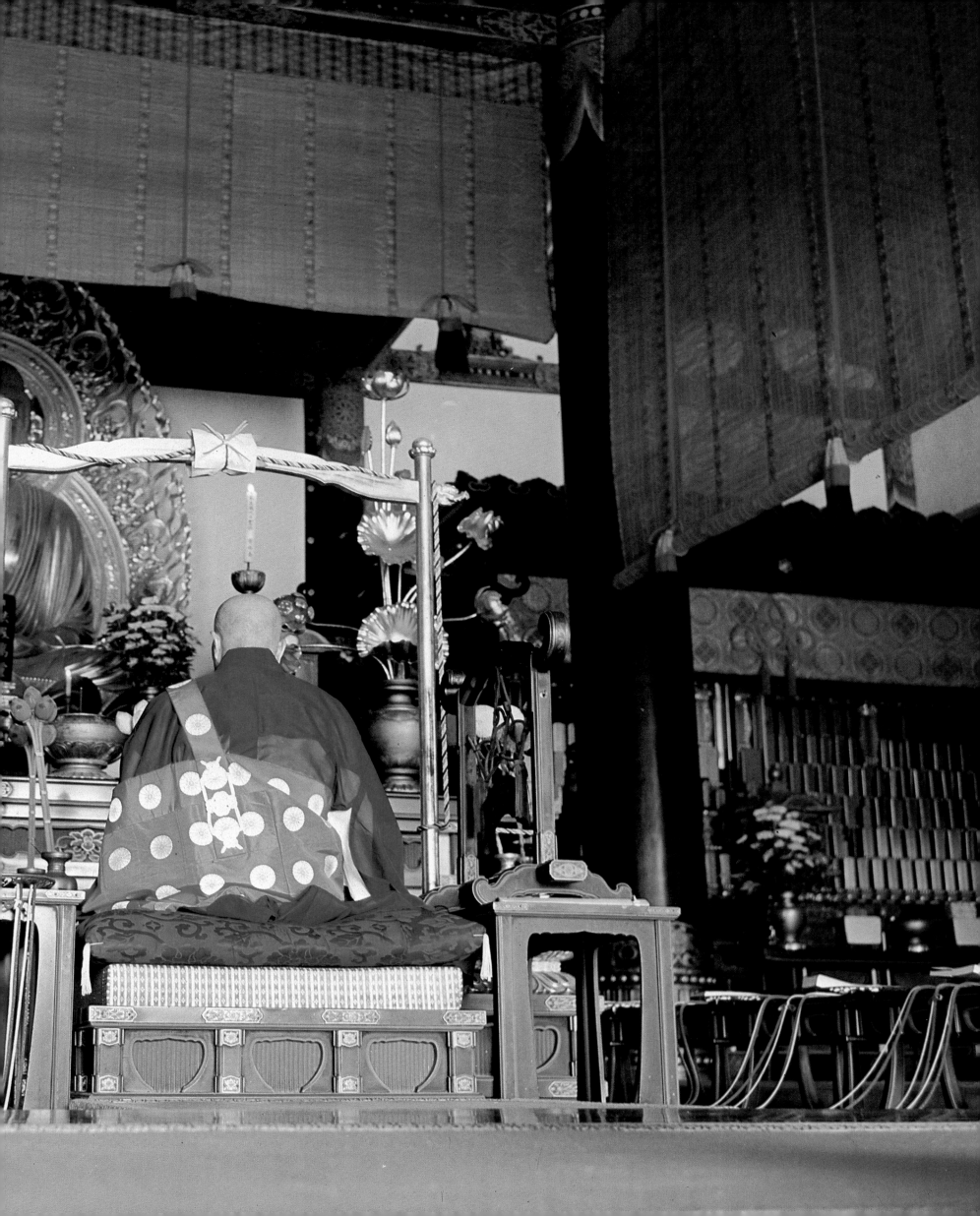

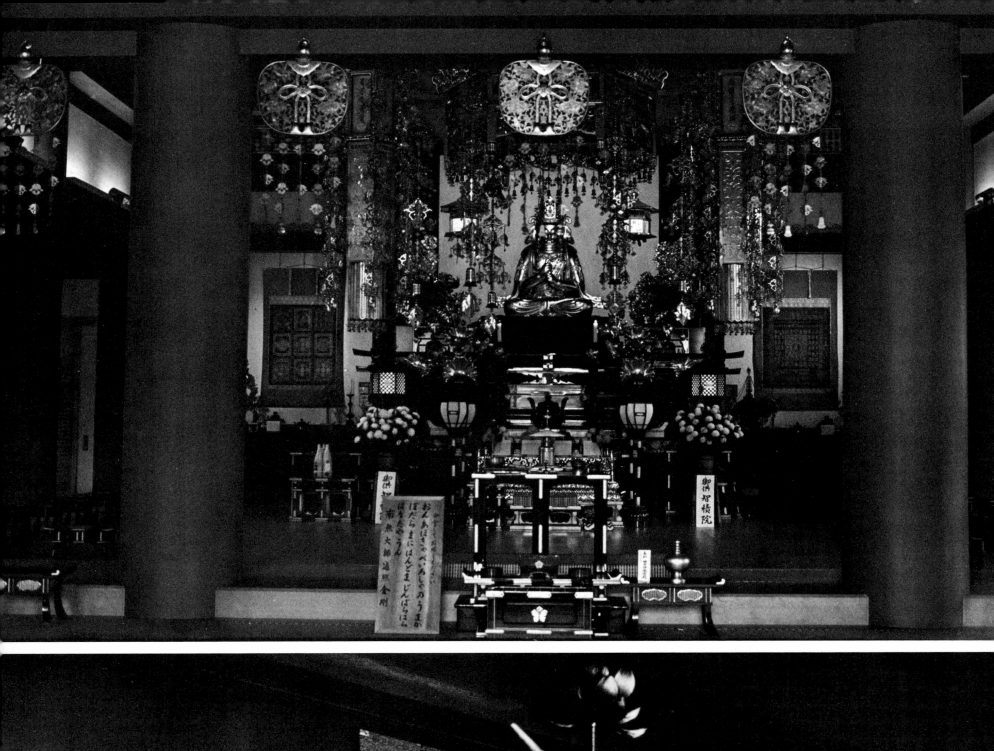

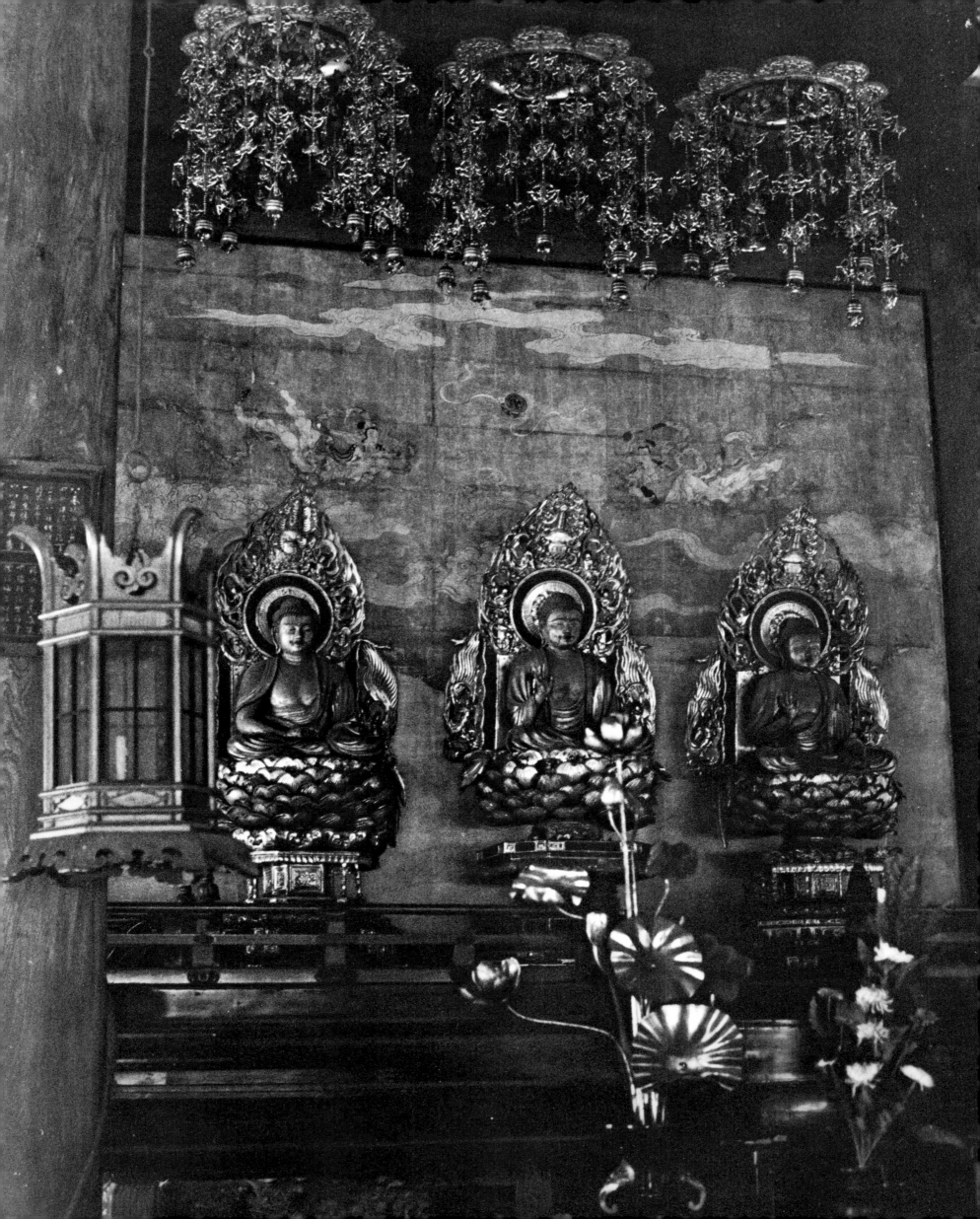

Lions from China at Kōyasan.

For each deity there is a corresponding *bija* and *mantra*. These *mantras* begin with "ōm" and end with the deity's *bija*. A *bija* which is engraved or drawn or sculpted is a *mantra* in condensed form. For the Tibetans, "ōm" is the *mantra* par excellence. It is made up of the letter A combined with the sound U. A + U is pronounced like "oh" in English plus the nasal termination "m," which is represented by a dot. AUM is the epitome of the teaching, and in Tibet, where it is thought that merely reciting it may bring about

MANTRAS: THE MAGIC FORMULAS

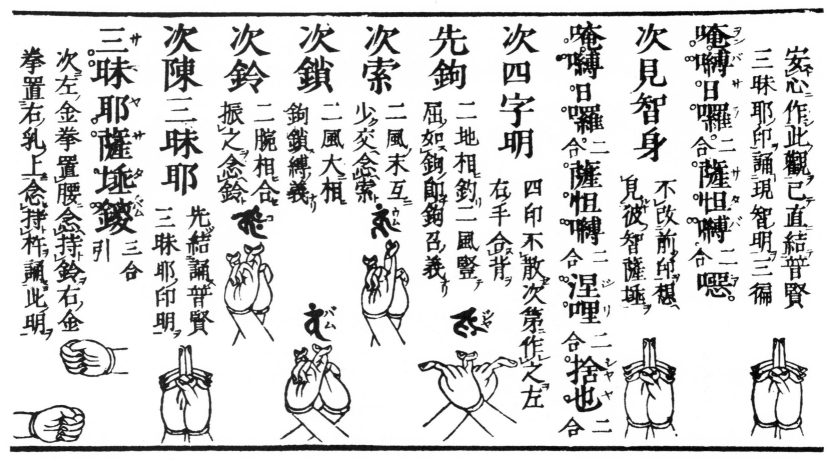

Pronounce the Samaya Hoḥ Vaṃ Hūm Jaḥ See the Body of Knowledge

Enlightenment, it is found everywhere, in temples, on banners and in prayer-wheels. In Japan it is rare, but is sometimes found in an unexpected form—that of a pair of lions seated face to face. The lion on the right has its jaws wide open and sometimes a ball in its teeth: it represents the sound A, the first sound that comes out of the mouth when it is opened. The lion on the left has its teeth clenched and produces the sound "mmm." The lion on the right is female, and corresponds to the Womb pattern, to the Garbhadhātu mandala which is represented by the *bīja* A 列 . The lion on the left is male, and corresponds to the Diamond pattern, Vajradhātu, *Vaṃ* 鑁 . This pair of lions, known in Japan as *kara shishi* or "lions of China"—they are in fact more like Pekinese dogs than lions, which are unknown in the Japanese archipelago—is often to be found in Shingon temples to left and right of the altar, and more frequently still on either side of the door in Shinto temples. (It should not be forgotten that when Kūkai returned to Japan he declared that all the *kamis* or Shinto divinities were nothing but aspects of the Tathāgata. Shinto and Buddhism remained almost completely merged until they were officially separated in 1868.

OṂ VAJRŌTTIṢṬHA HŪM

The first column, on the left, gives the formula which "startles the Buddha" (the Buddha within me), i.e. the mantra *which will be able to awaken me: Oṃ vajrōttiṣṭha hūm. Below, the corresponding* mudrā.

驚 覚 真 言

Musical notation of the mantra.

◄ *Two pages from a manual containing the Vajradhātu rite. The three simultaneous acts of body (mudrā), word (mantra) and thought are represented. The illustration shows the part of the ritual called "Seeing the Body of Knowledge," which includes the four-syllable mantra (Jah, Hūm, Vaṃ, Hoḥ). These are the bījas or germ-syllables of the four bodhisattvas in the mandala who hold, respectively, the hook, the rope, the chain (to attract, draw in and bind Wisdom) and the bell (to rejoice at the Realization of the Body of Knowledge).*

The great Chinese master Ganjin.

CONTEMPLATION OF THE LETTER "A"

The act of the body *(mudrā)* and the act of the word *(mantra)* are useless unless they are accompanied by the act of thought. For the Patriarchs of the Shingon or "True Word" school, who established the rules governing the ritual, man's mind is inclined to wander and needs images to help it concentrate. But it is not a question of mere static and complacent contemplation. The act of thought is dynamic. Images can only be starting points, or illustrate intermediate stages, or mark the end of a phrase. The function of iconography as a whole is to be an aid to the act of thought, which itself cannot be represented. The symbolic language of images makes it possible for the person using it to leave the realm of reason and of discursive thought. As in the Zen school, rational thought is the enemy. To overcome it, the Zen master of the Rinzai sect asks his disciple a question *(kōan)* which cannot be answered within the confines of language. In Shingon, it is by a symbolic image that the disciple is placed from the outset on a level other than that of every day. Images do not use the language of signs, in which signifier and signified are equal; they use the language of symbols, in which what is symbolized is beyond man's comprehension. A symbolic image is an *upāya* (tool, stratagem, skilful method) for attaining transcendence.

Let us look for example at the way the symbol, "Contemplation of the letter A," "works." In the golden *bīja* A 刃 , I contemplate the origin of all things, the Ultimate Reality of the Un-Born. It is set on a white lotus traced with green; it is Innate Reason. The whole is enclosed in a white lunar circle, Wisdom, the pure consciousness of the Buddha. I detach myself from the visible symbol by visualizing it at the tip of my nose. Then I imagine the lunar circle in my breast: the heart of the Buddha becomes my own heart. Then I make the lunar halo expand to include the whole Universe. Form disappears; everything melts into light. Only the void remains. I gradually reduce all dimension until everything enters into my body. If I have really apprehended, actualized, the content of the symbol, I am in the "Samādhi of the great Void," in the peaceful presence of Ultimate Reality.

In Japanese esoteric Buddhism the symbols are codified and arranged in a coherent system. Each one has a precise meaning, and is therefore at the same time a sign. By manipulating them we may break down the rational functioning of our minds and express the inexpressible. The deities of the mandala and the ritual objects are unmoving cogs in a precision mechanism set in motion by the performer of the ritual—a heavenly mechanism enabling Universal Reality to manifest itself in our own world, the mechanism of our awakened minds. But just as the study of a corpse, while it helps us to understand the interactions of the organs, does not explain life, so the study of a mandala, even if accompanied by useful instructions, does not lead us to Enlightenment.

As a general rule the process is as follows. The priest rehearses a thought—for example, from the "adoration of the Buddha of the East," Akṣobhya of the Vajradhātu:

There is the bīja Hūm, which is yellow (Hūm is the *bīja* of Akṣobhya)
It is changed into a five-pointed vajra (emblem of Akṣobhya).
My body is changed into a five-pointed vajra (I identify with Akṣobhya).
All the elements of my body become Vajrasattvas (assistants and therefore aspects of Akṣobhya).

At the same time the priest, while simultaneously performing a *mudrā*, recites the *mantra: Om, to do homage to all the Tathāgatas and serve them, I give myself. All Tathāgatas and Vajrasattvas, take possession of me!*

In the mandala one can see in graphic terms that Vajrasattva is placed between Akṣobhya and Vairocana. Vajrasattva is an aspect or emanation of Akṣobhya, himself an aspect of the central Vairocana. Thus there is a link between the practice of the ritual, the composition of the mandala, the arrangement of the ritual objects on the altar (if the three-pointed *vajra* is to the east of the central tower, that is because it is the emblem of Akṣobhya, who is placed to the east of Vairocana in the Vajradhātu mandala), and, as we shall see, the positioning of the sculptures in the temple.

The letter A, the primal sound. Painted engraving, fifteenth century.

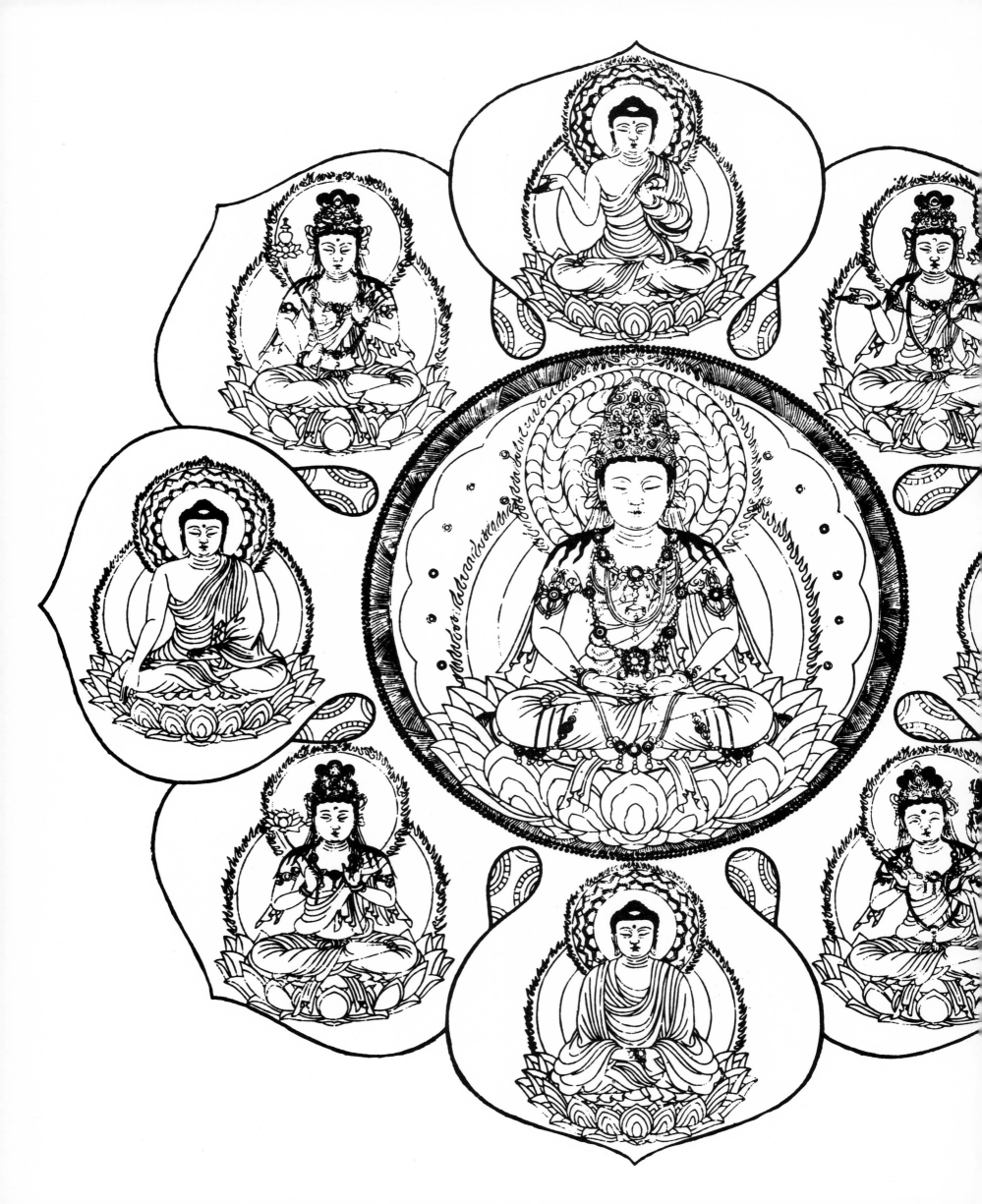

Images of the Absolute

Images of the Universe

Images of Enlightenment

Images of the Mind

Images of Emptiness

The eight-petal lotus of the central quarter of the Womb mandala.

NORTH

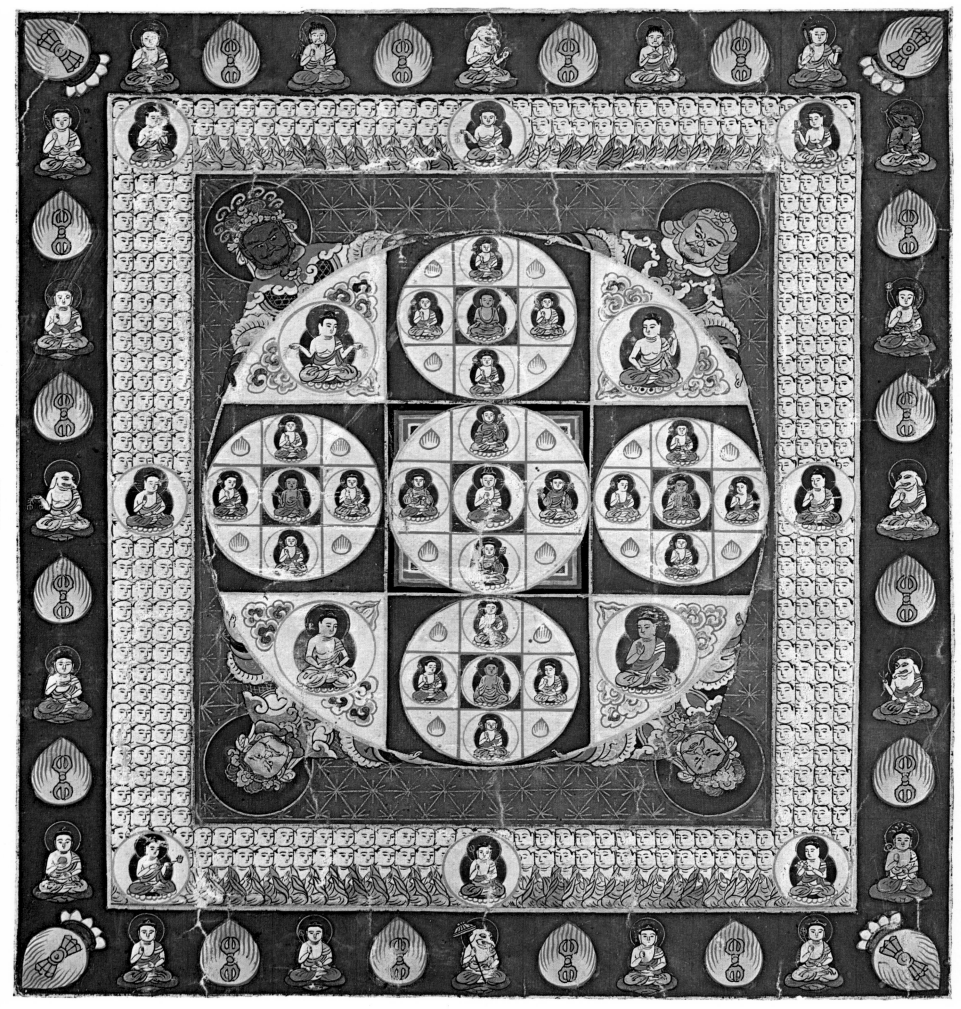

THE NINE MANDALAS OF THE
OF THE DIAMOND PATTERN

After a preliminary approach which I trust will enable the reader to understand the methods and means used by the devotees of esoteric Buddhism to attain Enlightenment, it is now possible to make a more detailed approach to the iconography. To avoid getting lost in the profusion of the Shingon pantheon, it may be useful to recall that every abstract idea (cosmic principle, component of consciousness, and so on) which is called a "deity," whether it takes the form of a person, a symbol, an object or a Sanskrit letter, may be represented by way of three aspects:

1) as a deity who reveals the innate and original Buddha nature in each being; this is a Buddha;

2) as a deity who is made manifest for the salvation of beings and who converts them by means of the "good Law"; this is a bodhisattva;

3) as a deity who is made manifest for the salvation of beings, but who seems angry in order to overcome the resistance of beings rebellious and difficult to convert.

The deities are all present in all three aspects in both the Womb and the Diamond mandala.

It has already been pointed out that the Diamond pattern mandala (Vajradhātu) consists of an assembly of nine mandalas. The most important, the one which epitomizes them all, and the only one which is used by the Tendai sect, is the central mandala. As the east is now below and the south to the left, this mandala is to be read in the reverse direction from that of the Womb mandala, which faces it in the temple. And thus Amida, the Buddha of the West, is now in the middle of the circle *above* the central circle where Vairocana is enthroned. Because of this central or "Great Mandala," the human mind may have access to the workings of the Universe, the Supreme and Perfect Illumination.

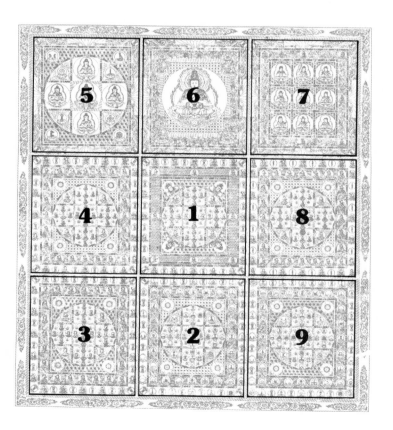

Mahāmaṇḍala, central mandala No. 1 of the Vajradhātu. Nineteenth century.

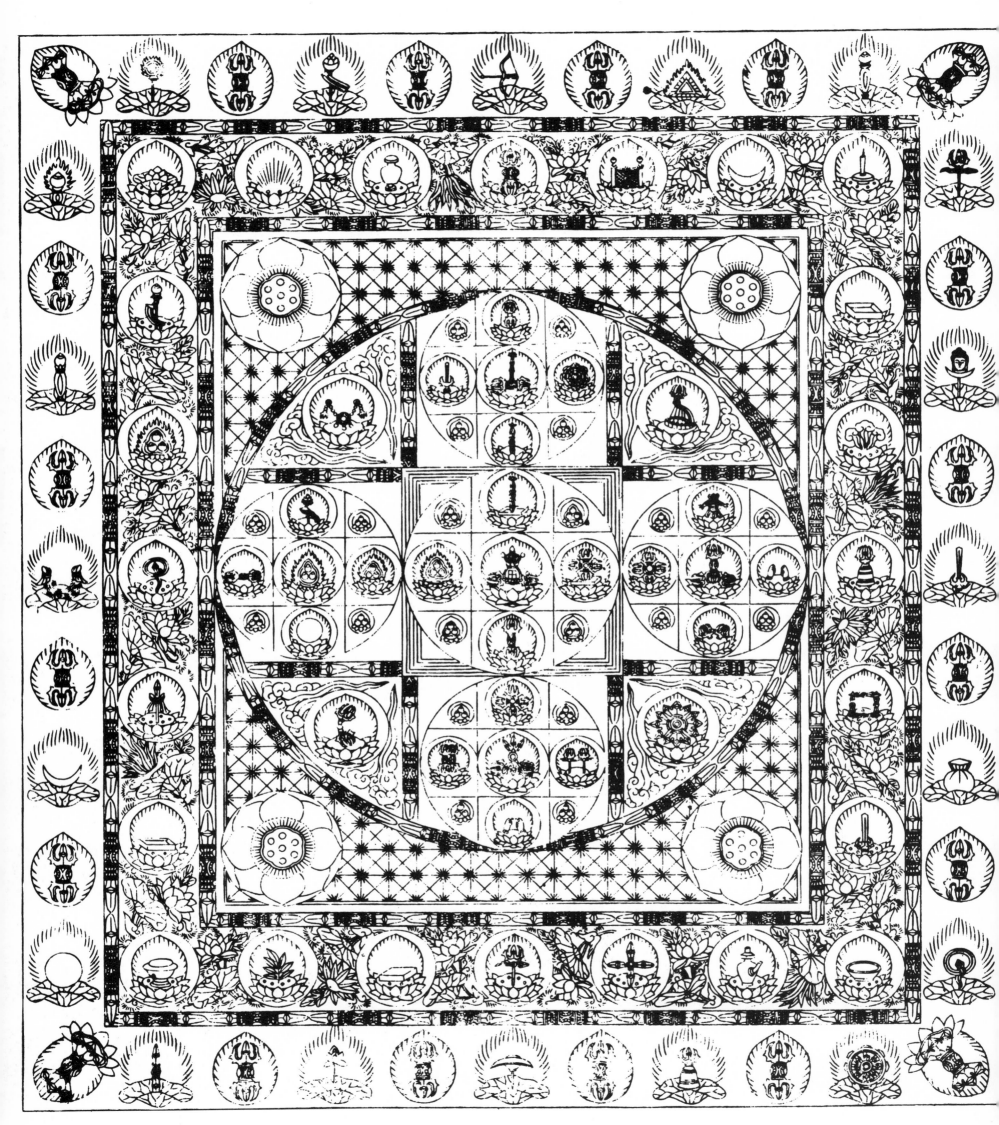

MANDALA No. 2,
A MANDALA OF SYMBOLS

Mandalas 2, 3 and 4, in which the lay-out is identical with that of the "Great Mandala," represent the three aspects or manifestations of a Mahāvairocana: Body, Word and Thought.

In Mandala No. 2 *(samaya maṇḍala)* the seventy-three persons are replaced by symbols: for example, Vairocana by a *stūpa*, Maitreya by a reliquary, Samantabhadra by a sword of which the pommel is a three-pointed *vajra*. This mandala is particularly valuable to the student of iconography. It symbolizes the "Great Vows" by which Buddhas and bodhisattvas entered on the path of Illumination with the sole aim of bringing deliverance to beings.

Japanese copy, dating from the first half of the eleventh century, of the Goku-shinkan, a scroll of iconographical drawings from T'ang China, given to the monk Enchin of the Tendai School by his teacher Fa-ch'üan in 855. The top level shows a deity, the middle level his mantra in Sanskrit, and the lower level his emblem framed by the mudrās of the ritual.

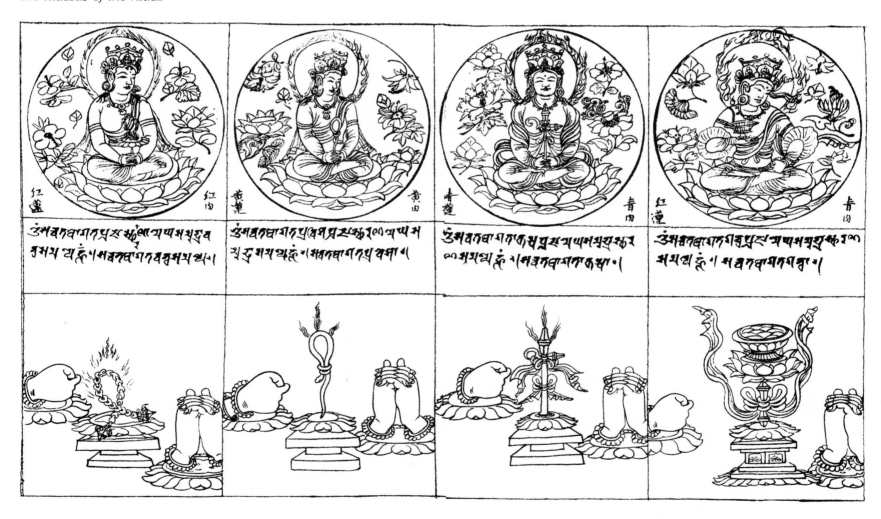

◀ *Mandala No. 2. The Hase mandara. Half-size. In this mandala of symbols the four bodhisattvas belonging to the middle of the second enclosure (a thousand Buddhas) are replaced by their respective attributes: the hook, the rope, the chain and the bell.*

MANDALA No. 3

In mandala No. 3 *(sūkṣma maṇḍala)*, which corresponds to the "Word" of Vairocana, the deities of the first two enclosures are shown leaning against a three-pointed *vajra*, for they are a manifestation of the subtle, minute and indestructible Wisdom of the Buddha who seeks to illumine beings.

MANDALA No. 4

In mandala No. 4 we find the same deities, each bearing his own attributes and making the gesture of offering them. Each attribute stands for a vow, a specific way of illuminating beings. This mandala is called the *Pūjā maṇḍala, pūjā* meaning veneration, worship. But offering is an act *(karma)*, and as thought also is regarded as an act, this mandala represents the "Thought" of Mahāvairocana.

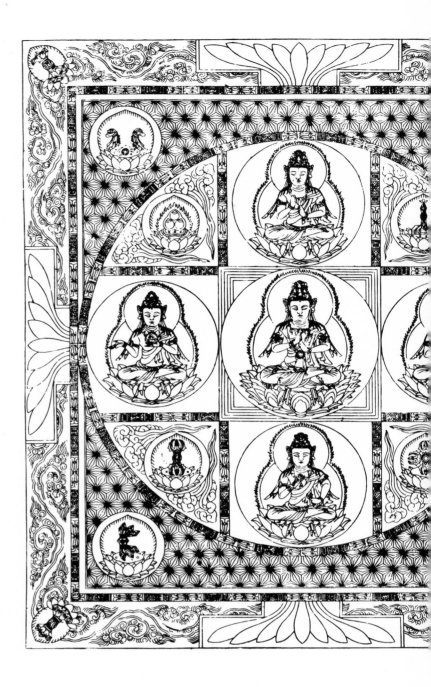

MANDALA No. 5

These first four mandalas in fact represent exactly the same thing from four different points of view. Mandala No. 5 expresses the same thing again, epitomizing all the preceding four. In the middle is Vairocana Tathāgata, surrounded not by the four Tathāgatas but by four bodhisattvas. For example, above (to the west), it is not Amida but Kannon one sees, easily recognizable by the unopened lotus flower which "she" holds in her left hand, and by the gesture by which, with her right hand, "she" helps the flower to open: i.e. helps beings to attain Enlightenment. The bodhisattvas are "causes," the Buddhas "effects." By replacing the four Buddhas by four of the bodhisattvas who usually surround them, this mandala expresses the identity of cause and effect, of subject and object.

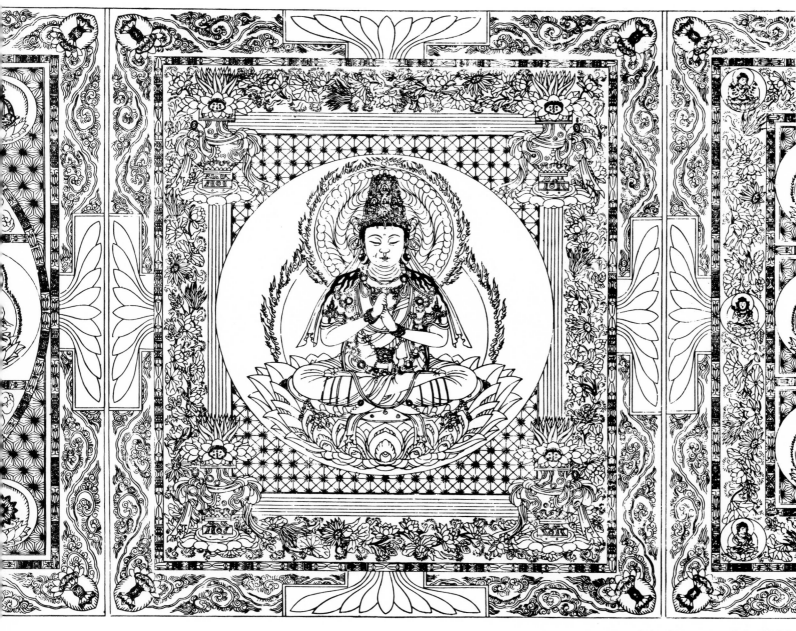

Detail, quarter-size, of the Hase mandala (1834).

MANDALA No. 6

Mandala No. 6 recapitulates No. 5, which itself was a synthesis of the first four. No. 6 expresses the fact that all the deities of the "Great Mandala" are merely different aspects of the "Great Illuminator." At the four corners of the first enclosure there are four vases, exactly the same as those surrounding the eight-petal lotus in the Womb mandala. But whereas the latter are pierced by a three-pointed *vajra*, the vases here contain five lotus flowers: another affirmation of the fundamental oneness of the two mandalas, of the Womb (lotus) pattern and the Diamond *(vajra)* pattern. Mandala No. 6 is the Shingon school's way of saying that all things are Mahāvairocana, its way of expressing universal Buddhahood.

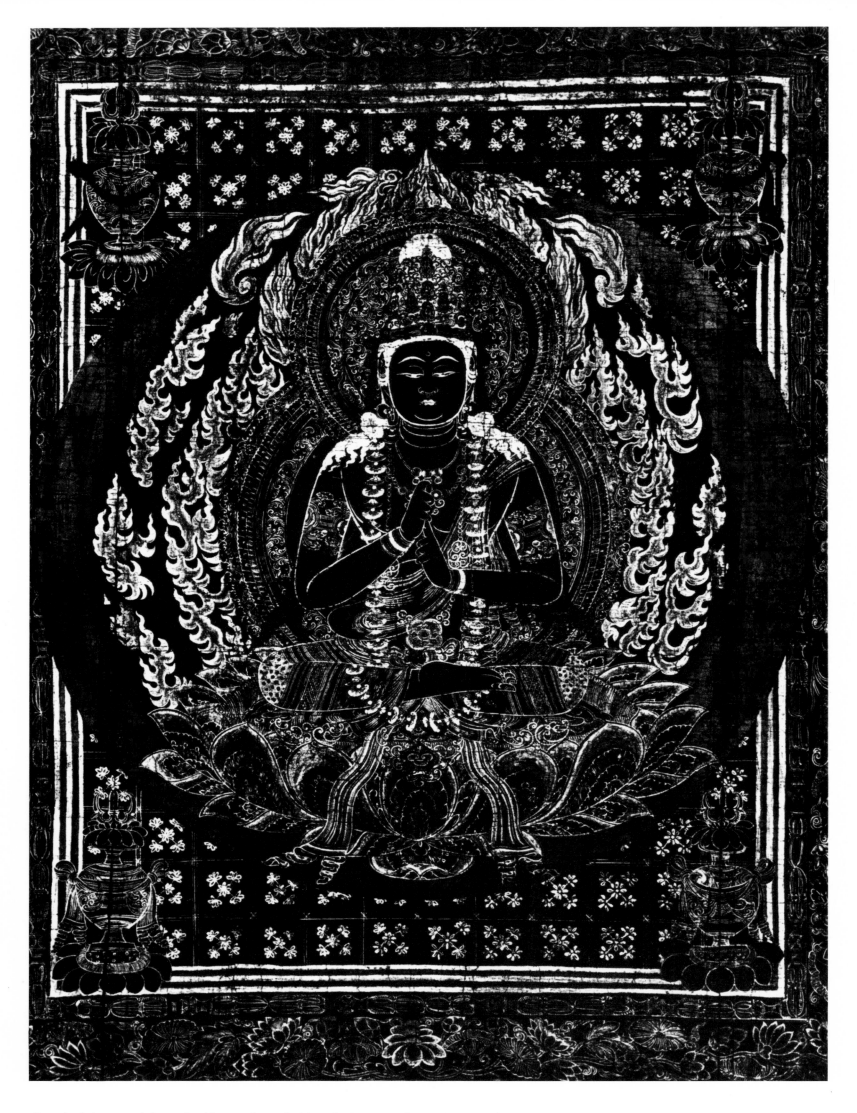

Detail of the mandala in the Kojima-dera. Gold and silver on silk. Early eleventh century.

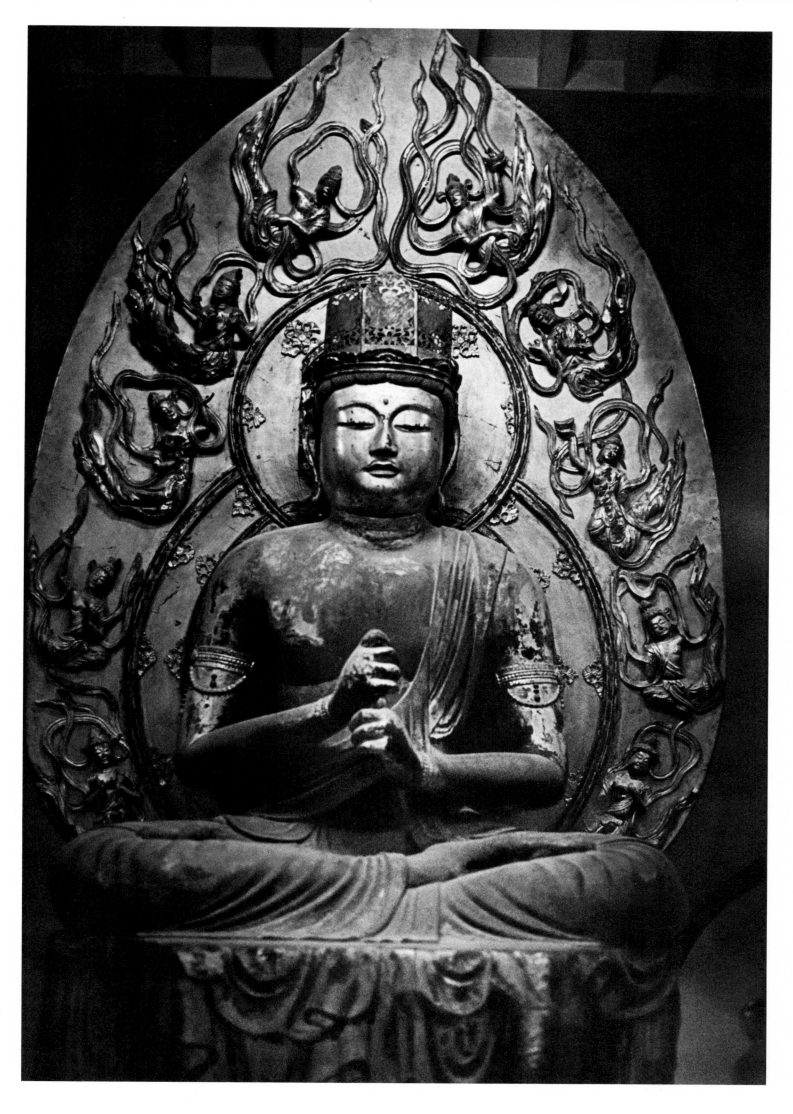

Dainichi Nyorai of the Vajradhātu. Heian period (794–1184). Kōyasan.

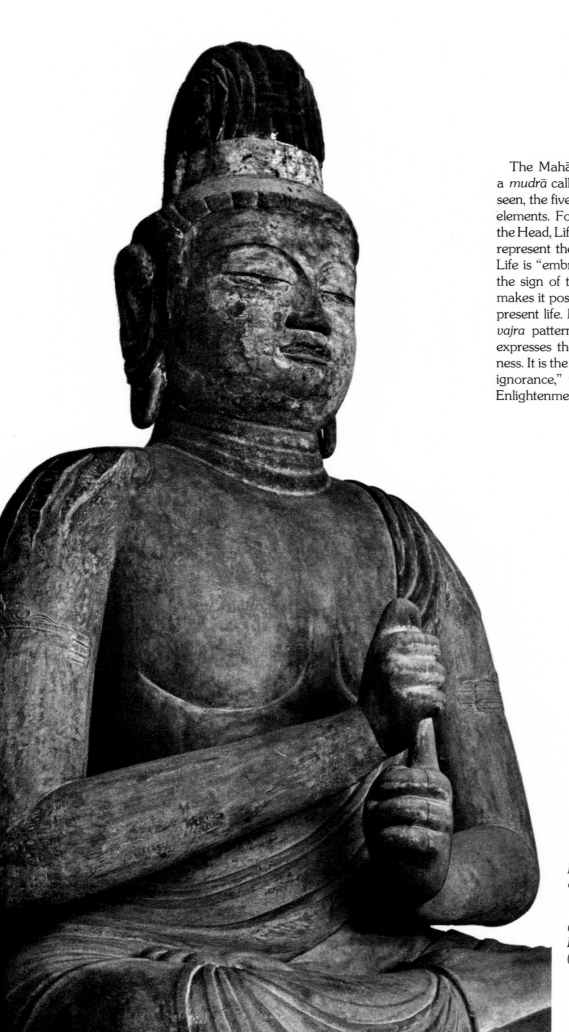

THE KNOWLEDGE FIST

智拳印
（金剛界大日の印）

The Mahāvairocana of the Diamond pattern performs a *mudrā* called the "Knowledge fist." As we have already seen, the five fingers of the left hand symbolize the first five elements. Four are bent; only the forefinger—the "Wind," the Head, Life—is raised. The fingers of the right hand, which represent the five Wisdoms, surround the right forefinger: Life is "embraced" by the Buddha Wisdom. This *mudrā* is the sign of the non-duality of man and Vairocana, which makes it possible for all of us to attain Buddhahood in our present life. Moreover, since the right hand symbolizes the *vajra* pattern, and the left that of the lotus, this *mudrā* expresses their "interpenetration," their fundamental oneness. It is the *mudrā* par excellence, the one "which destroys ignorance," which affirms the identity of ignorance and Enlightenment.

Dainichi Nyorai of the Diamond pattern. Treasury of the Tōshōdai-ji at Nara. Heian period (794–1184).

Chi-ken-in, the mudrā *of the "fist of knowledge." Detail of a bronze Dainichi Nyorai. Heian period (794–1184), Kōyasan.*

98

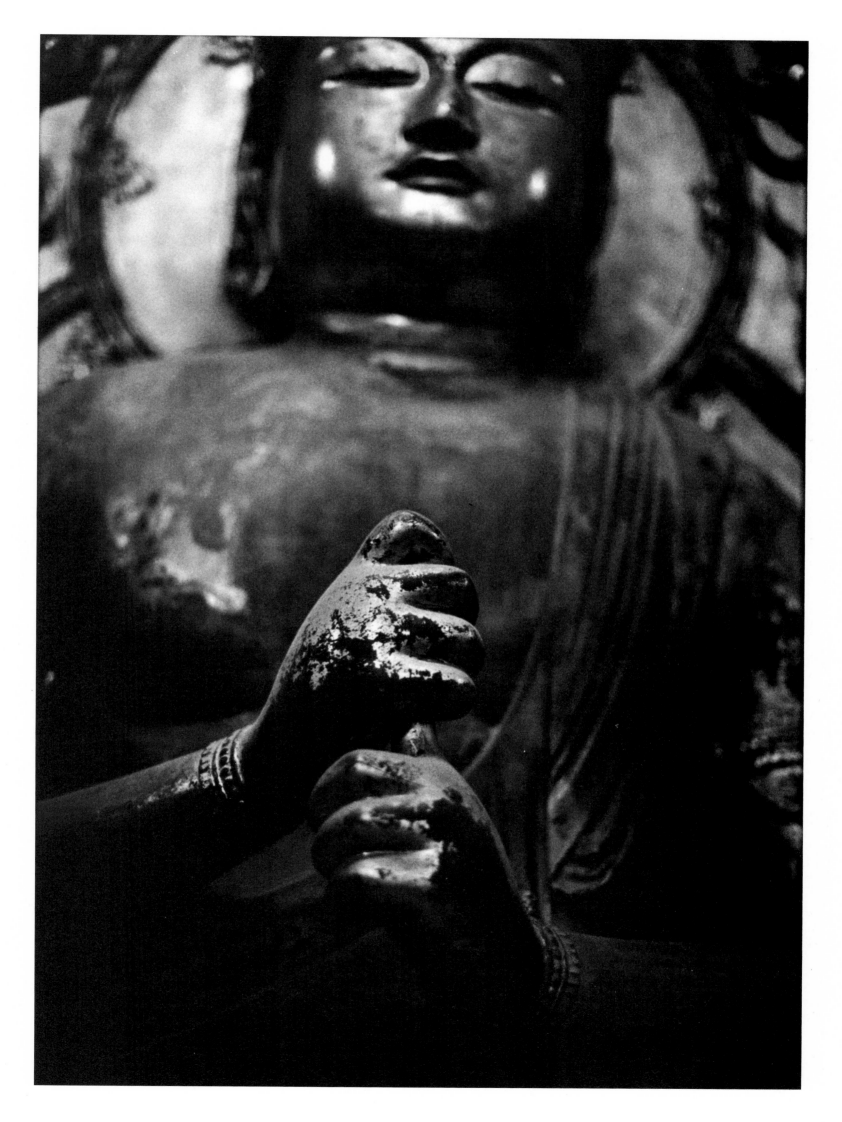

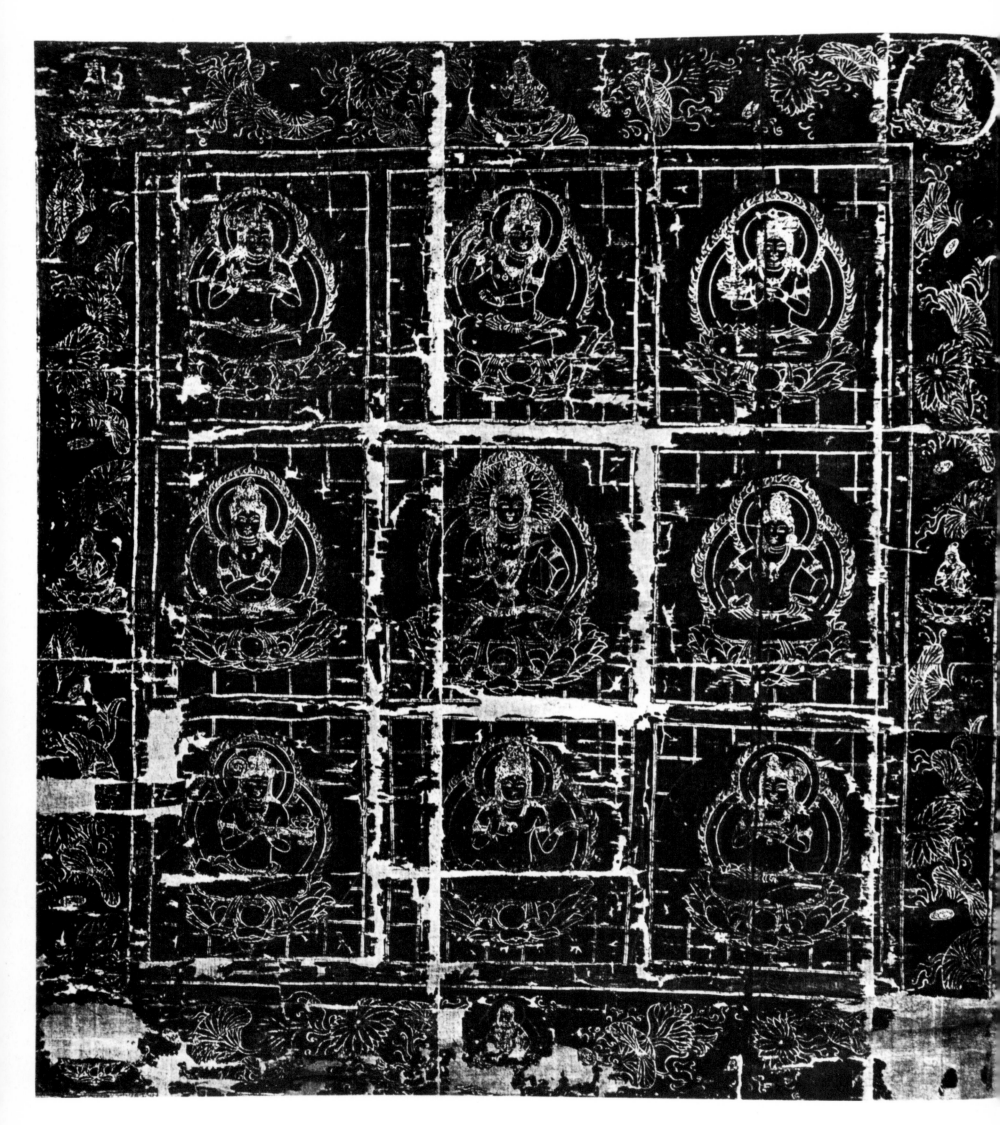

The materials of Illumination.

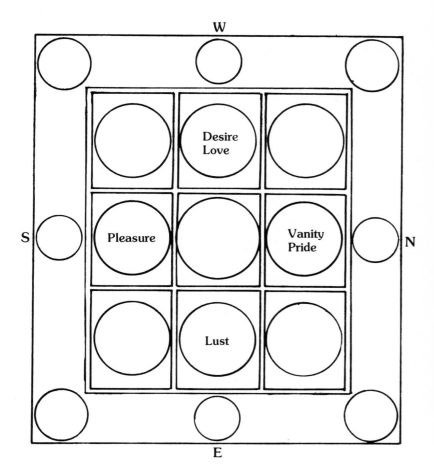

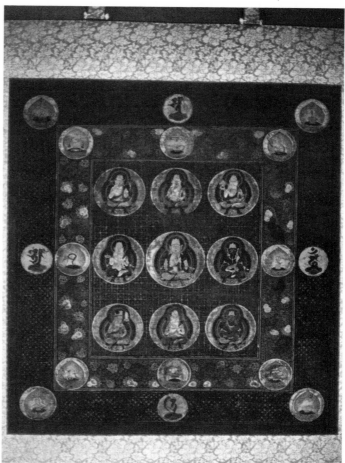

Mandala of the passions, preserved in the treasury of the Daigo-ji, near Kyōto.

MANDALA No. 7,
THE MANDALA OF THE PASSIONS

The Naya maṇḍala, *the mandala of the means (of Enlightenment).*

Mandala No. 7 expresses a fundamental idea of tantric Buddhism: the identity between the passions and Enlightenment. In the middle, Vairocana is represented in the guise of Vajrasattva: Vajrasattva, the second patriarch of the Shingon school, the mythical disciple and image of humanity who received the secret teaching of the Tathāgata when the latter was incarnate as the "historical Buddha," and who buried it in the "iron *stūpa*" in southern India until men should be spiritually mature enough to understand it. Vajrasattva is Man: the four bodhisattvas who surround him in the four directions are his four passions: Lust to the east, holding an arrow with both hands; Pleasure to the south, holding a five-pointed *vajra* in both hands, and coloured white, symbolizing the original purity of pleasure; Loving Desire to the west, coloured blue to signify the fullness of love; and to the north, Vanity or pride. Vanity is performing the *mudrā* of pride, both fists clenched, and is gold, the colour of pride. These four passions are regarded as raw materials of Illumination. The four bodhisattvas have assumed the form of our four illusions as a means of saving beings.

Passion makes the world captive
passion alone sets it free

Just as copper becomes pure gold if covered with miraculous paint, so, for one who knows, the passions become so many aids to salvation
 Aryadeva — an Indian text

The theory that "progress in passion" (rāga-caryā) leads to illumination goes back in the last resort to the following idea: a man moved by passion possesses in himself the drive to aim at and achieve redemption. This is not true of the inert individual, dull, indifferent, incapable of making decisions
 Glasenapp

I declare to you that it is within this body, mortal as it is and only six feet long, that the world and the origin of the world and the end of the world are to be found, together with the Way which leads to that cessation
 Buddha

Detail of the mandala in the Jingo-ji, which is a copy made in 831—during the life of Kūkai—of the Chinese original. Gold and silver on crimson silk.

MANDALAS No. 8 AND 9, MANDALAS OF ANGER

In the middle of mandala No. 8 is an incarnation of Vajrasattva, made manifest in order to overcome the three demons of hatred, greed and ignorance. He represents anger vis-à-vis the demons, and has three aces, and three eyes to detect them. He is surrounded by the flames of Wisdom which burn away desires; he has fangs with which to tear them. He is Trailokyavijaya, the "Conqueror of the three poisons," whom we find in the zone of "terrible" deities in the Womb mandala and who is frequently represented in paintings and sculptures in tantric temples.

In mandala No. 9 the deities are replaced by their symbols or attributes.

Trailokyavijaya (Shōzanze-Myōō) in the mandala in the Jingo-ji (831). Gold and silver on silk.

The nine mandalas taken together describe the means used by the Buddhas and bodhisattvas to illuminate beings. Read from 1 to 9, they show the way from Effect to Cause. Read in the reverse order, they give the path from Cause to Effect. In No. 9 a being awakens and becomes aware of his Buddha nature. In No. 8 he tries to eliminate his passions. In No. 7 he realizes that his passions are the raw materials of his Illumination. In No. 6 he realizes that, because this is so, he partakes of the Buddha nature. In No. 5 he "realizes" the four attributes of Mahāvairocana together. In Nos. 4, 3 and 2, he "realizes" them separately. When he reaches No. 1, he becomes aware of his Buddha nature. While the nine mandalas of the Vajradhātu are focused chiefly on the sixth element (Consciousness, the workings of the Spirit, the Subject, the "Knower," CHI), the Garbhadātu or Womb mandala is principally a graphic representation of the first five elements (the Principle that must be known, RI, the Object). Like Subject and Object, the two mandalas are inseparable; neither exists without the other.

Woodcut made in 1834 after the original Trailokyavijaya in the Jingo-ji.

The Garbhadhātu maṇḍala (Taizo Kai mandara) drawn and engraved on wood by Hasegawa Tōshuku in 1834 from an ancient model. The so-called Hase mandala.

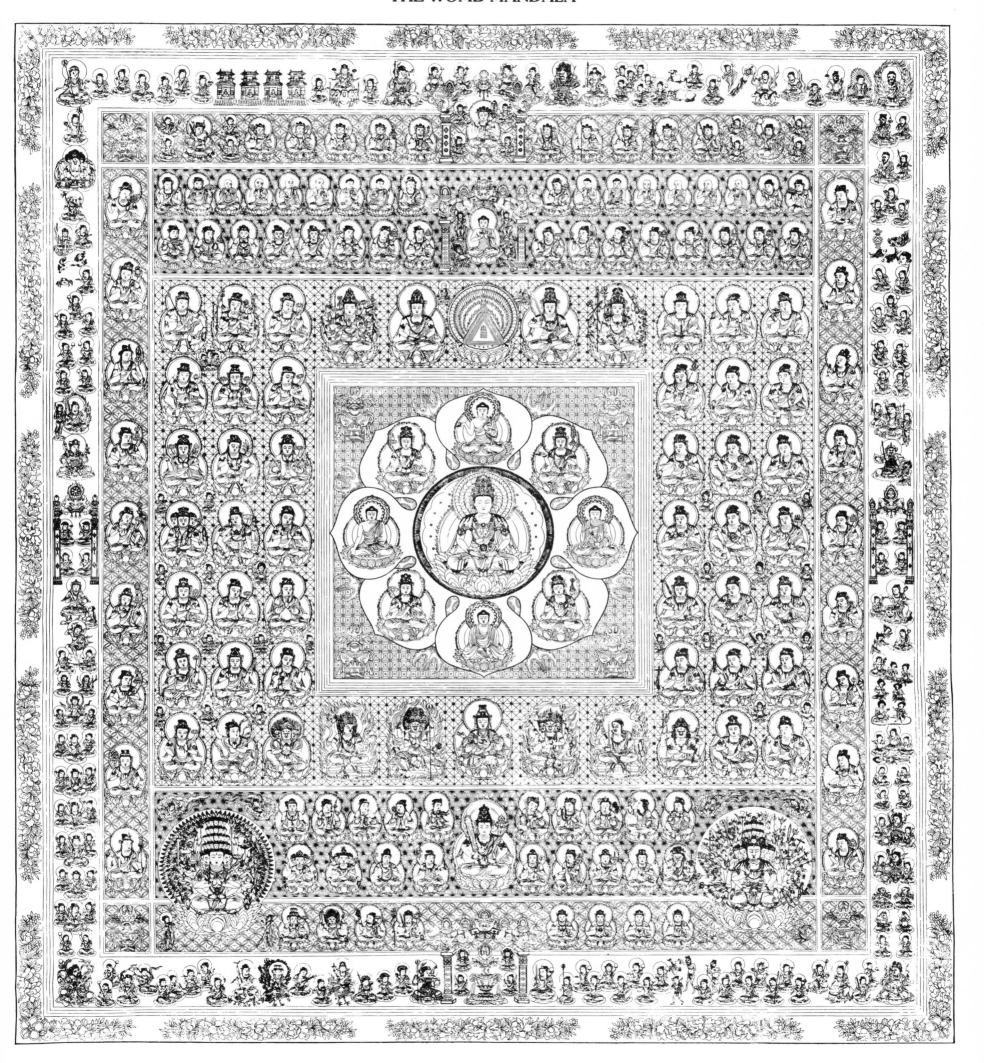

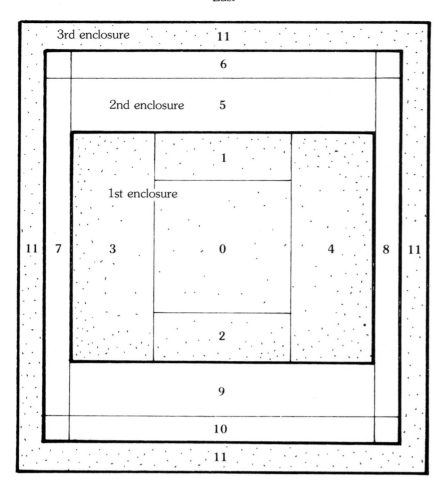

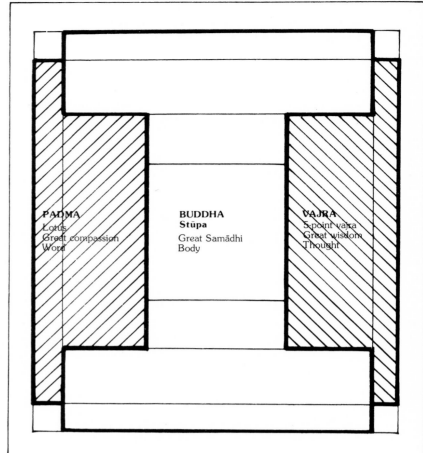

FIRST ENCLOSURE: ENLIGHTENMENT (BODHICITTA)
 0 CENTRAL QUARTER OF THE EIGHT-PETAL LOTUS
 1 QUARTER OF UNIVERSAL KNOWLEDGE
 2 QUARTER OF THE WRATHFUL ONES
 3 QUARTER OF AVALOKITEŚVARA
 4 QUARTER OF VAJRAPANI
SECOND ENCLOSURE: COMPASSION (KARUṆĀ)
 5 QUARTER OF ŚĀKYAMUNI
 6 QUARTER OF MAÑJUŚRI
 7 QUARTER OF JIZŌ
 8 QUARTER OF THE VIRTUES OF SAMANTABHADRA
 9 QUARTER OF AKĀŚAGHARBA
 10 QUARTER OF THE VIRTUES OF MAITREYA
THIRD ENCLOSURE: THE MEANS (UPĀYA)
 11 QUARTER OUTSIDE THE VAJRAS

Three acts	Class	Chief Deity	Attribute	Symbolic object
Body	Buddha	Mahāvairocana	Illumination	*Stūpa*
Word	*Padma*	Avalokiteśvara	Compassion	Lotus flower
Thought	*Vajra*	Vajrasattva	Wisdom	Five-point *vajra*

In the Womb mandala, an image of the Multiple All, all the component elements of the Universe are depicted in the form of 413 deities arranged around the central Mahāvairocana. All the deities of esoteric Buddhism, and more especially those of the "Great Vehicle," have a place in this mandala. And that place informs us about the relationships of the deities to one another, their meaning, and their functions in the All. The mandala is divided into twelve rectangular zones, twelve quarters. The five central quarters form the first enclosure or precinct, devoted to the *bodhicitta* or "bodhi heart," Illumination. The second enclosure, which includes six quarters bordering those of the first enclosure, expresses *karuṇā* or "Compassion." The third or outer enclosure includes the *upāyas*, "skilful means" or stratagems, leading to Enlightenment. There is another kind of division by which the 413 deities are arranged in three "classes." Seven quarters are devoted to the Buddhas; two, to the

north, to *padmas*; two, to the south, to *vajras*. The fourth quarter or frame contains the keepers or guardians of the doctrine, the deities of the "Six Worlds" in which living beings exist.

We shall begin with the Buddhas. There are five of them, set in the middle of the two mandalas, and we shall see that they are an image at once of the Ultimate Reality of the Universe, of Awakening, of the becoming aware of our Buddha nature, and of the correct working of our consciousness.

THE FIVE BUDDHAS

The thinkers of ancient India did not wait for the psychiatrists and psychologists and other "experts" who now flourish in the West before they concerned themselves with the fundamental problem of the workings of the mind. Their speculations led them to distinguish five different "notations" in what we refer to as "consciousness." The first five correspond to what we call the five senses: sight, hearing, smell, taste and touch. The sixth is "mind," mental awareness. The seventh is what they call "the passionate mind." The eighth, the "receptacle consciousness." The ninth and last, "the immaculate consciousness." This ninth consciousness, the sum of the eight previous ones, is represented iconographically by the Mahāvairocana Buddha, either in his active form in the middle of the Diamond mandala, or, as here, in his passive form in the flower of the eight-petal lotus of the central quarter of the Womb mandala.

Above him is the Buddha of the East, the eighth consciousness, the "receptacle" or "stored" consciousness, the one which when transformed by practice or "ascesis" becomes Wisdom, "like a great round mirror": being resembles a big glass reflecting the image of all things. Whoever attains it will be aware of the true nature of things; i.e. their Emptiness. This Buddha of the rising sun corresponds to the first stage on the road to salvation. He is the Buddha "of the heart's awakening," of the initial Enlightenment, the awakening of thought, the first awareness of the fact that through practice I may attain Enlightenment.

This Buddha of the beginning is represented by the *bija* A, the primordial sound, corresponding to the first element, Earth, in the *stūpa* of the five elements.

The Buddha of the South, to the right, is an image of the seventh consciousness, the "passionate," which practice may transform into the "Wisdom of natural equality," the awareness that there is no real difference between the "enlightened" and the "un-enlightened," that I myself partake of the Buddha nature. This Buddha also symbolizes the practice of asceticism, and the second element, "Water," of the *stūpa*. The sixth consciousness, the mind, is represented by the Buddha of the West, who may be transformed into the "Wisdom of marvellous discernment," i.e. awareness of the emptiness at the heart of the Relative.

This Buddha corresponds to the third stage of practice: the obtaining of *bodhi*, Illumination; and to the third element, "Fire," of the *stūpa*. Finally, to the north, are the first five notations of consciousness, the five senses, which lead to the "Wisdom which produces acts," acts devoted to the salvation of beings. This is the entry into *nirvāṇa*, the result of Illumination, and so the *mudrā* of this Buddha is that of "taking the earth to witness," which in esoteric Buddhism symbolizes the Awakening of the historical Buddha.

Thus, as has already been said, the central lotus is indeed a graphic, figurative, symbolic representation of our own consciousness. The arrangement of the four Tathāgatas who radiate from the central Mahāvairocana Tathāgata tells us about the way our mind works, shows us the means by which the components of our consciousness may be transformed into wisdoms, and how we may become aware of our own fundamental oneness with the Ultimate Reality of

THE NINE CONSCIOUSNESSES AND THE FIVE WISDOMS

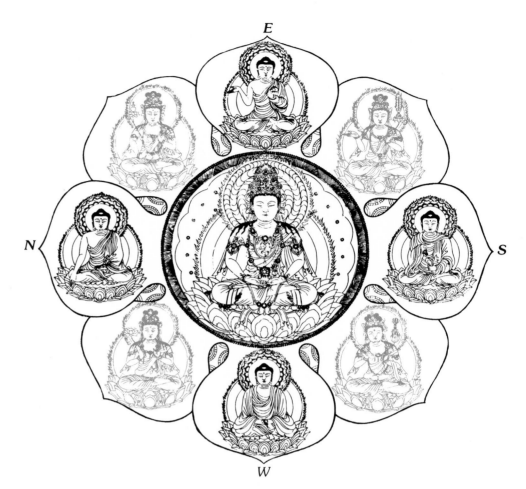

IN THE CENTRE
The 9th and "immaculate" consciousness,
sum of the first 8
The Means of Salvation
Buddha-stūpa
Ether

TO THE EAST
The 8th, the "store"-consciousness which will lead
to the Sapience "like a great round mirror"
The Awakening of the heart which precedes ascesis
Five-point *vajra*
Earth

TO THE SOUTH
The 7th consciousness, the "passionate mind"
which will lead
to the Sapience of "the natural equality of all beings"
Ascesis, practice
Ratna (jewel)
Water

TO THE WEST
The 6th consciousness, the mind, which will lead
to the Sapience of "marvellous discernment"
The obtaining of *bodhi*, of Illumination
Padma (lotus)
Fire

TO THE NORTH
The first 5 consciousnesses (the 5 senses) which will lead
to the Sapience "which produces acts"
It is the result of Illumination, the entry into *Nirvāṇa*
Karma
Air

the Universe. The central lotus also gives the answer of the sages of ancient India to the basic question: if Absolute and Relative, Buddha and beings, the Enlightened and the Un-Enlightened, are identical, what is the origin of the consciousness of the Universe which we all possess within us?

There is no origin, answers the central lotus. There is no Creator. The energy of the world, the cosmic principles, the spark of life, the consciousness of the Universe, our consciousness, Vairocana—all is A 𑀅 , *ādyanutpāda*, uncreated. It has always existed. It is Emptiness.

The central lotus also says that the irreducible elements of the world—symbolized by the five elements—are identical with the five degrees of our consciousness, represented by the five Buddhas. Thus the Buddha of the East is Earth; the Buddha of the South, Water; the Buddha of the West, Fire; and the Buddha of the North, Wind. Mahāvairocana is Ether, and because the ninth consciousness is the sum of the eight others he is also the *stūpa*, the Universe in its entirety.

The same teaching is tirelessly repeated, through images, in the most varied forms: "Thou art Buddha," you are "That" *(Tat)*, you are Vairocana-Tathāgata. According to Tajima: "The devotee of Shingon, sitting crosslegged in *yoga* exercises, should contemplate the five circles or their *bījas* on his own body. Thus he contemplates below his hips the mandala of *vajra* and of the 'circle' of earth, which is yellow in colour and square in shape. Its *bīja*, A, is the most important. On his navel he contemplates the mandala of the 'circle' of water, white in colour and round in form. On his heart, the mandala of the 'circle' of fire, red in colour and triangular. Between his eyebrows, the mandala of the 'circle' of wind, dark blue in colour (or black, varying with the Commentary) and shaped like a half-moon. On the top of the skull, the mandala of the 'circle' of ether, 'the colour of the firmament' and rounded in shape. Thus by 'contemplation of the five circles' on his own body he becomes one with Vairocana Tathāgata."

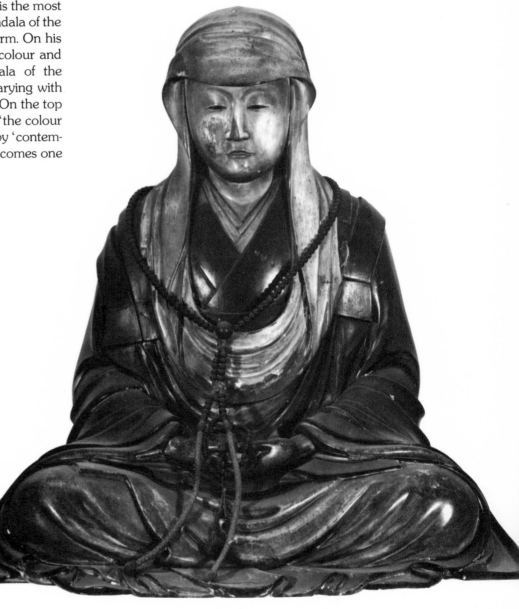

Chūjo hime, a holy maiden of the eighth century. Lacquered wood, eighteenth century.

It will be seen that the figure depicted in the drawing has two pairs of arms. With the lower pair he performs the *mudrā* of the Vairocana of the Womb pattern (passive, receptive), and with the upper pair the *mudrā* of the Vairocana of the Diamond pattern (active). The two small circles drawn in the fifth element, Ether, symbolize the protuberance on the Buddha's head, the thirty-second and last distinctive sign of the historical Buddha in his "glorious body."

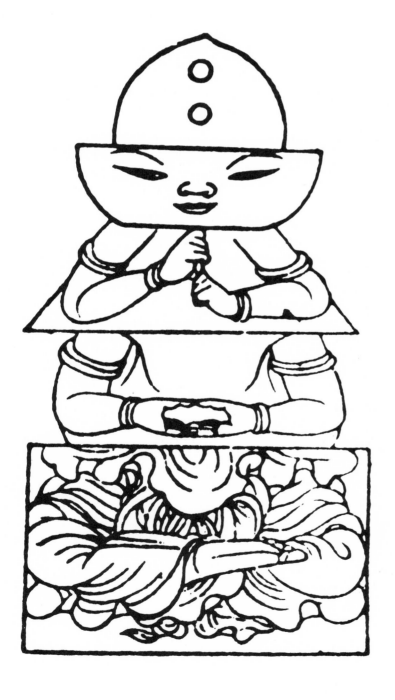

**Ether
Blue
The Absolute
The ninth Consciousness**

**Wind
Black
Nirvāṇa
The five senses**

**Fire
Red
Enlightenment
Mind**

**Water
White
Practice
The "passionate mind"**

**Earth
Yellow
The initial Awakening
The "store"-Consciousness**

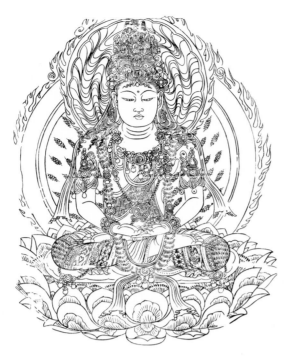

The Dainichi Nyorai of the Womb pattern

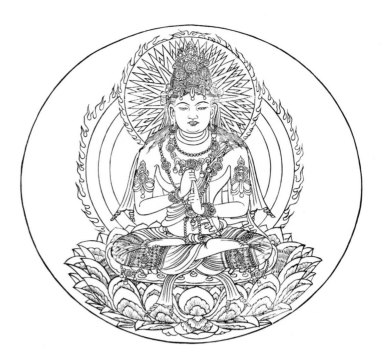

The Dainichi Nyorai of the Diamond pattern

IMAGES OF THE NINTH CONSCIOUSNESS

Apart from the mandalas one finds comparatively few anthropomorphic representations of Mahāvairocana Tathāgata in Shingon temples, but he is present everywhere because each painting, sculpture and ritual object is an emanation of one of his representations. If we compare the two images of the Vairocana, the Great Illuminator, nucleus of all that exists, as they are depicted in the centre of each of the two mandalas, we find at first little difference between them. Contrary to what we see in the imagery of Tibet, the two Vairocanas are not presented in their sexual aspects in China and Japan, but as somewhat androgynous personages, rather like effeminate males. When we examine differences in detail we shall find, however, that the two Vairocanas do in fact express the two different points of view from which the Universe is apprehended. The Vairocana of the Womb pattern is performing the *mudrā* of "Contemplation," of "Wisdom," of *Samādhi.* His right hand, resting on the left, affirms the identity between Buddha and beings, and conveys the fact that thought (the right hand) emanates from matter (the left hand). This *mudrā* thus clearly symbolizes the Womb pattern, while at the same time it expresses the openness and availability of the mind, the passive and receptive aspect, compassion. The Vairocana of the Diamond pattern, on the other hand, is performing the *mudrā* known as the "Knowledge fist," which has been mentioned earlier and which has an obvious phallic connotation. In the Womb pattern, the halo of the Vairocana is made up of wavy lines suggesting the element Water, while in the Diamond pattern the Vairocana's halo consists of broken lines suggesting Fire. Both Vairocanas are seated on a lotus flower, but—and the difference is a crucial one—the Vairocana of the Diamond pattern, together with his lotus, is surrounded by a ring, the lunar circle of Thought.

A rare image of the two Tathāgatas depicted one above the other. Above is the Dainichi Nyorai of the Diamond pattern inside a circle of discs. Below is the Dainichi Nyorai of the Womb pattern. The ground is made up of the Five Colours. Eighteenth century.

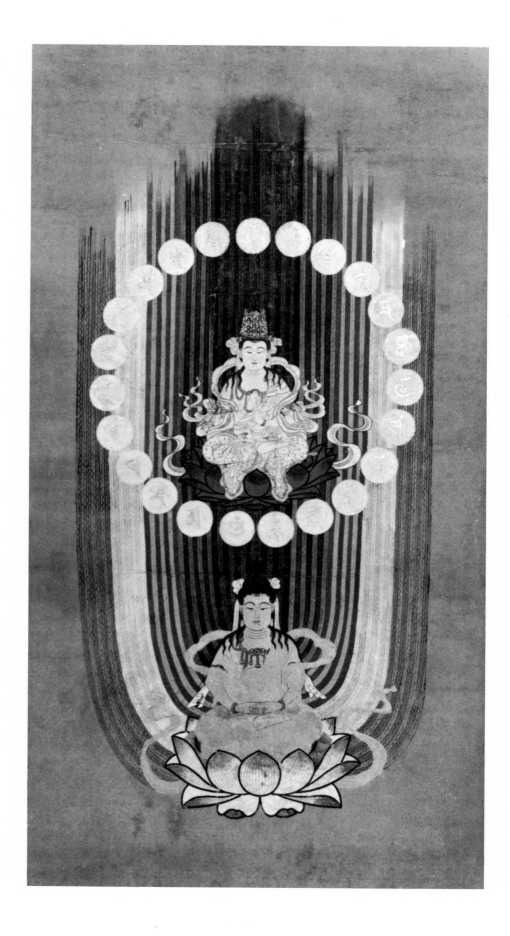

The circle *on* the lotus is spirit or mind emanating from matter. The lotus *in* the circle is matter produced from mind.
Without the phenomenal world there is no consciousness. Without consciousness there is no phenomenal world. Without object, no subject; without subject, no object.

If we replace the lotus flower by a square, the square of Earth, then the representation of the Ultimate Reality of the Universe, of our true nature, of the correct functioning of our minds, of Enlightenment, of non-duality, of the Absolute, of Emptiness, is reduced to its simplest terms: the two elementary symbols of the circle and the square. But what we have is both a circle in a square *and* a square in a circle.

The Gharba pattern *The Vajra pattern*

It is therefore in accordance with the logic of esoteric iconography that Buddhas, bodhisattvas and a large number of the Garbhadhātu deities should be represented in a circle resting on a lotus, while the deities of the Vajradhātu rest on a lotus inside a white disc.

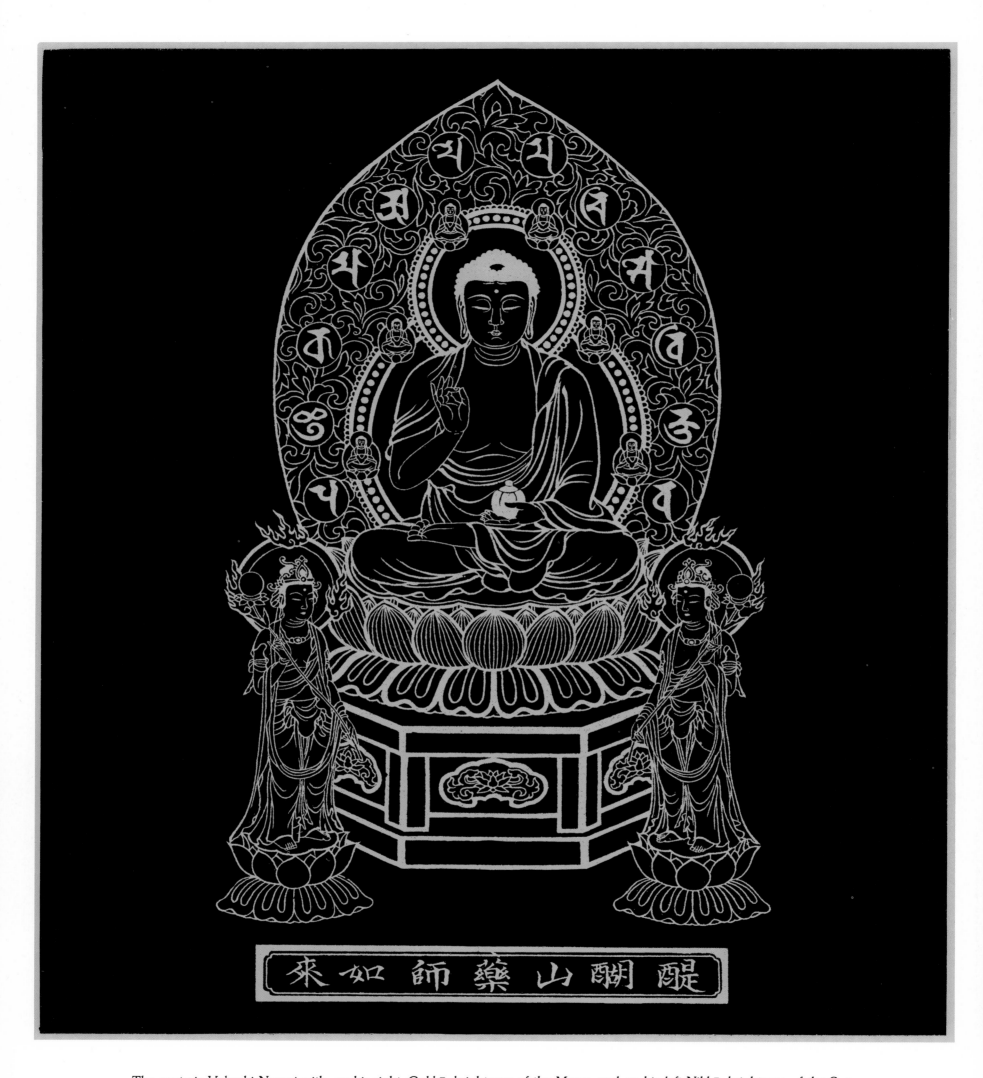

The esoteric Yakushi Nyorai with, on his right, Gakkō, brightness of the Moon, and on his left Nikkō, brightness of the Sun. Modern drawing, gold on cardboard, actual size.

YAKUSHI NYORAI:
THE MASTER OF MEDICINE
(in Sanskrit: Baiṣajyaguru)

This Buddha, who cures ignorance, the worst of all the ills mankind suffers from, is a special case. He was very popular from the earliest times, and the main deity in the Nara temples—i.e. before esotericism was introduced into Japan. But he does not appear in the mandalas. This could mean that he was not yet widely worshipped when the *sūtra* of which the Womb mandala is the graphic expression was written; i.e. in the middle of the seventh century. Another of his peculiarities is that he is the only Buddha who holds an object in one hand.

As a general rule, in China and Japan, only bodhisattvas and secondary deities actually carry attributes. But Yakushi holds in his left hand a "medicine bowl," either spherical or twelve-sided, suggesting the twelve saving vows he made when he was still a bodhisattva, swearing not to become a Buddha until the pledges were fulfilled. The left hand is raised in the *mudrā* "which grants absence of fear."

Right hand of a Yakushi Nyorai performing the mudrā *granting absence of fear. Bronze, Heian period (794–1184), Kōyasan.*

薬師仏施無畏ヲ結三界印

According to Tajima, there is an absolutely secret form not mentioned in the texts, which was transmitted orally from masters to disciples and which maintained that Yakushi Nyorai and the Vairocana Tathāgata of the Garbhadhātu were identical. That is why I have introduced Yakushi here, before presenting the iconography of the various aspects of Vairocana. Yakushi Nyorai, in many temples the central figure on the altar, is usually surrounded by an even number of acolytes, or by the twelve "sacred warriors" (who, apart from their usual significance, here represent this Buddha's twelve vows), or again by the "eight great bodhisattvas"; or he may have, on his left, Sūryaprabha, "Light of the Sun" (in Japanese, Nikkō), and on his right Candraprabha, "Light of the Moon" (in Japanese, Gakkō). The twelve warriors rule over the twelve months of the year. Nikkō and Gakkō rule over day and night respectively.

Modern drawing of the bronze statue of Gakkō, the Moon, on the right of the Master of Medicine in the Yakushi-ji at Nara (697).

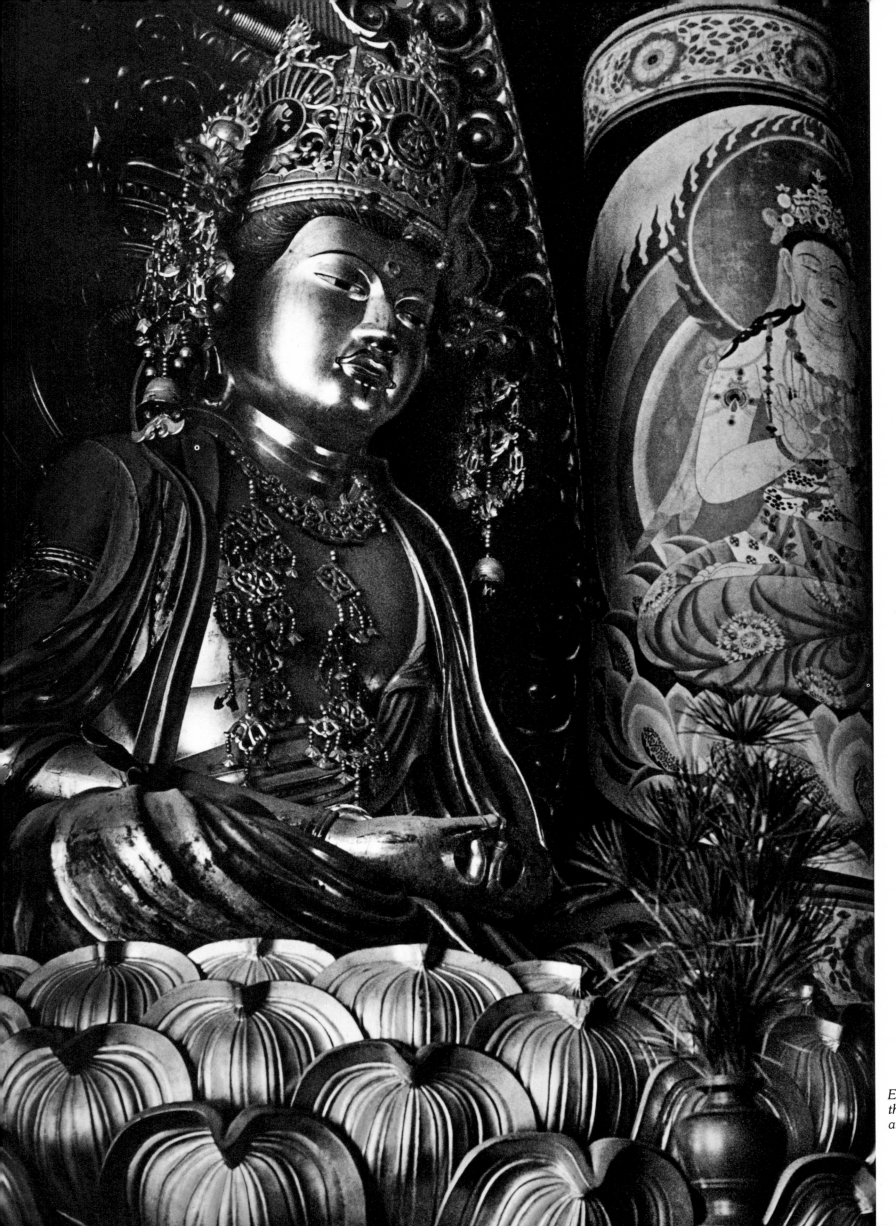

Esoteric Amida in the great pagoda at Kōyasan.

AMIDA, IMAGE OF THE MIND

It may be said that, apart from those of Yakushi Nyorai, sculptures of Mahāvairocana Tathāgata (Dainichi Nyorai) are very rare. Sculptures representing the Buddhas of the East, the South and the North are exceptional. On the other hand, Shingon shrines contain many statues of the Buddha of the West. He is called, in Sanskrit, Amitāyus (Infinite Life) in the west petal of the central lotus of the Womb mandala, and Amitābha (Infinite Light) in the corresponding position in the Diamond mandala. The Japanese call him Amida. He is an "honorable principal," i.e. one of the aspects of Vairocana before whom the esoteric rituals are carried out. Amida is the sixth consciousness, the mental consciousness, which when "transformed" by ascesis may lead us to the obtaining of the sapience of "marvellous discernment," the achieving of *bodhi*, of Illumination.

The cult of Amida became sufficiently widespread to give rise to two Amidist sects (Jōdo and Jōdo-shin), whose devotees believe that the mere recitation of the Amida Buddha's name—*Namu Amida Butsu*—was enough to admit them after death to the Buddha's Western Paradise. In the paintings of the Amidist sects, Amida is depicted standing and welcoming the faithful to his "Pure Land" paradise.

上品上生
（ジョウボンジョウショウ）　中品上生
（チュクボン）

下品上生
（ゲボン）

The esoteric Amida is recognizable from his own special *mudrās*, which are variants of the "meditation" type. Here the fingers of the right hand (world of the Buddha) and those of the left hand (world of beings) form two juxtaposed circles, symbolizing the harmony of the two worlds and the unity of the two aspects of the cosmos (Diamond and Womb).

Mudrā of an Amida Nyorai, twelfth century, Kōyasan.

Two Amidas of the Heian period (794–1184), Kōyasan.

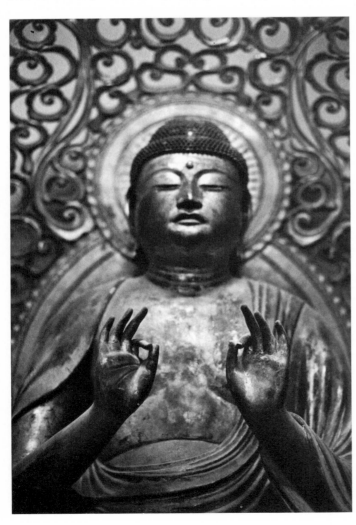

ウヨレゲ ンホウチ

Mudrās of Amida in a book preserved in the library of the Buddhist University at Kōyasan.

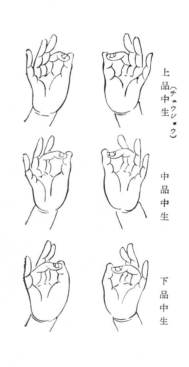

上品中生（チュウショウ）

中品中生

下品中生

ウヨレウチ ンホ ウチ

Amida. Wooden statue, ▶
thirteenth century.

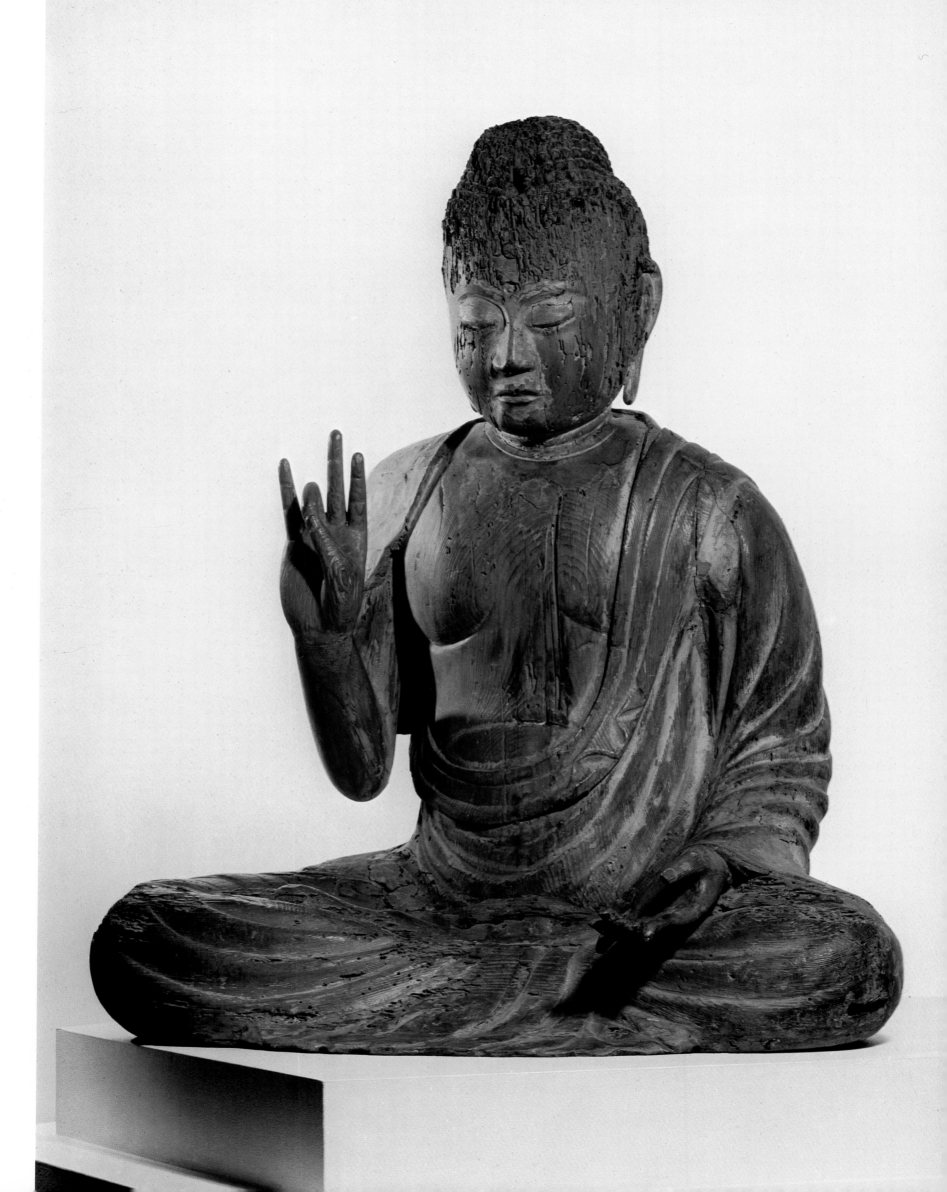

Amida in the middle of the secondary altar in the Okadera, in the Nara region. On the left is the bodhisattva Mahastamaprapta (Seishi bosatsu) with his hands folded, an image of the closed lotus (the heart of man) ready to unfold. On the right is the Amida Kanzeon, with Jizō in the foreground.

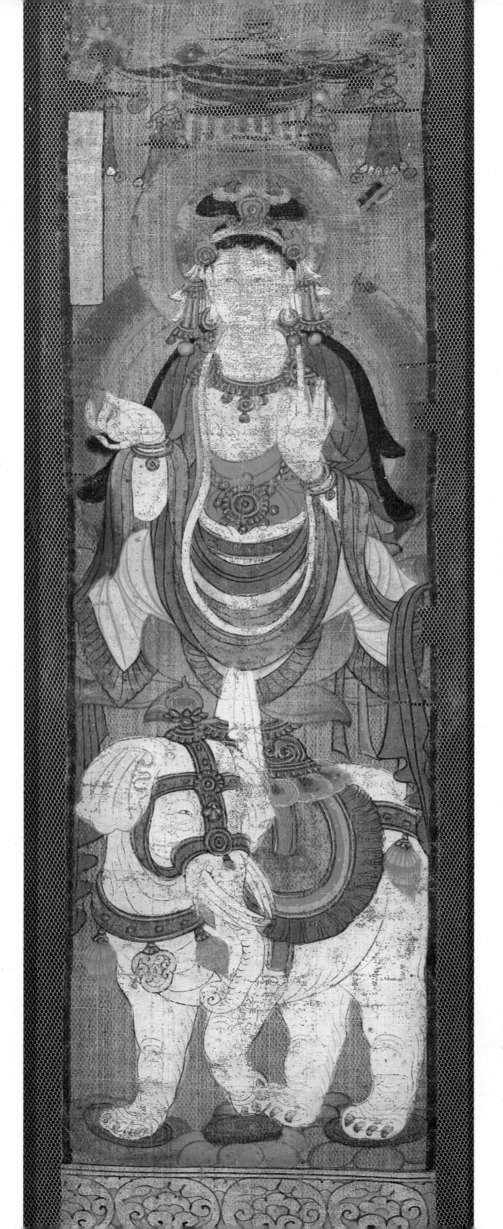

Samantabhadra (in Chinese P'u-hien, in Japanese Fugen) on a white elephant with six tusks. Painting on silk dating from the middle of the eighth century, from the cave-library at Tun-huang.

THE FOUR BODHISATTVAS

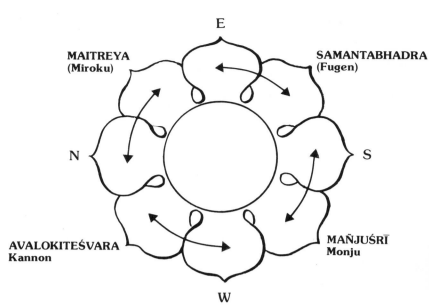

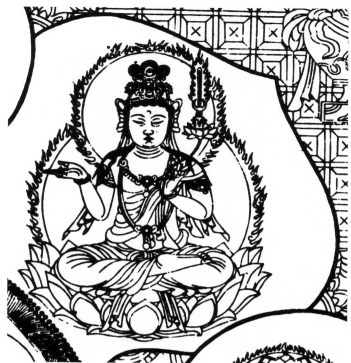

Positions of the four bodhisattvas in the eight-petal lotus in the central quarter of the Womb mandala.

Fugen, in the south-east petal, emanation of the Buddha of the East.

Samantabhadra, painted wood, twelfth century.

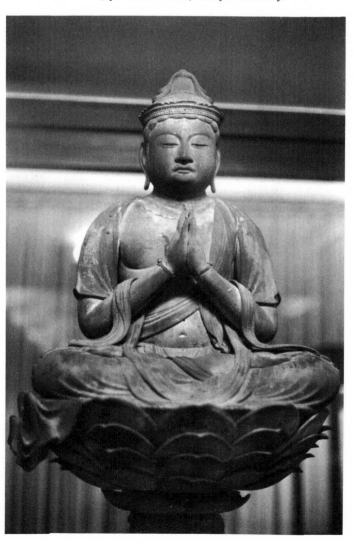

The Buddhas on the four petals at the cardinal points of the lotus—images of the four wisdoms of the central Vairocana—are regarded as "fruits," the effect of the practice of ascesis. The causes are represented by the four bodhisattvas depicted on the four petals at the ordinal or secondary points of the lotus.

These four bodhisattvas play a very important part in esoteric Buddhism and are frequently met with in temples in the form of paintings and sculptures. The bodhisattva to the south-east is SAMANTABHADRA (Fugen in Japanese), the "cause" of the Buddha of the East and of the wisdom "of the great round mirror." To the south-west is MAÑJUŚRĪ (Monju), "cause" of the Buddha of the South and of the wisdom "of the natural equality" of all beings. To the north-west is AVALOKITEŚVARA (Kanjizai), "cause" of Amida, the most important bodhisattva in tantric iconography. We shall say more about him in the following pages. Finally, to the north-east is MAITREYA (Miroku), "cause" of the Buddha of the North and of the wisdom "which produces acts."

SAMANTABHADRA

Samantabhadra is a personification of Wisdom. His joined hands are not so much a *mudrā* of adoration as a reminder of the coexistence of the two inseparable patterns of the Womb and the Diamond, and the reciprocal action of spiritual and material, static and dynamic.

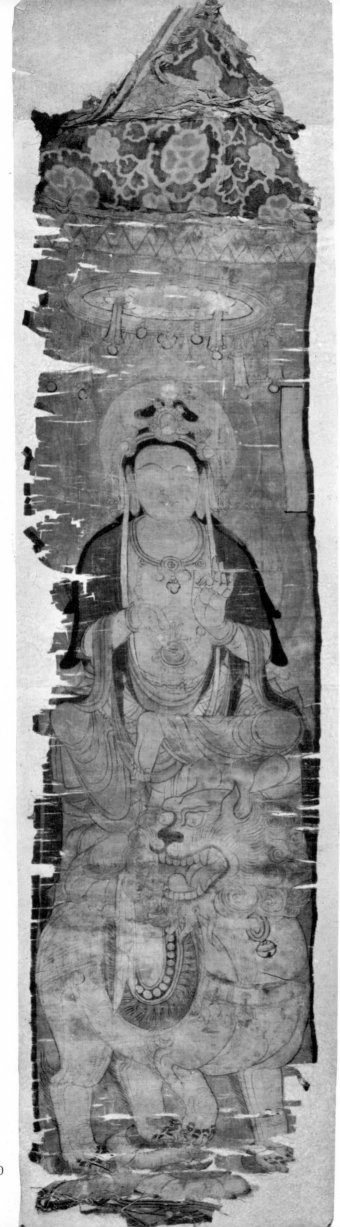

Monju in the Hase mandala (1834).

MAÑJUŚRĪ

His body is dark gold. He wears a diadem with five florets, the five wisdoms of the Tathāgata. He has the appearance of a smiling youth, and sits on a white lotus. He is holding a blue lotus—blue is the colour of victory—on which stands a three-pointed *vajra* symbolizing the natural equality between the Buddha, non-illuminated beings, and our thought. His right hand performs the *mudrā* granting prayers, or holds a book of *sūtras.* He answers the prayers of all beings, and destroys error.

MAITREYA

In the Mahāyāna, Maitreya is the Buddha of the future, the one who is to appear on earth 3,920 million years after Śākyamuni. In his left hand he holds an unopened lotus flower. The oldest Maitreyas in Japan are the work of Korean artists. Maitreya does not play a very important part in tantric iconography.

◀ *Mañjuśrī, in Chinese Wen-chu, in Japanese Monju, makes the gesture of turning the wheel of the Law. Tenth-century painting on silk from Tun-huang.*

Maitreya, in Japanese Miroku, in the north-east petal, ▶ *"cause" of the Buddha of the East. Detail of the Womb mandala, twice actual size.*

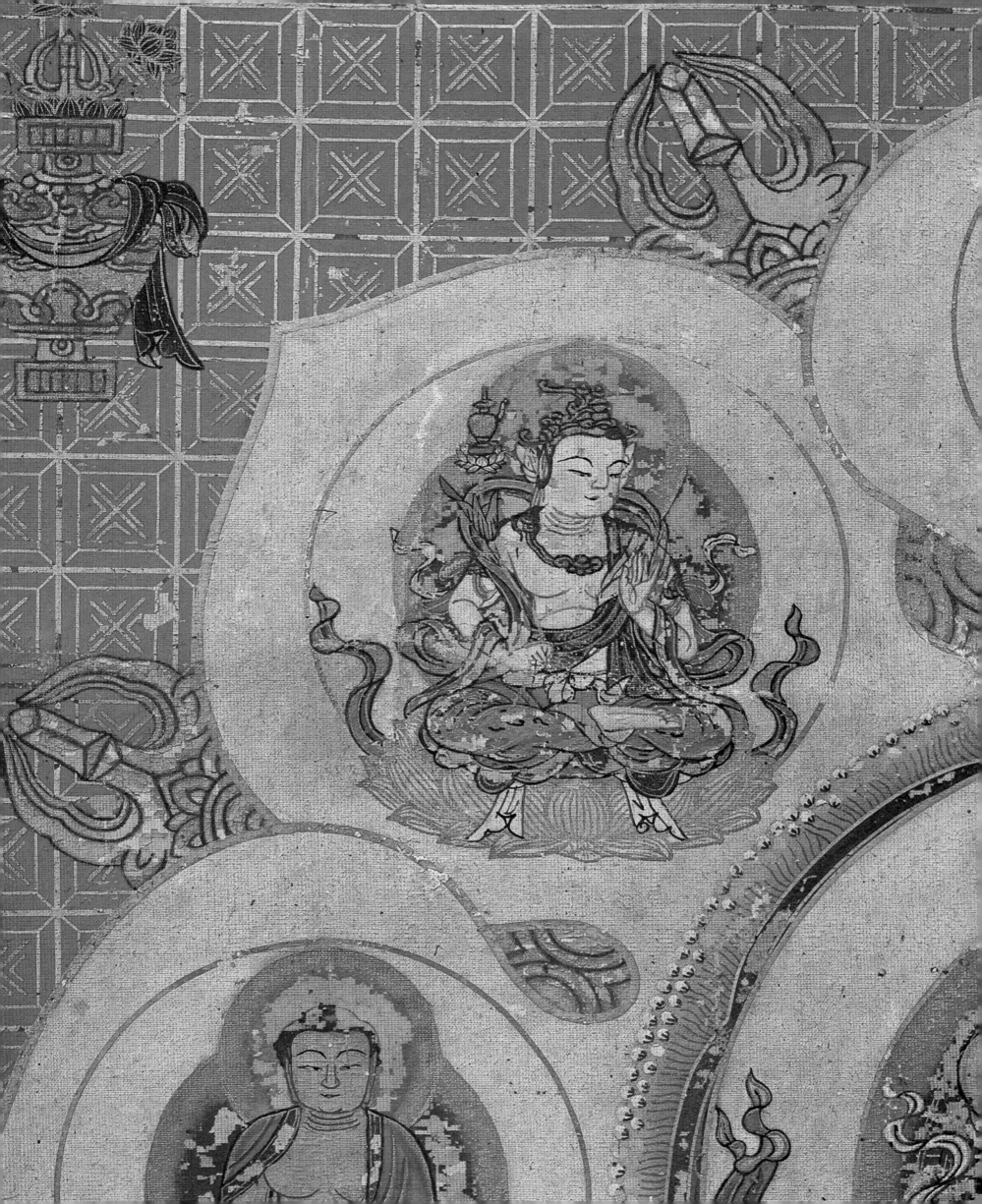

AVALOKITEŚVARA

Avalokiteśvara in the north-west petal, "cause" of Amida of the west petal. Hase mandala (1834).

Avalokiteśvara is the most important bodhisattva in the Buddhism of Faith, because he is the "cause" of Amida. He is "the one who brings safety to those who are anxious." He always carries a small Amida in his headdress. He is the personification of compassion. He is pink in colour, and in his right hand he carries a not quite opened lotus. With his left hand he often makes the gesture of opening the lotus of the heart of all beings—the *mudrā* of fulfilment. His name means "he who looks down in compassion." He is a solar deity, the Master of Light. His name can also mean "he whose face is turned in all directions"—he who at once can see all and can be seen from everywhere. In Chinese translation his name is Kuan-Yin; in Japanese, Kannon. Avalokiteśvara was a-sexual in India and Java, but became definitely feminine in China and Japan. He is often represented with ten small additional heads looking in all directions, or with "a thousand" hands, illustrating the infinity of means of salvation his great compassion employs for the good of others. The "thousand" eyes with which his hands are sometimes provided represent the limitless wisdom which sees all beings and leads them to salvation (Tajima).

Avalokiteśvara. Bronze from central Java.
Ninth-tenth century.

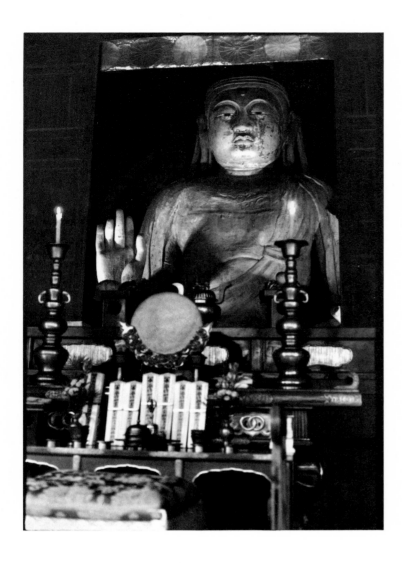

Nyoirin Kannon in the Okadera Temple in Nara. Ninth century. Painted clay. Height 3.90 m. Kūkai visited the temple, which was founded in 703, while the statue was being made. Only the head is original; the body was ruined in the course of an attempt at restoration.

Banner depicting Kuan-Yin in monastic dress. Painting on silk from Tun-huang. Late ninth-tenth century.

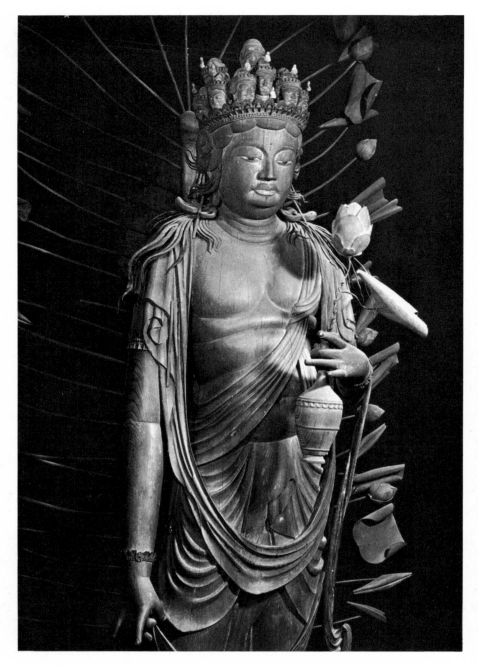

Eleven-headed Kannon in the Hokke-ji Temple in Nara. First half of the ninth century. Wood, 1 metre high.

JŪICHIMEN KANNON

NYOIRIN KANNON

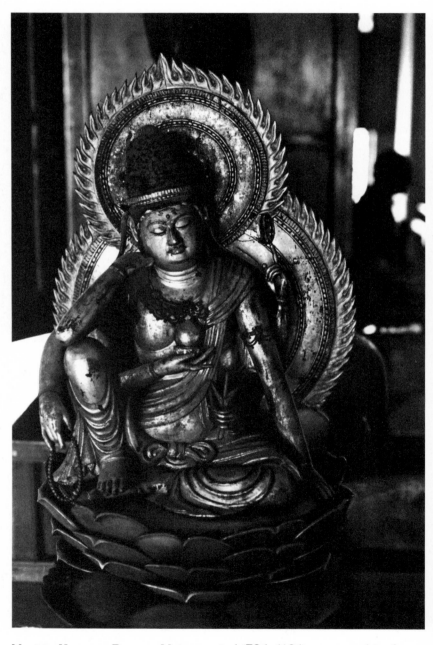

Nyoirin Kannon. Bronze, Heian period (794–1184), preserved in the treasure chamber in the Daigo-ji, in the region of Kyōto. Nyoirin is the flaming ball (cintāmaṇi) which Kannon holds in one of his three right hands.

Nyoirin Kannon. Painting on silk, first half of the nineteenth century.

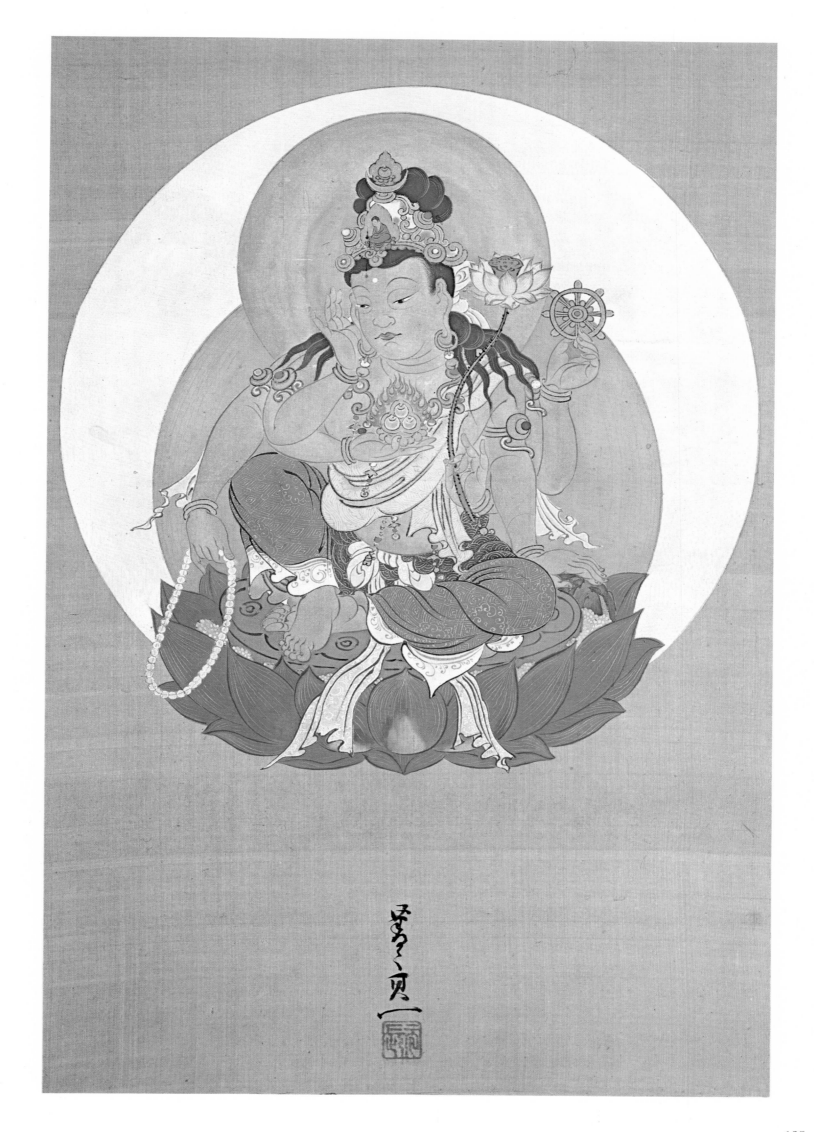

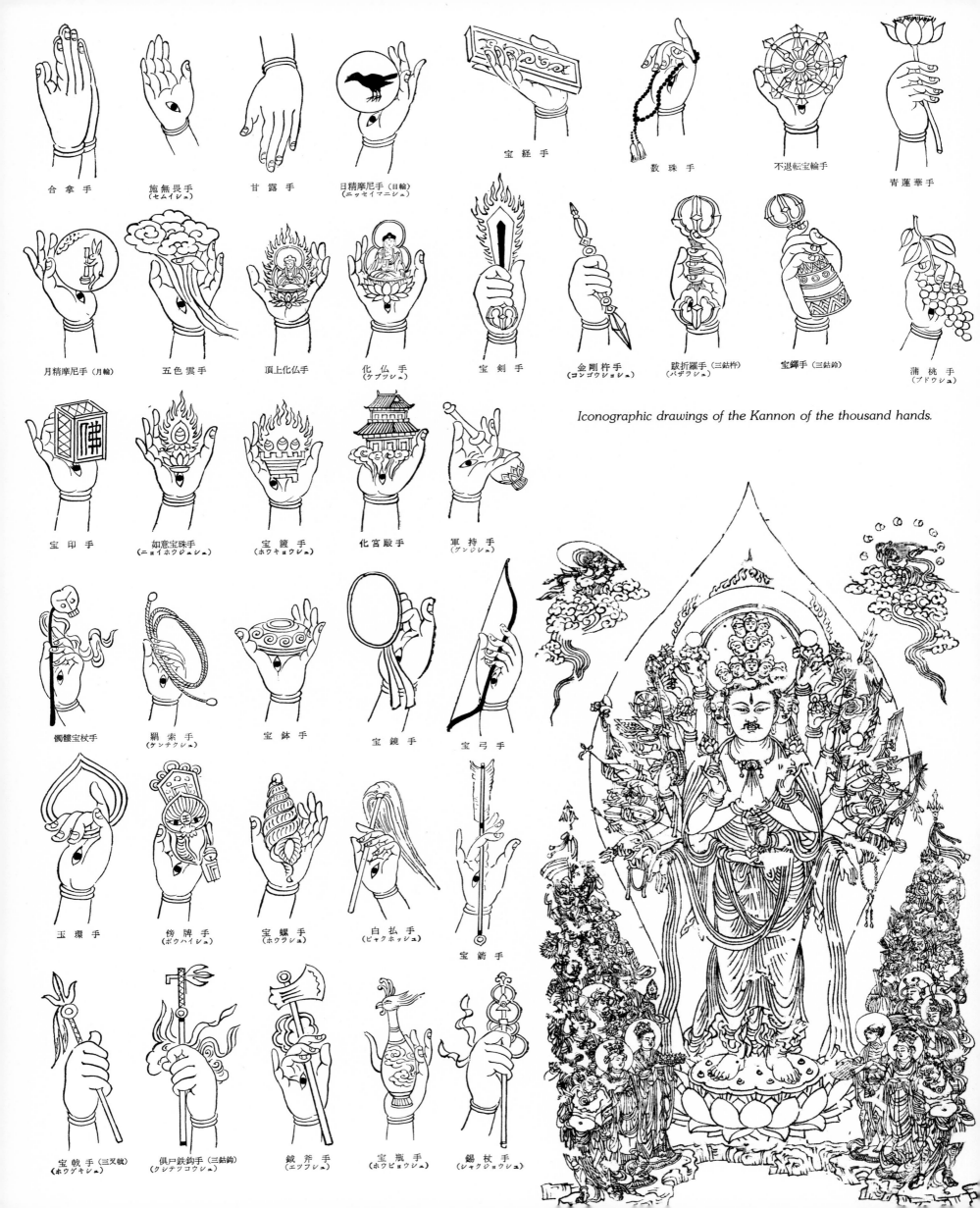

合掌手 施無畏手（セムイシュ） 甘露手 日精摩尼手（日輪）（ニッセイマニシュ） 宝経手 数珠手 不退転宝輪手 青蓮華手

月精摩尼手（月輪） 五色雲手 頂上化仏手 化仏手（ケブツシュ） 宝剣手 金剛杵手（コンゴウショシュ） 跋折羅手（三鈷杵）（バザラシュ） 宝鐸手（三鈷鈴） 蒲桃手（ブドウシュ）

宝印手 如意宝珠手（ニョイホウジュシュ） 宝篋手（ホウキョウシュ） 化宮殿手 軍持手（グンジシュ）

Iconographic drawings of the Kannon of the thousand hands.

髑髏宝杖手 羂索手（ケンサクシュ） 宝鉢手 宝鏡手 宝弓手

玉環手 榜牌手（ボウハイシュ） 宝螺手（ホウラシュ） 白払手（ビャクホッシュ） 宝箭手

宝戟手（三叉戟）（ホウゲキシュ） 倶尸鉄鈎手（三鈷鈎）（クシテツコウシュ） 鉞斧手（エッフシュ） 宝瓶手（ホウビョウシュ） 錫杖手（シャクジョウシュ）

紫蓮華手

KANNON OF
THE THOUSAND HANDS

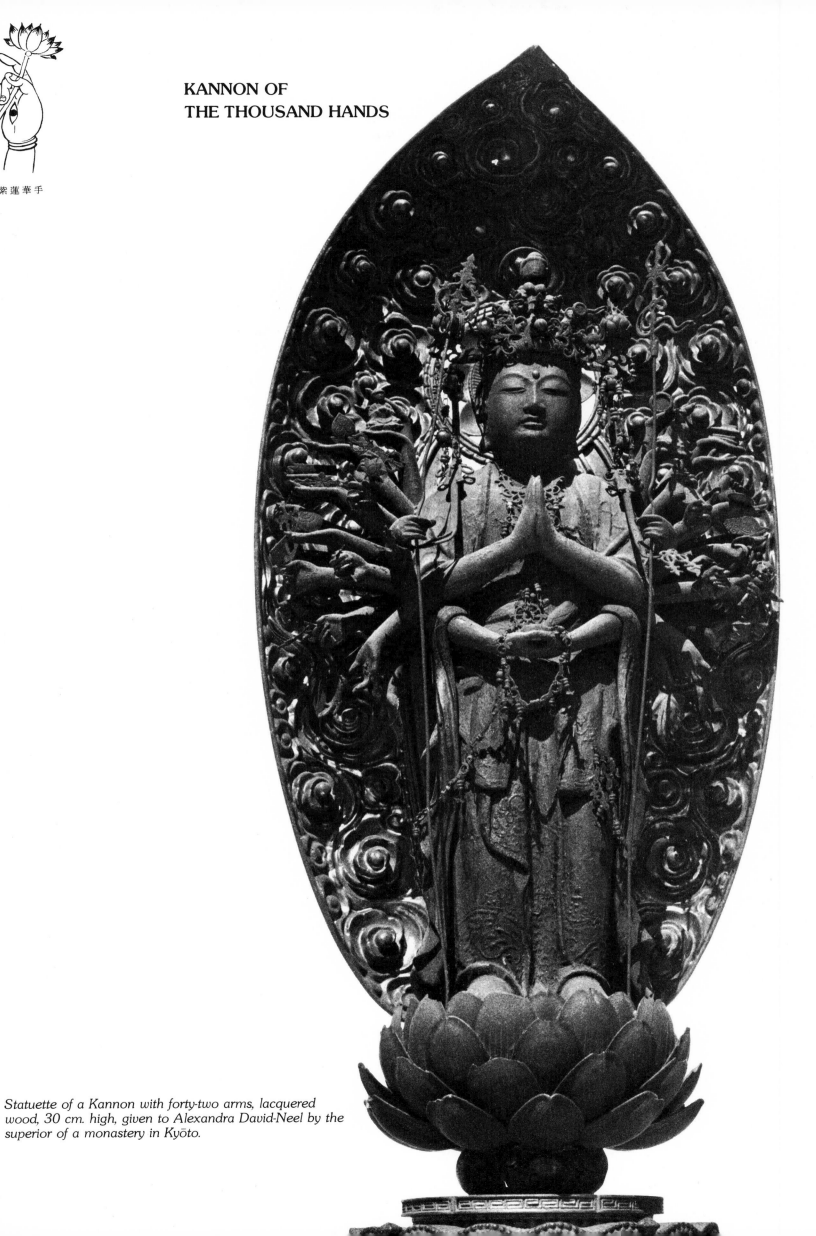

Statuette of a Kannon with forty-two arms, lacquered wood, 30 cm. high, given to Alexandra David-Neel by the superior of a monastery in Kyōto.

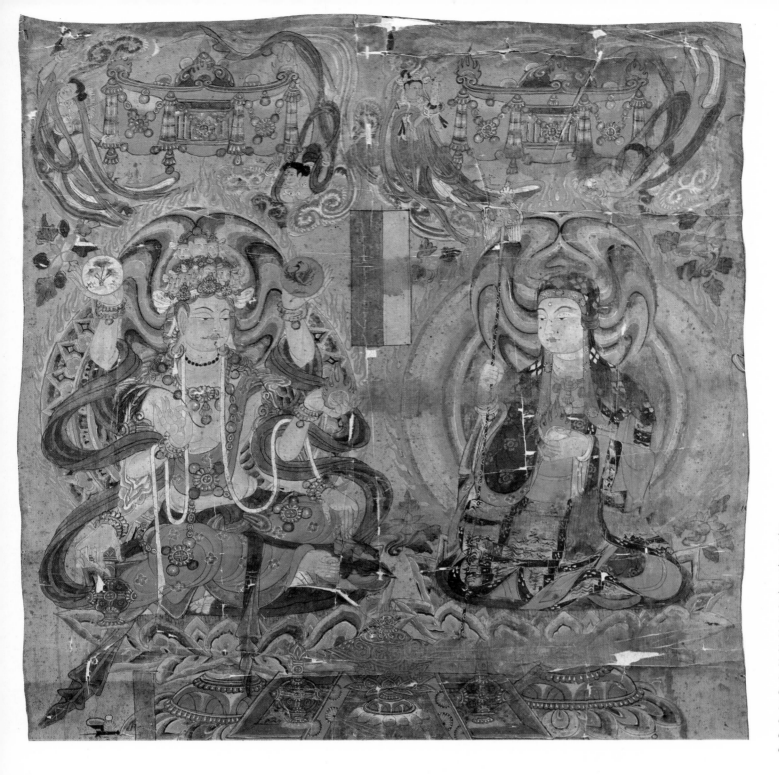

Kannon and Jizō (Kuan-Yin and Ti-Tshang), painting on silk from Tun-huang. Tenth century. Kuan-Yin has twelve heads and six arms, and in her right hands holds the disc of the moon inscribed with a cassia tree between a hare and a toad, a willow branch and a flask. In her left hands she holds the disc of the sun inscribed with a three-footed phoenix, and the jewel.

A KUAN-YIN MANDALA FROM T'ANG CHINA

Mandala of Kuan-Yin (Avalokiteśvara). Chinese painting on silk, tenth century, from Central Asia (0.93 × 0.63 m.).

In the upper register the five Tathāgatas sit between Nyoirin Kannon and Kannon of the thousand hands.
❶ *Vairocana (Ta-jih Ju-lai).*
❷ *Ratnasambhava (Pao-sheng Ju-lai).*
❸ *Akṣobhya (A-ch'u Ju-lai).*
❹ *Amitābha (A-mi-t'o Ju-lai).*
❺ *Amoghasiddhi (Pu-k'ung Ch'eng-chiu Ju-lai)*
❻ *Cintāmaṇi cakra (Nyoirin Kannon)*
❼ *Avalokiteśvara with nine pairs of arms.*
In the centre of the mandala is Kuan-Yin surrounded by her four aspects at the four cardinal points:
① *Hayagrīva.*
③ *Hayagrīva with eight arms.*
⑤ *Kuan-Yin with four arms.*
⑦ *Kuan-Yin with four arms,*
and by the four bodhisattvas of the inner offering:
⑧ *Vajralāsyā, rejoicing.*
② *Vajramālā, presenting a garland of flowers.*

④ *Vajragītā, playing a four-stringed lute.*
⑥ *Vajranṛtyā, performing a dancing gesture; also by the four bodhisattvas of the outer offering:*
⑨ *Vajradhūpa presents a perfume-brazier; on either side of him are a pink conch between two flaming jewels, and a flaming jewel on a lotus.*
⑩ *Vajrapuṣpā presents a tray of flowers; on either side of him are a flaming lotus and a white moon encircled with red and inscribed with the three-branched tree, the toad and the hare pounding up drugs.*
⑪ *Vajralokā presents a lamp; on either side of him are the red sun with the three-footed phoenix and the flaming double vajra on a lotus.*
⑫ *Vajragandhā presents a perfume shell; on either side of him are a flaming vajra on a lotus, and a precious flask between two flowers.*
The mandala is circumscribed by a wall with four gates of different colours, each occupied by a custodian. These are the four bodhisattvas of "interception":
⑬ *Red gate: Vajrasphota holds the two links of a chain.*
⑭ *Green gate: Vajravesa holds a bell in the left hand.*
⑮ *White gate: Vajrankuśa, his foot on a three-tusked elephant, holds in his right hand an axe with a green hook.*
⑯ *Blue gate: Vajrapāśa brandishes a lasso.*
The lower register shows, from right to left, the donor's wife and her daughter, a Buddhist monk, and the donor and his sons.

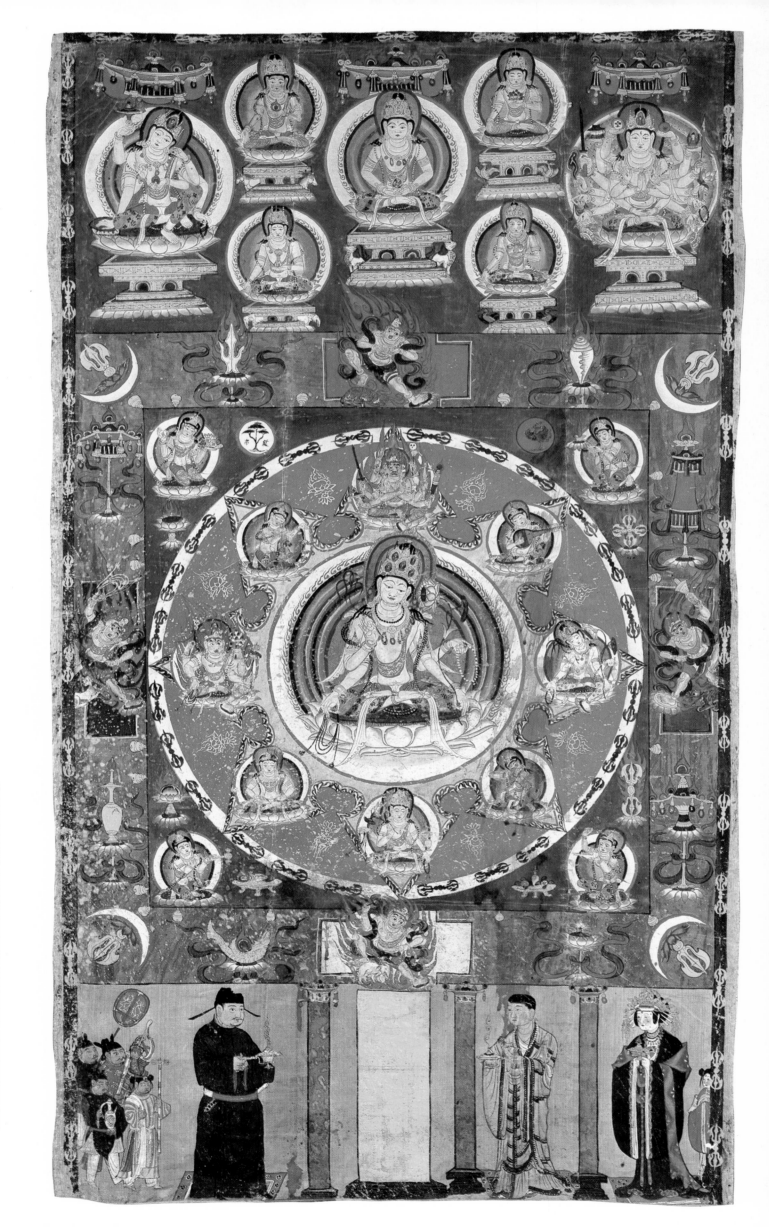

Jizō carved in the rock at Usuki on the island of Kyūshū. Heian period (794–1184).

There is a very close link between Avalokiteśvara (Kannon) and Kṣitigarbha (Jizō). We have already seen that Kannon occupied the north-west petal of the lotus in the central quarter of the Womb mandala. All the quarter north of the lotus is devoted to Kannon, who is represented there under twenty-one aspects. This quarter of "Great Compassion" is bordered, still to the north, by another quarter which epitomizes it in condensed form, including only nine deities. This is the quarter of Kṣitigarbha, "Womb of the earth." This bodhisattva of deep compassion guides beings until the arrival on earth of Maitreya (in three billion nine hundred and twenty million years!). Jizō comes to the aid of all the beings who have fallen into evil "worlds," and so is often met with in the form of the Six Jizōs, one saviour for each world (the worlds of the hells, of hungry spirits, of animals, of men, of flying spirits, and of heavenly beings). Jizō usually holds a sistrum or sounding stick in the right hand and a ball in the left. Jizō, an emanation of Kannon, herself an emanation of Amida, who is an "aspect" of Mahāvairocana, is placed, in the mandala, right next to one of the four doors of the outer enclosure, and thus in close proximity to un-awakened beings, ourselves. This is why Jizō has become one of the most popular deities in Japan. He is found everywhere, including in cemeteries and by the roadside. Because he is considered the most accessible of all deities, parents ask him to protect their children, and dress him up in little brightly-coloured aprons.

JIZŌ

Jizō in the kōdō of the Horyū-ji at Nara.

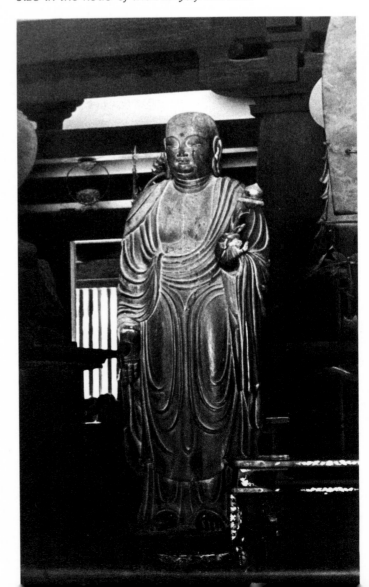

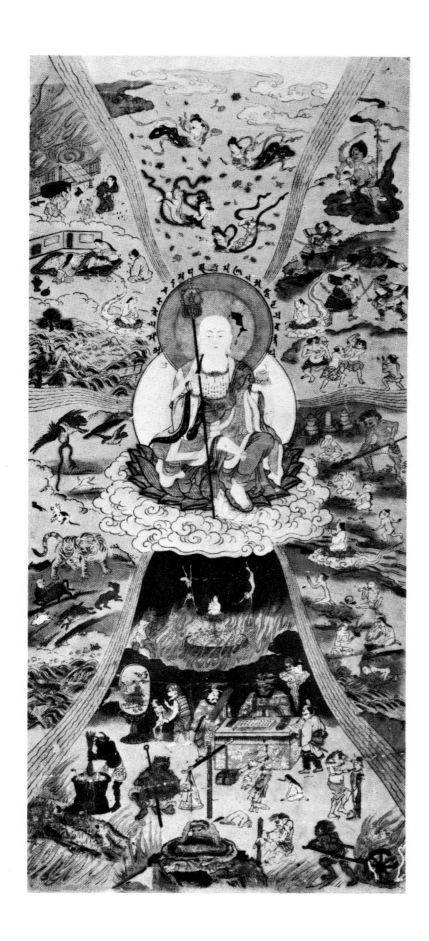

Jizō in the midst of the Six Worlds: those of the hells (below), of animals and of men (to the left), of flying spirits (above), of celestial beings and of hungry spirits (to the right). Edo period (1600–1868).

Jizō. Votive offering from a shrine on the island of Kyūshū. Actual size.

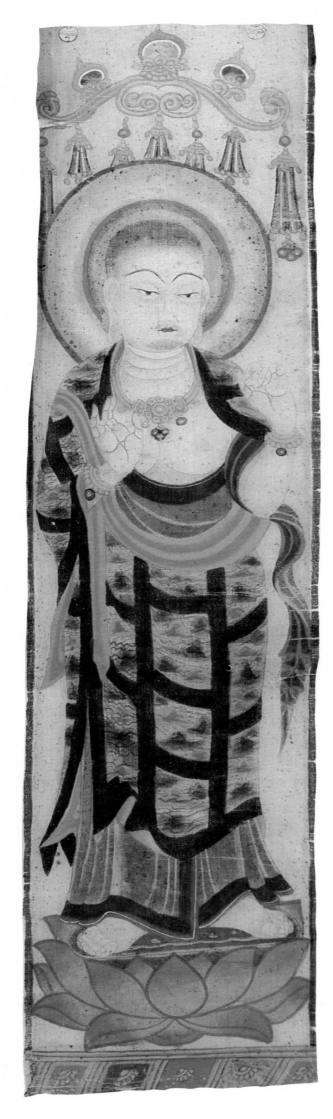

Three stone Jizōs in the cemetery at Kōyasan.

Jizō (in Chinese Ti-tshang), painting on silk from Tun-huang. Ninth century (0.87 × 0.17 m.).

A recent statue of Kannon making the gesture of appeasement with the right hand and, with the left, the gesture of giving, an expression of her great compassion. Cemetery at Kōyasan.

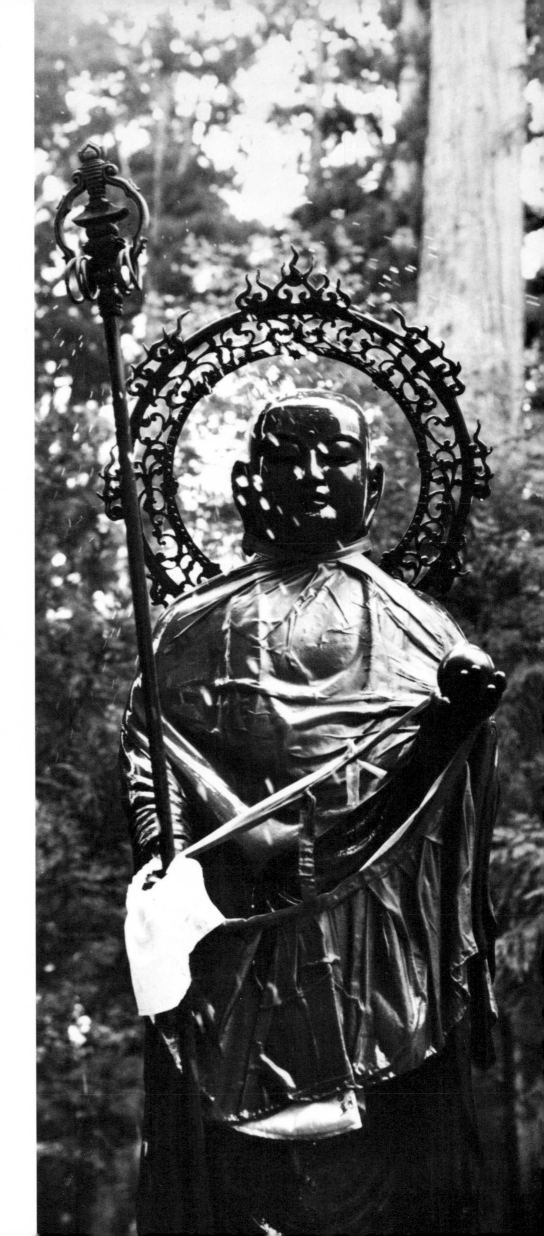

Bronze Jizō decorated with cloths and sprinkled with water by pilgrims in the cemetery at Kōyasan.

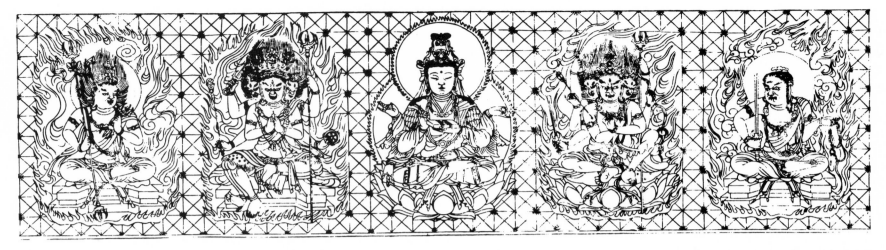

The quarter of the "angry" or "wrathful" ones, the Five Great Kings of Light. From left to right: Trailokyavijaya (Shōzanze Myōō), Yamantaka (Yamantaka Myōō), Prajnaparamita, Trailokyavajra (Gōzanze Myōō), and Acalanatha (Fudō Myōō).

THE ANGRY BUDDHAS: FUDŌ MYŌŌ

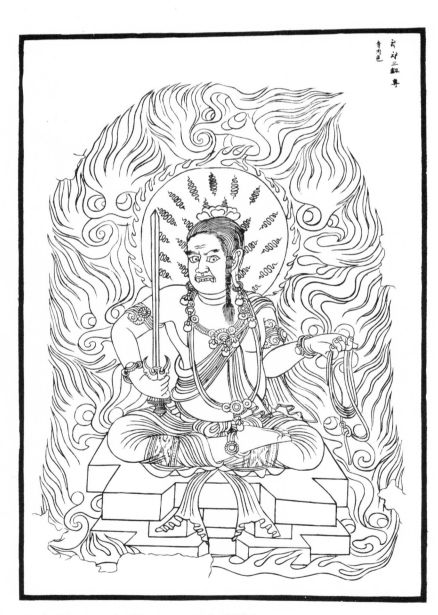

Fudō Myōō in the Hase mandala (1834).

While the four Buddhas of the cardinal points represent the stages of Enlightenment, Mahāvairocana, in the centre, the "immaculate consciousness," symbolizes the means of salvation. The row of five deities below the eight-petal lotus are "angry forms" of Mahāvairocana. Their furious aspect is supposed to quell us careless and rebellious humans and set us on the path to "initial Enlightenment," the first becoming aware (the east petal). These five deities symbolize Mahāvairocana's power over the passions. They each brandish a *vajra* denoting the wisdom which is within us and which will be ours when they have overcome our laziness and inertia, and thrust us along the path of practice that leads to Enlightenment. The deity on the right, Acala, is the one who plays the most important part in the ritual, and is the one most frequently represented. There are few resorts of tantric Buddhism where Acala is not to be found. In Sanskrit, Acala means the motionless, the unshakable, the unchangeable. His Japanese name is Fudō-Myōō. The devotee, as he identifies with Fudō-Myōō in the course of the ritual, becomes aware of the innate and intrinsic Buddha-nature within him. Fudō-Myōō will give him the power to drive away evil spirits and set aside the obstacles opposing the "coming" of the Buddhas. The first act to be accomplished is to assume the body and personality of Fudō.

The ritual relating to Fudō Myōō, part of the Garbhadhātu rite, according to the commentary of the venerable Horyo Toki. From the Shi-do-in-zu, *published in Paris in 1899.*

Detail of the Fudō Myōō drawn by Shinkan in 1283, preserved in the Daigo-ji, Kyōto.

JO FUDO
CH'ÊNG PU TUNG

Becoming or performing Fudo

This rite is made up of a series of acts depicted in seals 104 to 110. By its virtue the god Fudo myooho is incarnated in the body of the officiant, so as to give him power to drive out evil spirits and eliminate the obstacles in the way of the Buddha's coming.

The first act to be performed is to take on the body and personality of Fudo. The priest does this by sanctifying his own body, laying on his breast the seal of Fudo Ken, or the Fists of anger.

The Flames of Fudo

Then, extending the forefingers of the Fists of anger so that the tips touch, he forms a triangle, symbol of fire, and produces in a state of perfection the Flames of Fudo myooho, purifying himself by the application of this seal to his breast at the same time as he pronounces the dharani of *Ra*.

Drawing the sword

Fudo Myooho is armed with a sword to fight the demons. This sword is represented by the right hand of the priest, with the forefinger and middle finger extended and the thumb bent back on to the nails of the third and fourth fingers. The left hand, which makes the identical gesture, represents the sheath or scabbard and is placed on the left thigh. In the drawing, the sword is in the scabbard and the priest is about to draw it.

First threat

The priest draws the sword, places it over his right breast and puts the scabbard on his head, turning the scabbard round three times. This is the first threat.

Putting the sword back in the scabbard

The officiant puts his left hand back on his left thigh and replaces the sword in the scabbard.

Second threat

The priest draws the sword again and brings it to his right breast; then, brandishing it, he purifies the whole temple, above and below and at the four cardinal points, so as to drive out the demons. During this time the left hand remains on the left thigh.

Putting the sword back in the scabbard

The demons are completely routed and the priest replaces the sword in the scabbard.

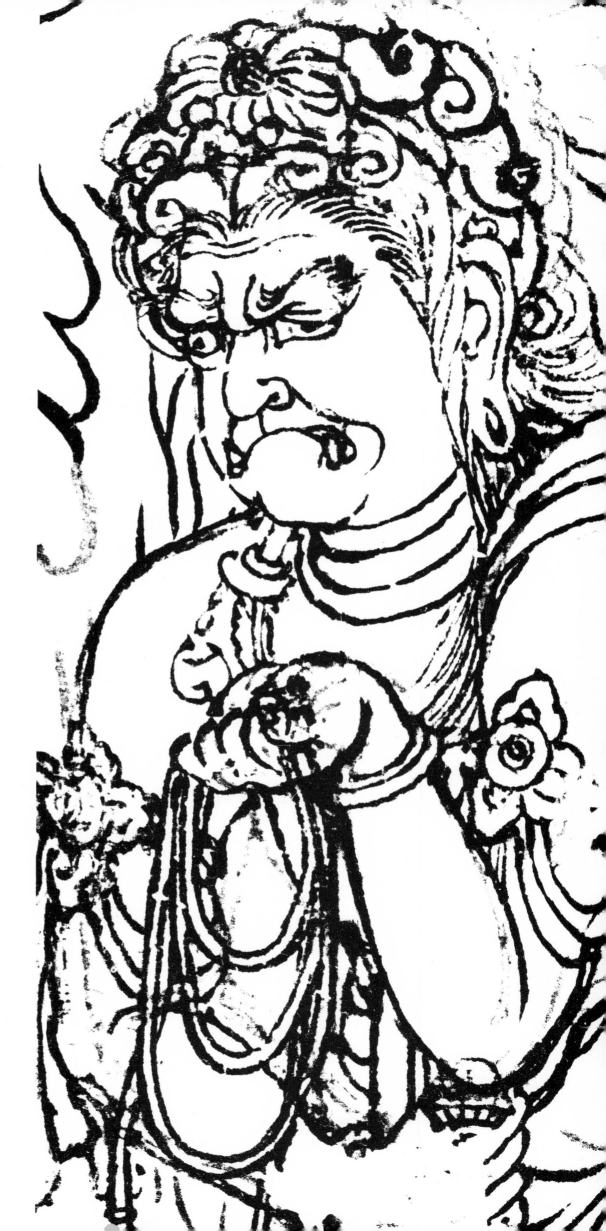

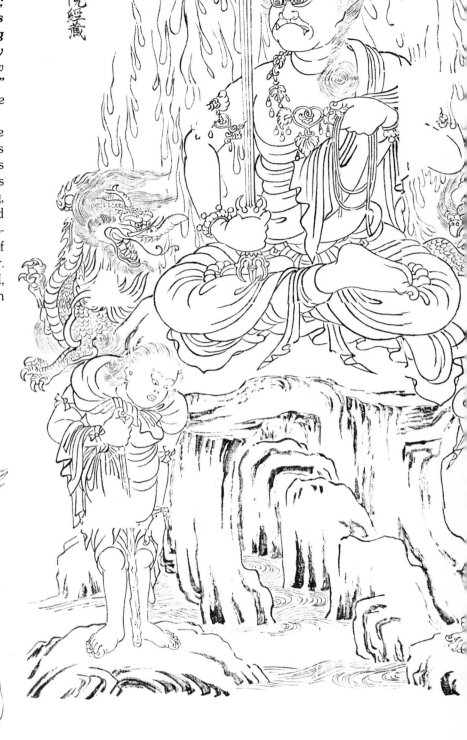

"Beneath the Lord-of-the-mantras, in the direction of nirṛtī (the south-west), is Acala, servant of the Tathagata; he holds the 'sword of Wisdom' and the pāśa (rope). His hair hangs to his left shoulder; with one eye squinting slightly, he gazes fixedly; fiery flames dart from his body inspiring holy terror; he sits on a great rock; on his brow are wrinkles like waves on water; he is a plump youth."

It was this passage in the *sūtra* which enabled Japanese artists to depict Fudō-Myōō in iconographical terms.

In his left hand Fudō-Myōō holds a rope. This is an image of our bonds, of the snare in which we are caught. And it is this rope which will enable the Buddha and the bodhisattvas to lay hold of beings and lead them to salvation. The rope is also a symbol of the prohibitions: against killing, stealing, lasciviousness, lying, the drinking of alcohol. With the sword he flourishes in his right hand (the hand of Wisdom), Fudō-Myōō will slay doubt and confusion. It is the symbol of intelligence, Knowledge, victory over ignorance and error. The sword and the rope affirm once again that RI and CHI, Reason and Knowledge, the Principle which is to be known and the Knower, are one and the same.

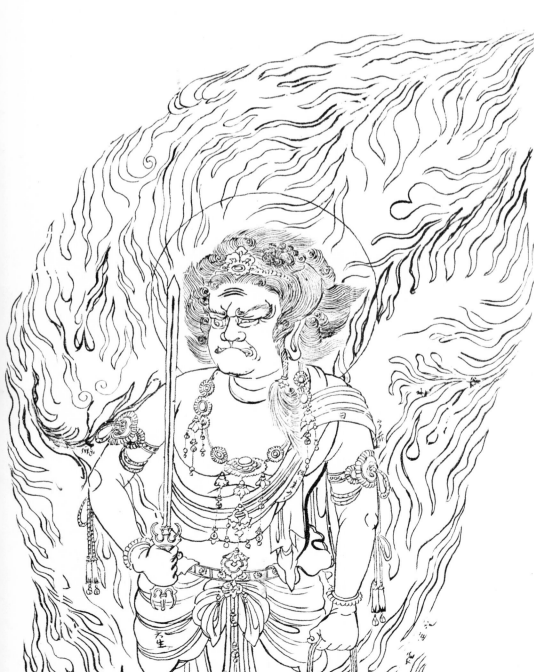

Iconographical drawings of Fudō Myōō. Kamakura period (1185–1307).

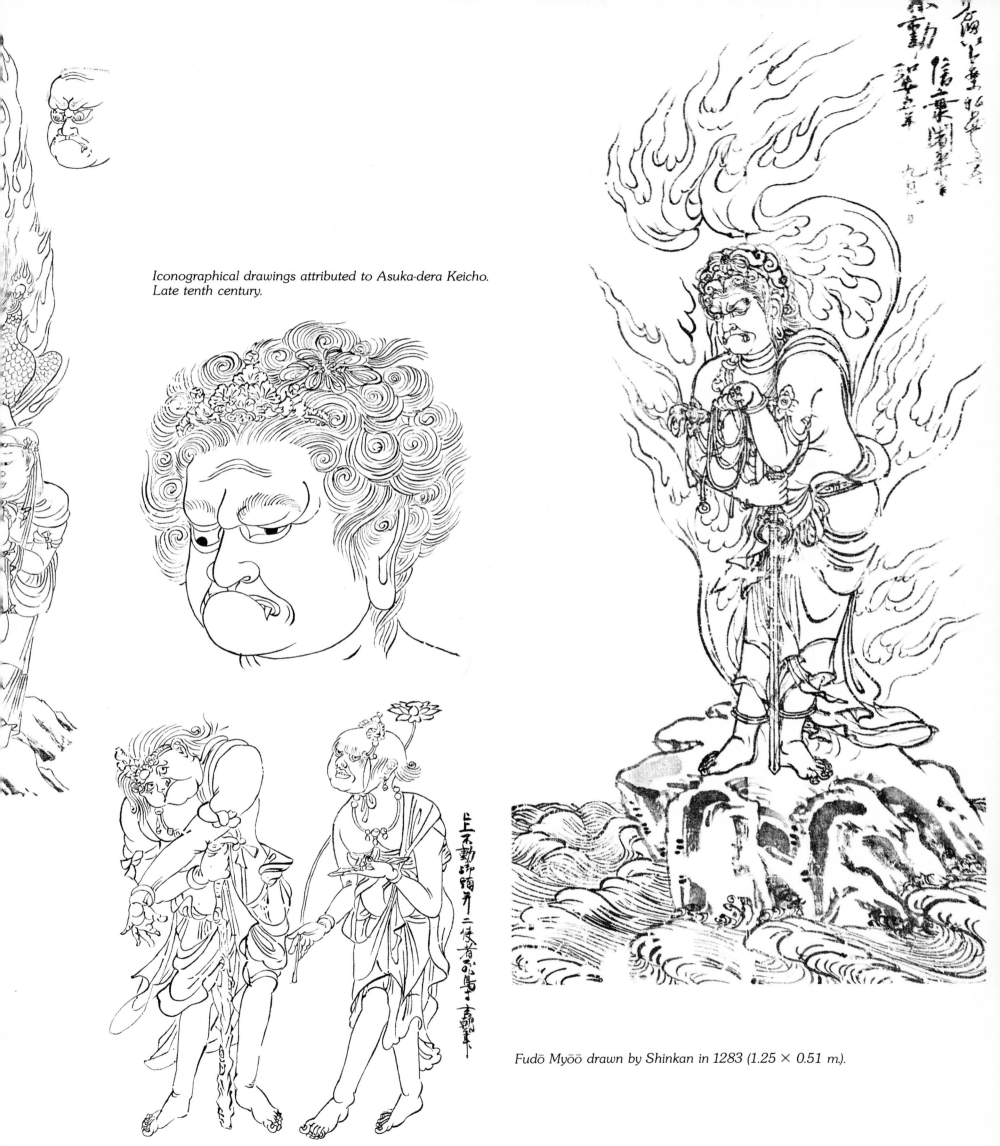

Iconographical drawings attributed to Asuka-dera Keicho.
Late tenth century.

Fudō Myōō drawn by Shinkan in 1283 (1.25 × 0.51 m).

137

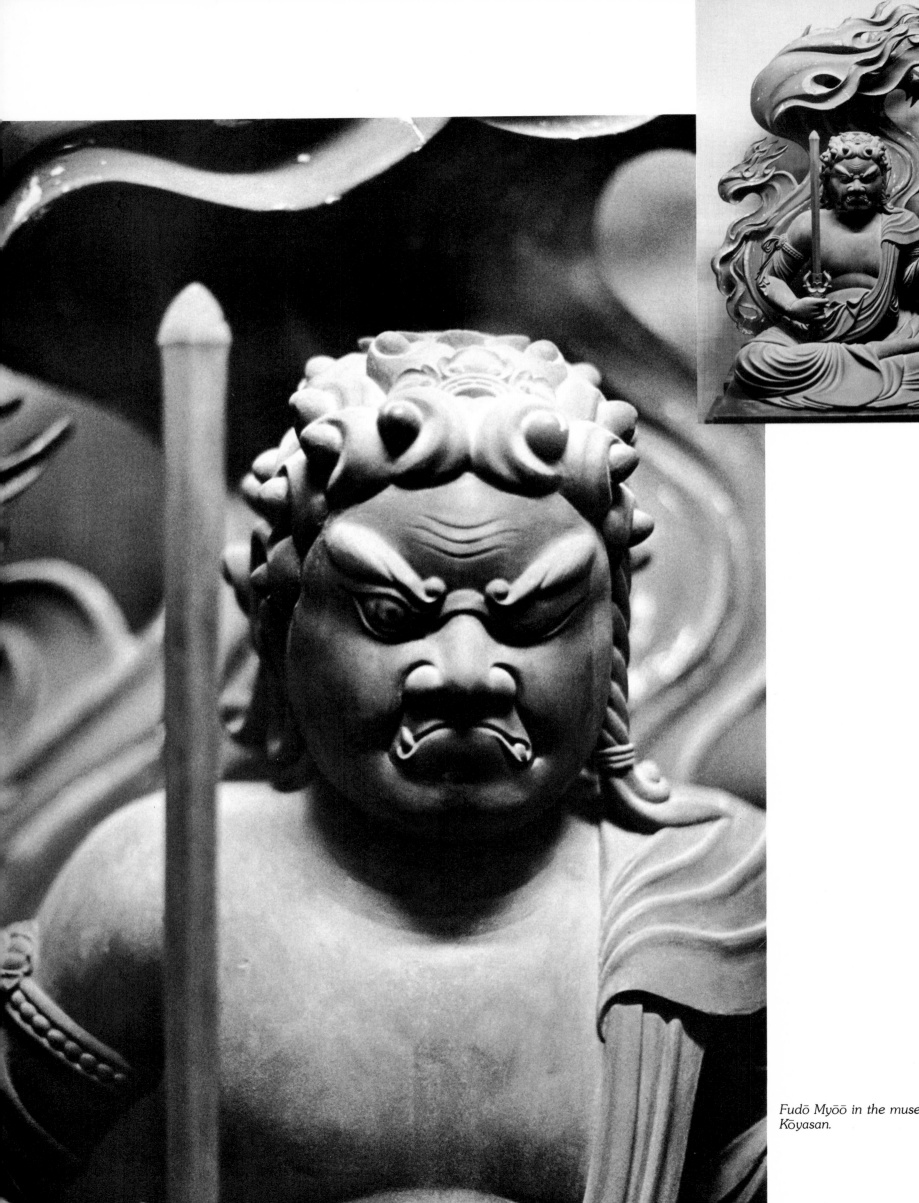

Fudō Myōō in the museum at Kōyasan.

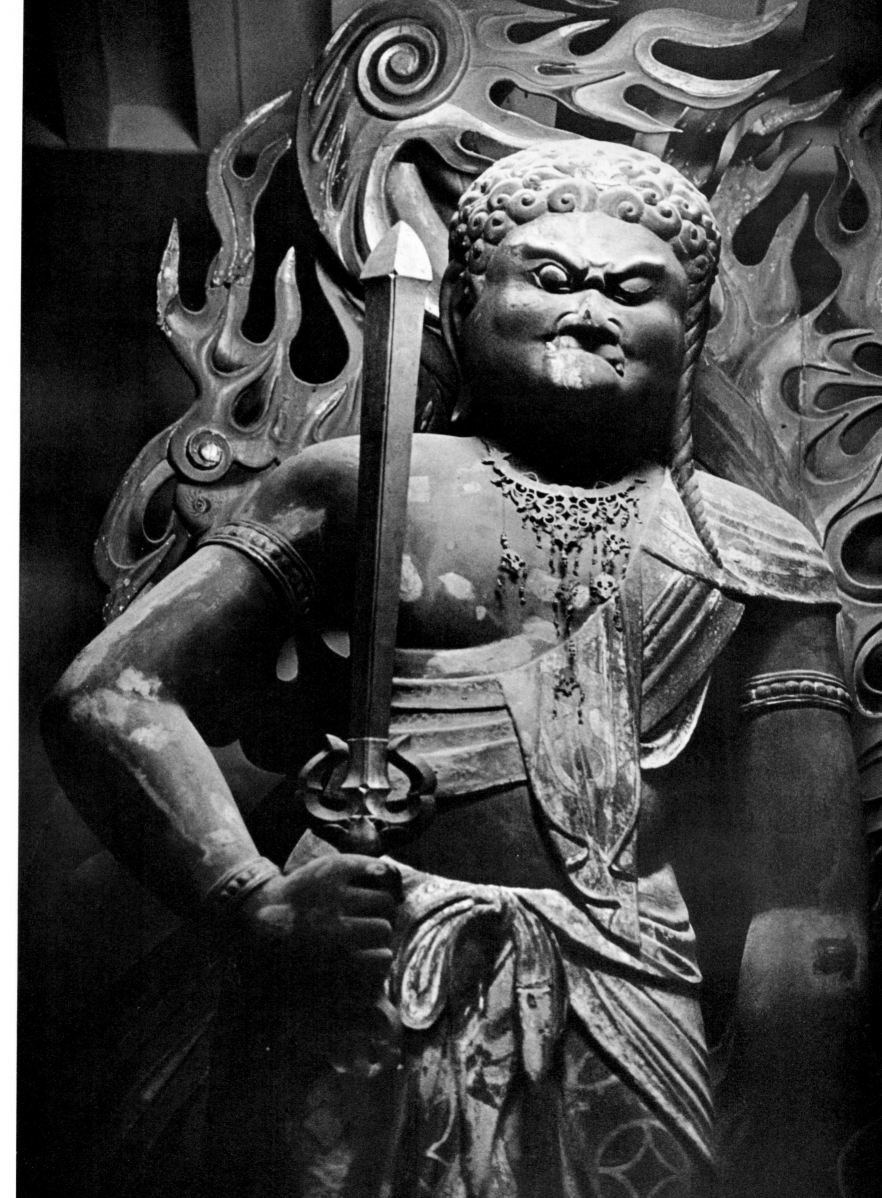

Fudō Myōō in the Tōdai-ji in Nara.

Fudō Myōō, with body made up of Sanskrit letters. Print, eighteenth century.

Fudō Myōō represented by his attributes: the sword with vajra-hilt, and the rope, here become a dragon; the whole surrounded by flames. Seventeenth century.

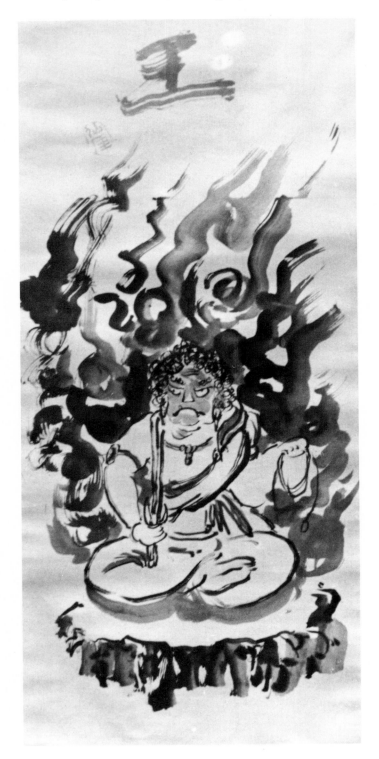

Fudō Myōō. Painting on silk. Twelfth century. ▶

Fudō Myōō by the Zen monk Sengai (1750–1837).

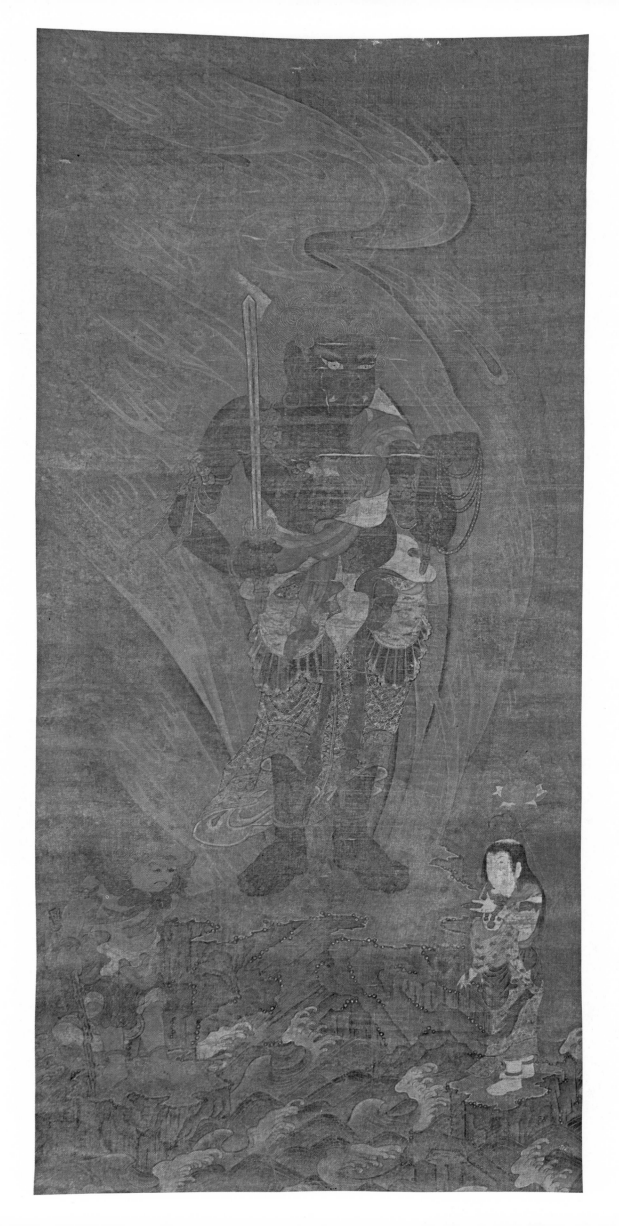

Trailokyavijaya (Shōzanze Myōō) trampling down the passions and the intelligence. Detail of a kakemono representing the Five Kings of Light in the Tentoku-in Temple at Kōyasan.

THE FIVE GREAT KINGS OF LIGHT

Shōzanze Myōō in the Kami Daigo-ji Temple. Heian period (794–1184).

Trailokyavijaya, in the same quarter of "terrible" deities as Fudō, is, like him, one of the five "Great Kings of Light." In Sanskrit his name means "Conqueror of the three poisons," i.e. the three passions: love, hatred and ignorance. His Japanese name is Shōzanze-Myōō. His four faces represent victory over the illusion residing in the four directions, a victory won with the help of the four wisdoms of Vairocana. His three eyes represent victory over the three poisons. His left foot spurns Maheśvara, an image of

Shōzanze Myōō prepares to trample on the consort of Maheśvara. Detail of a painting dated 1127 in the Tō-ji in Kyōto.

the passions, and crushes his head. With his right foot he is about to trample Maheśvara's consort, symbol of the understanding of knowledge. The passions and the intelligence are obstacles to deliverance and Illumination. Shōzanze-Myōō has four pairs of arms, which enables him to brandish to his left a trident, a bow and a rope, and to his right a *vajra* (or a bell surmounted by a *vajra*), an arrow and a sword. With his two remaining arms he makes the *mudrā* of appeasement characteristic of this deity.

Kongō-Yasha Myōō in the Kami Daigo-ji Temple. Heian period (794–1184).

Another Great King of Light is Yamantaka-Myōō. As his Sanskrit name suggests, he is the conqueror of death, of Yama, the Hindu god of the Underworld. In Chinese he is called "He who looses the fetters of all beings." He has six faces, six arms and six legs to help beings escape from the six evil worlds. His mouth is open to denounce all obstacles to Illumination. The flames which surround him burn away the sins of all beings.

Daiitoku Myōō (Yamantaka). Detail of a kakemono depicting the Five Kings of Light, Kōyasan.

Daiitoku Myōō in the Kami Daigo-ji Temple. Heian period (794-1184).

Yamantaka performs the mudrā of "crushing evils," which in the ritual comes immediately after that of "summoning up evils."

144

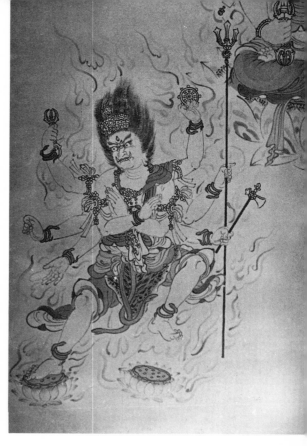

Gundari Myōō (Kuṇḍali). Detail of a kakemono depicting the Five Kings of Light, Kōyasan.

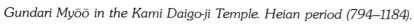

Gundari Myōō in the Kami Daigo-ji Temple. Heian period (794–1184).

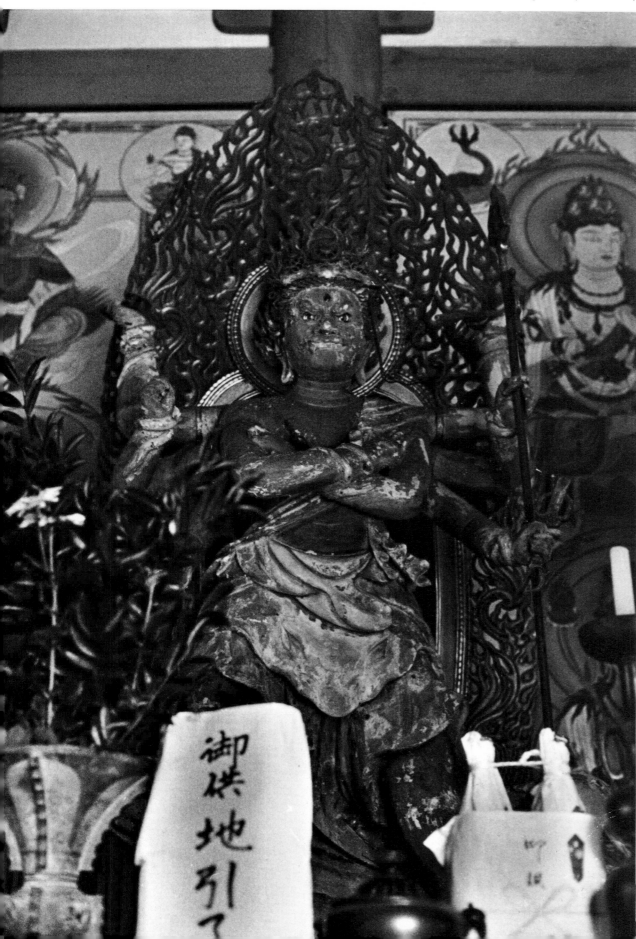

御供地引て

145

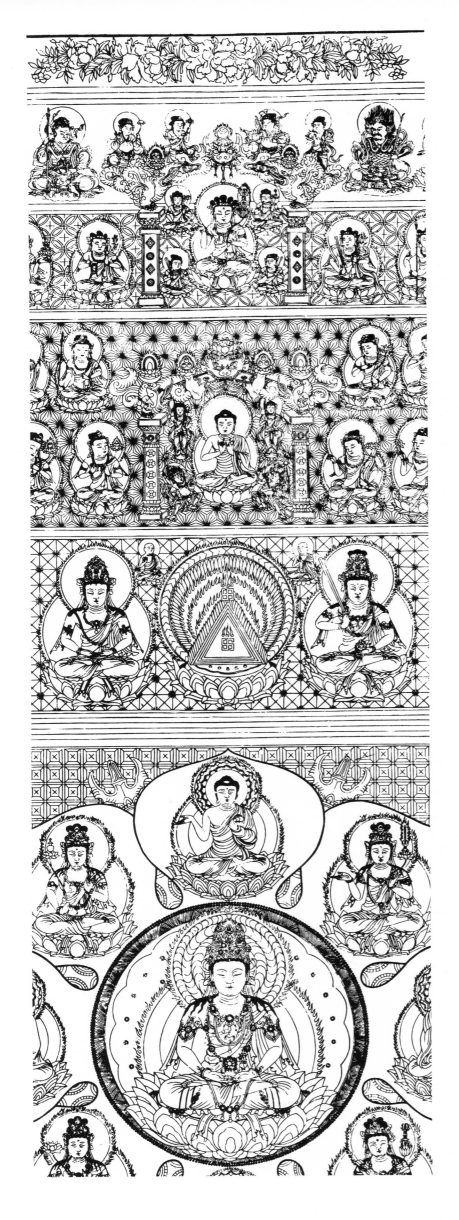

THE QUARTER
OF UNIVERSAL KNOWLEDGE

Just above (and to the East of) the eight-petal lotus is the quarter of "Universal Knowledge." The "Symbol of the Universal Knowledge of the Tathāgatas," which occupies the centre of this quarter, is a white triangle surrounded by flames and standing on a lotus. This is the only abstract idea in the Womb mandala which is represented not by an anthropomorphic deity but by a geometrical figure. The eight-petal lotus is a figurative expression of the Buddha who is latent within us. The quarters to the north and the south represent, respectively, the Compassion and the Wisdom of the Tathāgata (the one cannot exist without the other). The quarters to the west and to the east stand for the first manifestations of Enlightenment within us. To the west is the quarter of the five "Great Kings of Light," the quarter of the "Angry Ones" who will overcome our desires and burn away our passions by the power of the *vajra*. To the east is the quarter of "Universal Knowledge," to which we attain through a second birth. There is a slight mystery about this triangle. In the "Commentary" on the *Mahāvairocana Sūtra* it is said that the triangle has its apex pointing downwards, whereas in the mandala itself the apex is at the top. According to Tajima there is a tradition according to which the triangle really has its apex pointing forward, but as this is impossible to represent graphically, the apex is shown sometimes pointing upwards and sometimes pointing downwards. "When the apex is on top, it symbolizes Illumination obtained individually, and when it is below it expresses Illumination obtained through the help of the Buddha. Pointing forward, the apex signifies that these two modes of Illumination and salvation may be reconciled." But there is also another explanation. According to Professor Rolf A. Stein, in the first mandalas drawn by the Indians in the seventh century the triangle was pointing downwards, thus representing a *yoni* or female sexual organ. But in the mandala as transmitted to Japan (in the year 805), the triangle was reversed. We should remember here that the Chinese Buddhists have always avoided using the very obvious sexual symbols dear at first to the Indians and then to the Tibetans. So the triangle, with its apex pointing upwards, became the symbol of fire, the fire of knowledge, the purifying fire which burns away the passions. But at the same time as the triangle was reversed, two small figures were added on either side of the apex: the Kāśyapa brothers, two Brahmans, fire-worshippers, who are said to have been converted by the Buddha and to have become his disciples. In fact these two figures seem to have a deeper significance. One of them killed his father, and the other committed incest with his mother. Thus the graphic presence of the Oedipus complex in this quarter restores to the triangle its sexual and maternal value. One of the brothers represents hatred, the other love. But what seems to us to be hatred is sometimes only violence, the liberating violence whose weapon is the *vajra*.

In ascending order above the central lotus are the quarters of Universal Knowledge, of Śākyamuni, of Mañjuśrī, and the quarter outside the vajras. *Detail of the Hase mandala (1834).*

THE QUARTER OF ŚĀKYAMUNI

Above the quarter of Universal Knowledge is the quarter of Śākyamuni (in Japanese, Shakamuni). This is the historical Buddha, but in the manifest form of Mahāvairocana Tathāgata. The deities surrounding him are personifications of his thirty-two distinctive signs (protuberance of the skull, tuft of white hairs between the eyebrows, etc.). The historical Buddha is depicted just above the triangle of Universal Knowledge. He is in the middle of a door—which in a mandala means a divinity expounding doctrine—and he is expounding "popular" Buddhism (the Lesser Vehicle) to beings incapable of receiving the esoteric doctrine. The latter is however unveiled to the initiate, because Śākyamuni is a direct emanation of the Tathāgata, who is represented on the northern petal of the central lotus.

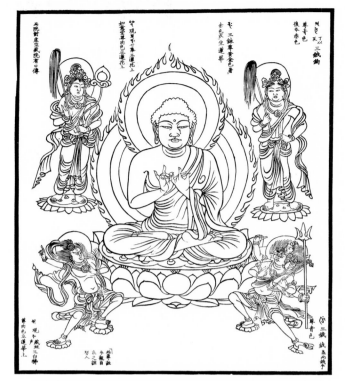

Iconographical drawing. In the middle is Śākyamuni, with, above to the right, Avalokiteśvara, and above to the left Akāśagarbha.

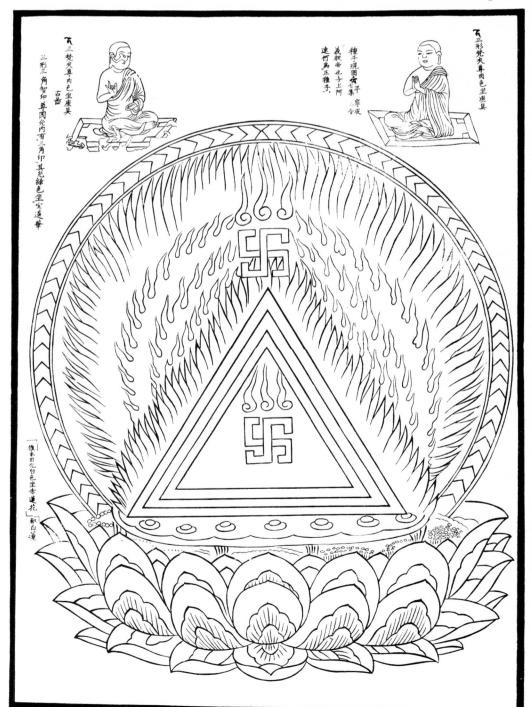

Central image of the Quarter of Universal Knowledge (knowledge of the All).

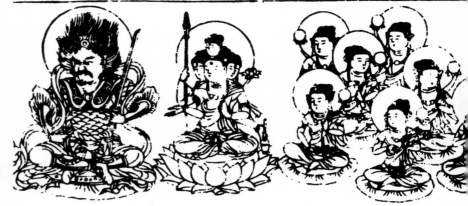

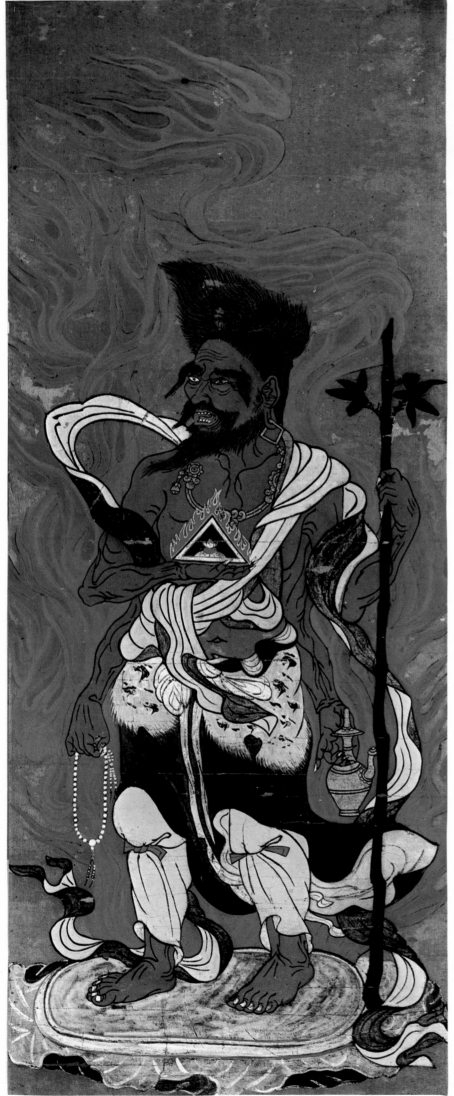

AGNI: FIRE

Outside the various "quarters" which go to make up the mandala there is a frame representing over two hundred deities. They are *devas*, guardians of the Law, and deities who protect the esoteric doctrine. Between the first enclosure—which includes, in addition to the central lotus, the quarter of Universal Knowledge to the east, the quarter of the "Five Angry Ones" to the west, the quarter of Avalokiteśvara to the north, and that of Vajrapāni to the south—and the second enclosure—which includes the six other quarters—and this third enclosure, there are "doors." If you go through these doors from the centre towards the perimeter, you have an image of the manifestation of Buddhahood in the Universe of phenomena. All beings are epitomized in this third enclosure. In it one can distinguish the twelve *devas*, the twelve signs of the zodiac, the twenty-eight mansions of the moon, the nine planets, and all the deities in the Hindu pantheon. It goes without saying that they are not arranged arbitrarily. The lay-out is closely linked to the orientation of the mandala, and there is a whole system of correspondences between these deities in the third enclosure and those which are represented in the first and second enclosures and of which they are the emanations. The name of each deity, his posture, attributes, garments, colours, and position in the mandala all throw light on the abstract ideas which this particular deity represents. But "all the *devas* and demons and so on, however many they may be," says one commentary, "all the *devas, nagas, pretas,* constellations and infernal deities are epitomized in the twelve *devas.*"

Agni (Katen), Fire. Fourteenth-sixteenth century (0.81 × 0.30 m.).

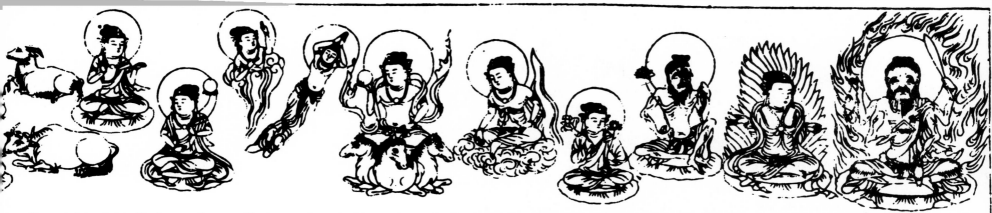

From left to right: Jikoku-ten, Bonten (Brahman, the zenith) on a lotus, the Ram (Mesa), the Bull (Vṛṣa), the Twins (Mithuna), the comet (Ketu), the sun on his steeds (Sūrya), followed by his family, with Vasu as an ascetic. Finally, in the south-east corner, Agni, deity of Fire. Hase mandala (1834). Half actual size.

THE TWELVE HEAVENLY KINGS
THE TWELVE DEVAS OF THE ORIENTS

These twelve *devas*, frequently represented in esoteric Buddhism's places of worship, include the eight *devas* of the orients or directions:

To the east: Indra (Taishakuten)
To the south-east: Agni (Katen); Fire
To the south: Yama (Emmaten)
To the south-west: Nirṛti (Rasetsuten)
To the west: Varuṇa (Suiten); Water
To the north-west: Vāyu (Futen); Air
To the north: Vaiśravana (Bishamonten)
To the north-east: Iśāna (Ishanaten).
To these must be added:
The Zenith: Brahman (Bonten)
The Nadir: Pṛthivī (Earth)
The Sun: Sūrya (Nichiyō)
The Moon: Candra (Gatten).

Sometimes the whole series of twelve *devas* is found in the temples, either as twelve separate paintings or brought together on a screen. Agni (Katen) is the most honoured of all, and their epitome. In certain texts the twelve *devas* are called the twelve Agni.

"In the south-east corner are situated all the gods of fire... Agni is seen in the midst of the flames. He has three smears of ashes, on the brow and on the elbows, as is the custom with the Brahmans... Over his heart he has the triangle... In his left hand he carries a rosary, and in the right a ewer..."

Tajima points out that the above passage from the Commentary shows Agni to be "a personage borrowed from the esotericism of the Brahmans, who were fire-worshippers. Agni is one of the forms of Vairocana. Moreover, to give an esoteric explanation, Agni symbolizes the total destruction, through the *bodhicitta*'s fire of knowledge, of the three impediments: illusion, activity and pain. The god's four arms symbolize Vairocana's four sapiences: the sapience of the great round mirror is represented by the symbol of fire (the triangle), that of natural equality by the ewer, that of marvellous discernment by the rosary, and that which produces acts by the rod."

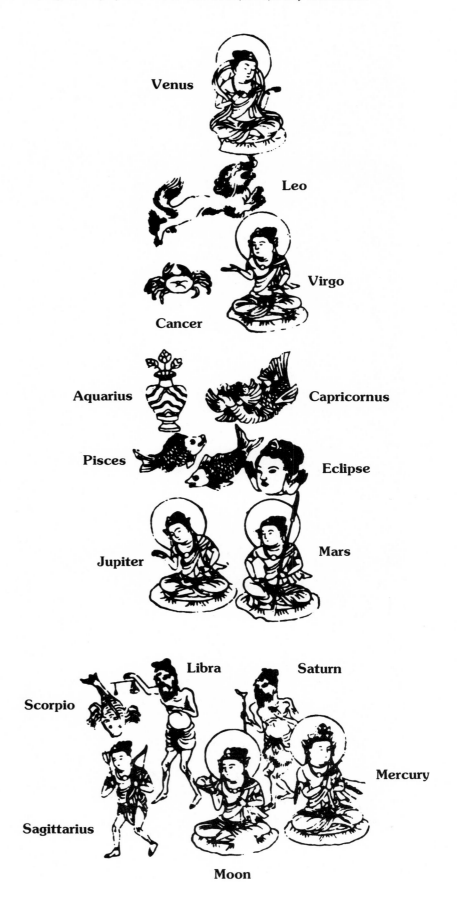

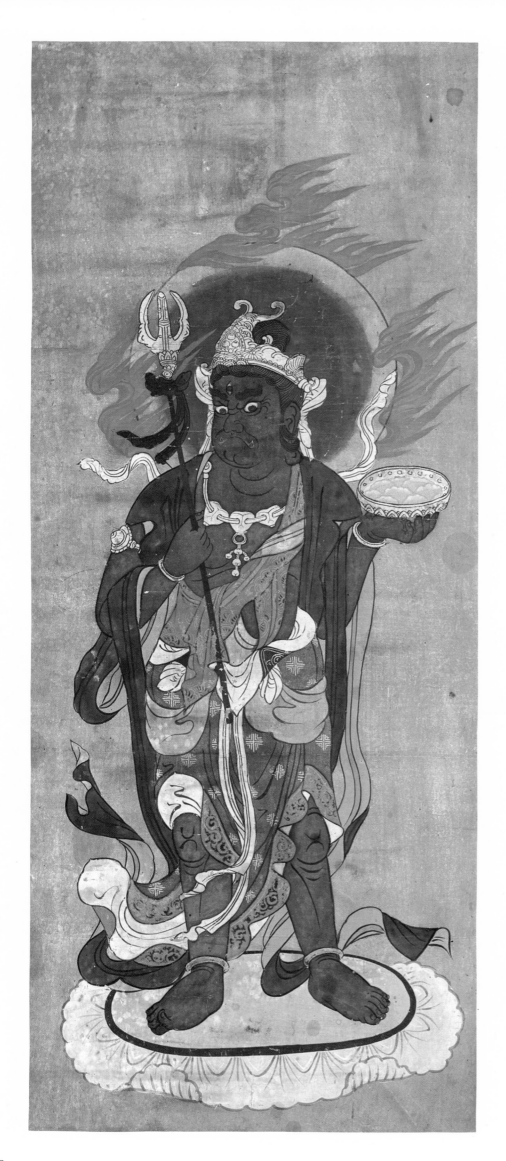

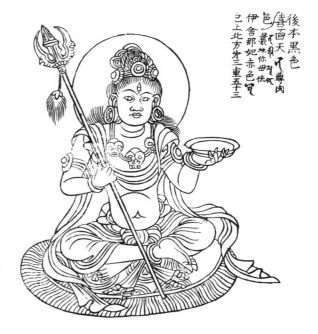

Ishanaten, in the north-east of the mandala.

Iśāna (Ishanaten)
According to the Sutra Commentary, "Iśāna, who is blue-black in colour, has three eyes. He wears a garland of skulls. In his left hand he holds a bowl and in his right the trident."
According to Tajima, "His wrathful aspect, with blue-black colouring and three eyes, symbolizes the repression of the passions which are the three poisons: rāga, dveṣa and moha; he slays them with the breath of his anger. His garland of skulls symbolizes the darkness of the passions caused by innate ignorance. The ornament of skulls symbolizes the identity between the passions and bodhi. The fact that the bowl in his left hand contains blood means that he drinks up the passions; his left hand, holding the trident, symbolizes the defeat of the passions by the trident, which expresses the triple equality between the heart of the subject, the Buddha, and all beings, and signifies the destruction of the two obstacles in order to obtain nirvāṇa and Illumination."

Taishakuten, in the east of the mandala.

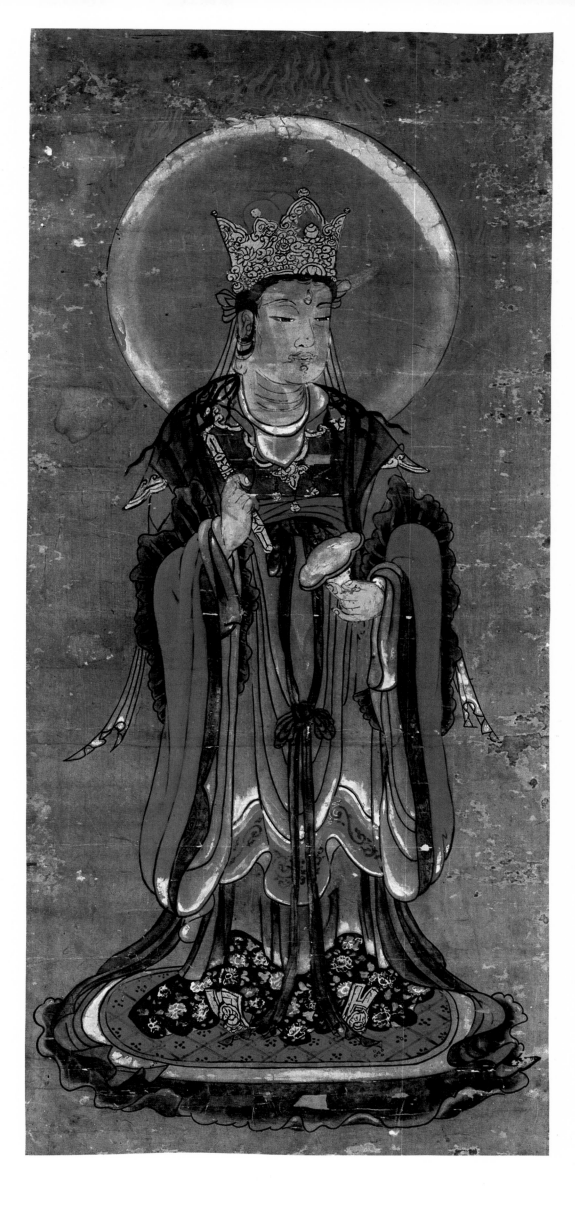

*Indra (Taishakuten), Hindu deity of Heaven.
In the Vedas he is the king of the gods.*

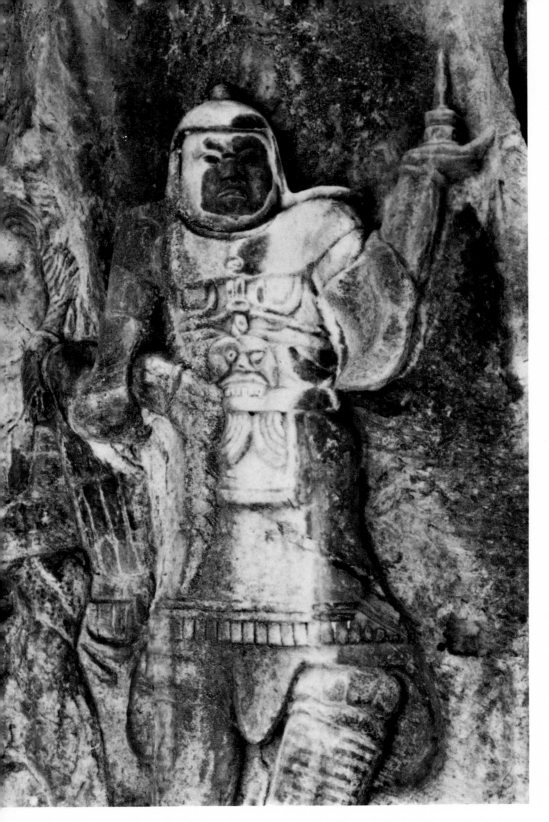

Bishamonten carved on a cliff at Usuki on the island of Kyūshū. Heian period (794–1184).

The statues of the deities are arranged on the altar in the same way as in the mandalas. In the kōdō of the Tō-ji, in the middle are the five Buddhas of the Diamond pattern, on the right the five bodhisattvas, on the left the five Great Kings of Light, and at the four corners the four Kings who are guardians of the sky.

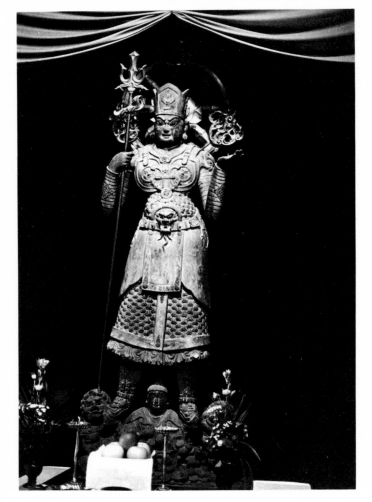

Vaiśravana (Bishamonten). Wood statue, ninth century, in the treasure chamber of the Tō-ji in Kyōto. Height 1.94 m. Detail on the right.

We have already mentioned the connection between the structure of the mandalas and the way statues of deities are arranged on the altars. In the middle is Vairocana, usually represented in one of his aspects—either Yakushi Nyorai (the Master of Medicine), or the "honourable principal" with whom the devotee is to identify during the ritual (Kannon, Fudō-Myōō or Amida). These deities all belong to the first enclosure of the mandala. The statues surrounding them come from the third enclosure, and are oriented in the same way in the temple as in the mandala. For example, I have seen Yakushi Nyorai with Nikkō, Light of the Sun, on his left, and on his right Gakkō, Light of the Moon, a threatening *deva*, the guardian of Yakushi, Amida between two acolytes, and, in front, a statue of Fudō-Myōō. In the mandala, the quarter of the "Five Angry Kings," to which Fudō belongs, is below the central lotus: i.e. in front, in space.

Of course there is a hierarchy among the various deities in the mandala. The most important belong to the central lotus, but those who are nearest to us are those of the third enclosure. They are also the closest to us in the temple: the most visible, the best lit, and closer to the devotee in style also. While the Buddhas are Indian in style, and the bodhisattvas Chinese, the deities of the third enclosure —although they have kept their Chinese clothes and armour—are Japanese.

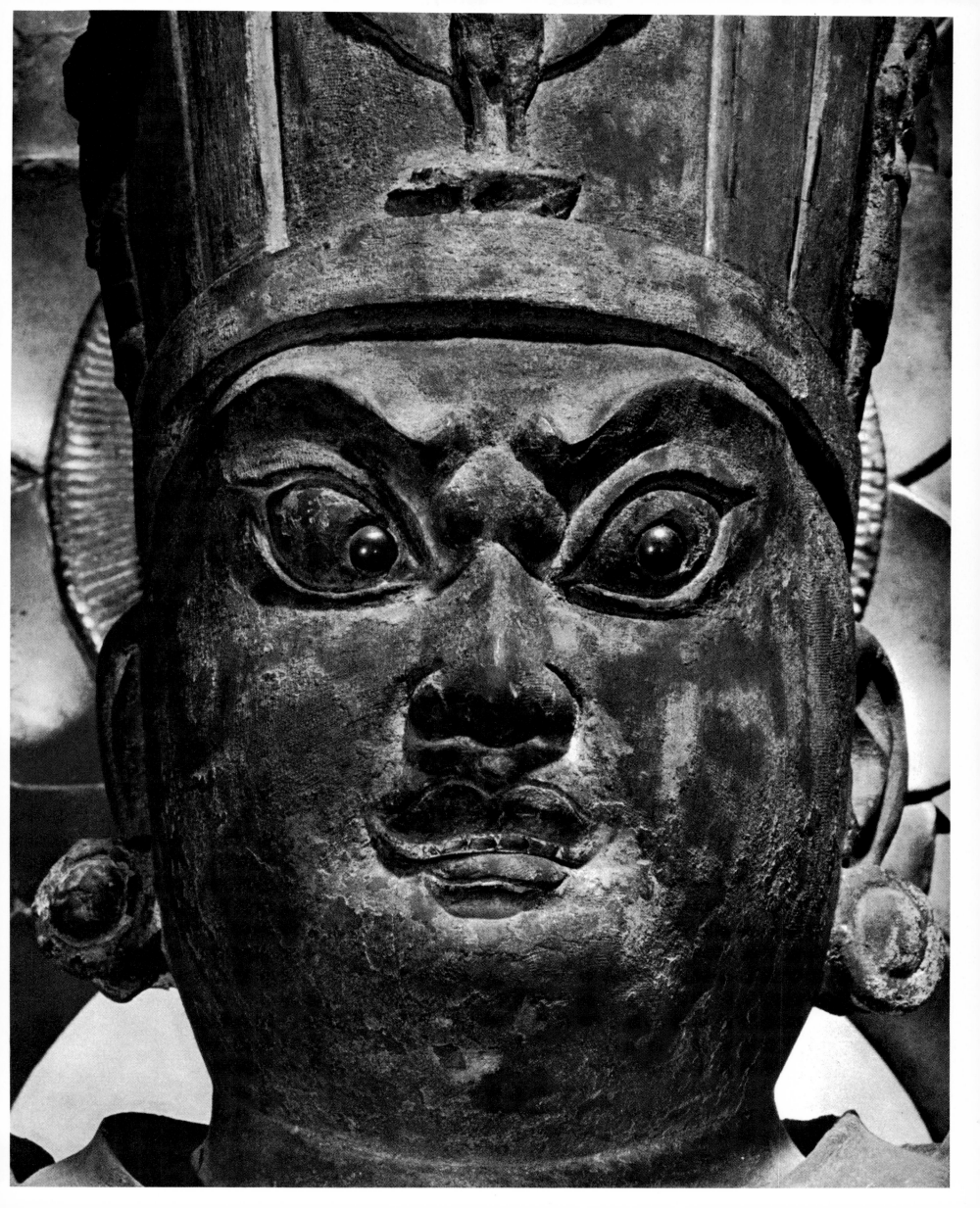

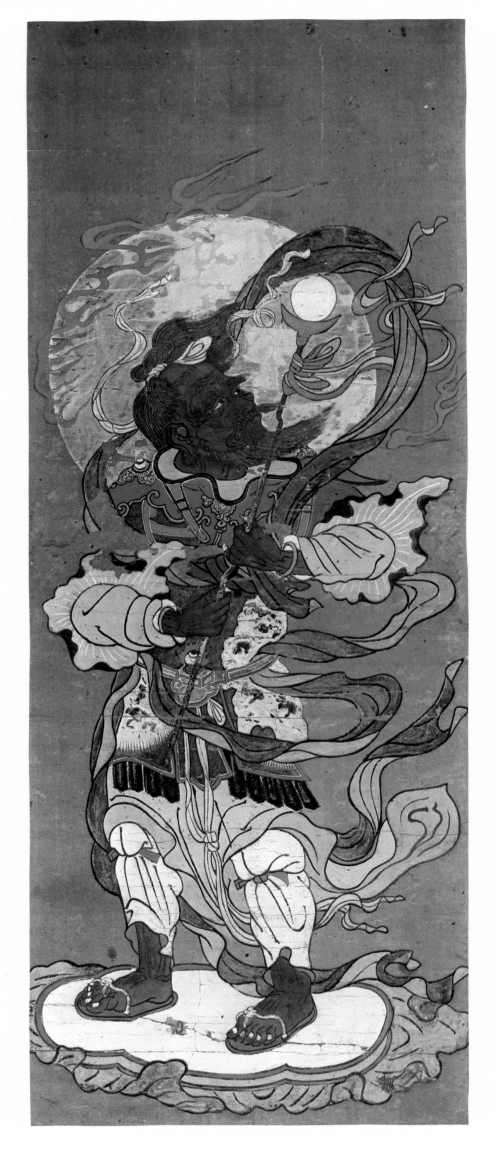

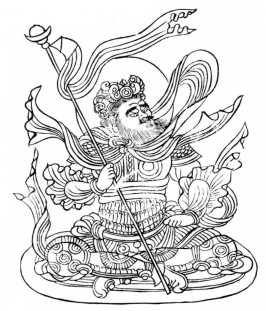

Fūten in the north-west of the mandala.

◀ Vāyu (Fūten), the Wind.

Suiten and maid in the west of the mandala.

Varuṇa (Suiten), Water. ▶

Rasetsuten in the south-west of the mandala.

Nirṛtirāja (Rasetsuten), the ogre. ▶

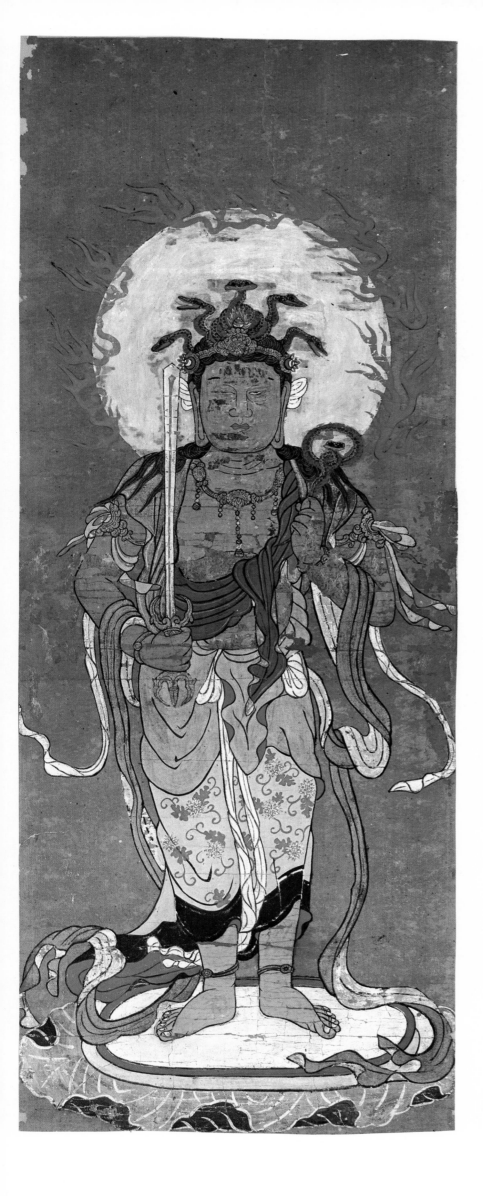

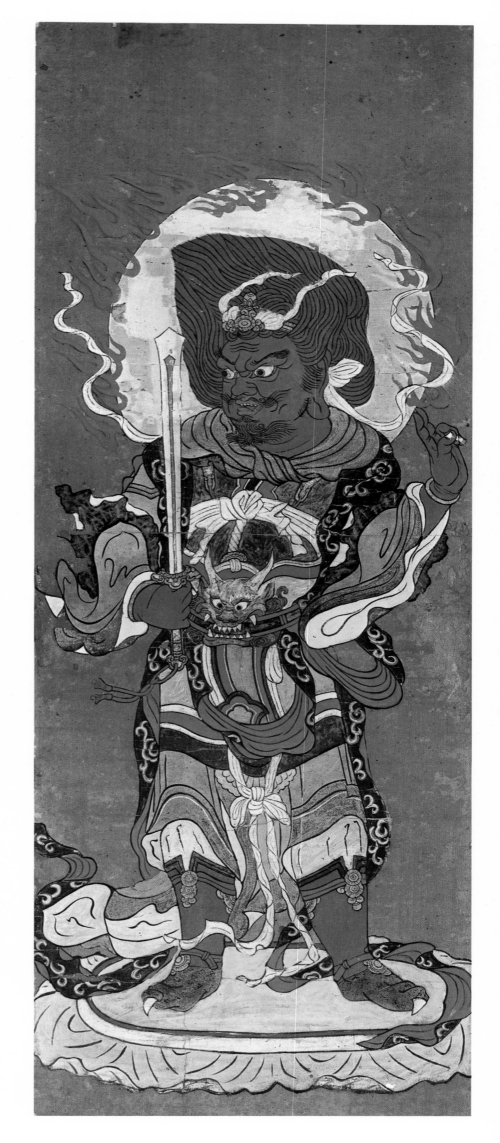

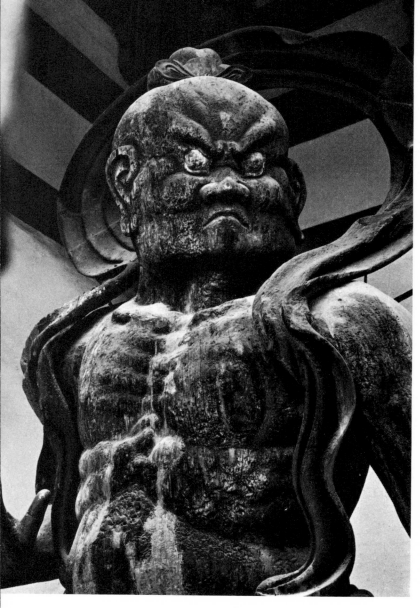

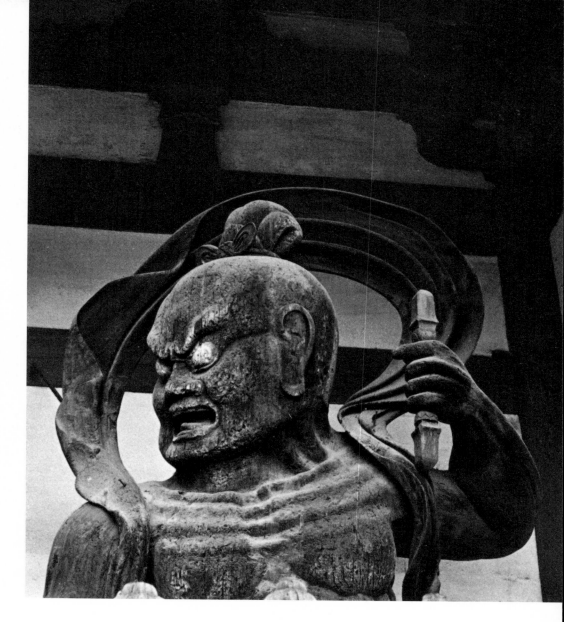

Details of a pair of Kongo Rikishis (Vajradharas) which flank the gate of the Daigo-ji, in the region of Kyōto. Heian period (794–1184). Height 3.60 m.

THE GUARDIANS OF THE DOCTRINE

Beneath their human appearance, Buddhas and bodhisattvas are completely spiritual beings, without fleshly substance. The *devas* or guardians, on the other hand, are represented in exaggerated human form. I had already been struck, in India, by the difference in style between the deities adorning the various parts of the early Hindu tantrist temples (fifth to eighth century) and the guardians of the doors. The latter were represented as strapping fellows, peasants armed with clubs. In Japan too the entrance gates to the temples are flanked by astonishing wooden statues two or three metres tall, with bare torsos, jutting veins and knotted muscles—the very embodiment of physical strength and virility. The guardian on the right has his mouth open; the guardian on the left has his jaws clenched. They thus express the beginning and the end of all things, like the "Chinese lions" flanking the gates of Shinto shrines.

Guardian in the Enryaku-ji, Mount Hiei, centre of the ▶ Tendai School, north-east of Kyōtō.

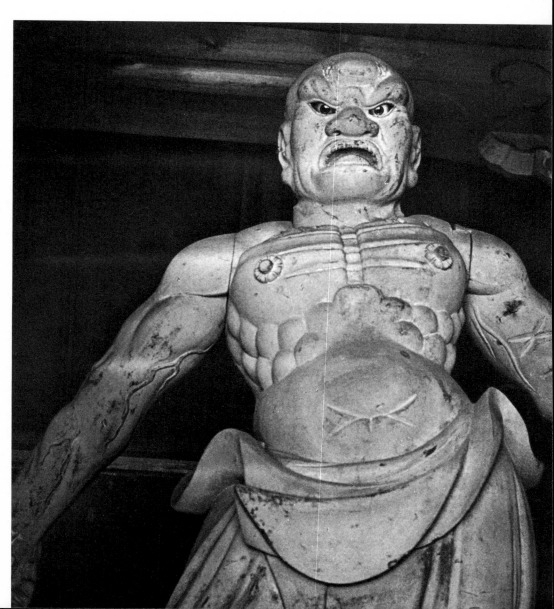

THE THIRTEEN BUDDHAS
OF THE SHINGON SCHOOL

Paintings representing the Thirteen Buddhas *(Jusan Butsu)* are frequent in the Shingon school from the fourteenth century on. In fact the group consists of five Buddhas, seven bodhisattvas and Fudō-Myōō. These paintings enable someone who is dying to identify with all the chief deities of the two mandalas in turn. In addition, each of the Thirteen Buddhas in turn must be invoked by the relatives and friends of a deceased person, in ceremonies held at increasingly long intervals: Fudō-Myōō (No. 1 of the series) has to be invoked one week after the death, and Kokuzo (No. 13) thirty-three years after.

① **Fudō Myōō**
② **Śākyamuni**
③ **Mañjuśrī**
④ **Samantabhadra**
⑤ **Kṣitigarbha (Jizō)**
⑥ **Maitreya (Miroku)**
⑦ **Bhaiṣajyaguru (Yakushi)**
⑧ **Avalokiteśvara (Kannon)**
⑨ **Mahastamaprapta**
⑩ **Amitābha (Amida)**
⑪ **Akṣobhya**
⑫ **Mahāvairocana**
⑬ **Akāśagarbha**

The thirteen Buddhas of the Shingon School.
Painted engraving, sixteenth century.

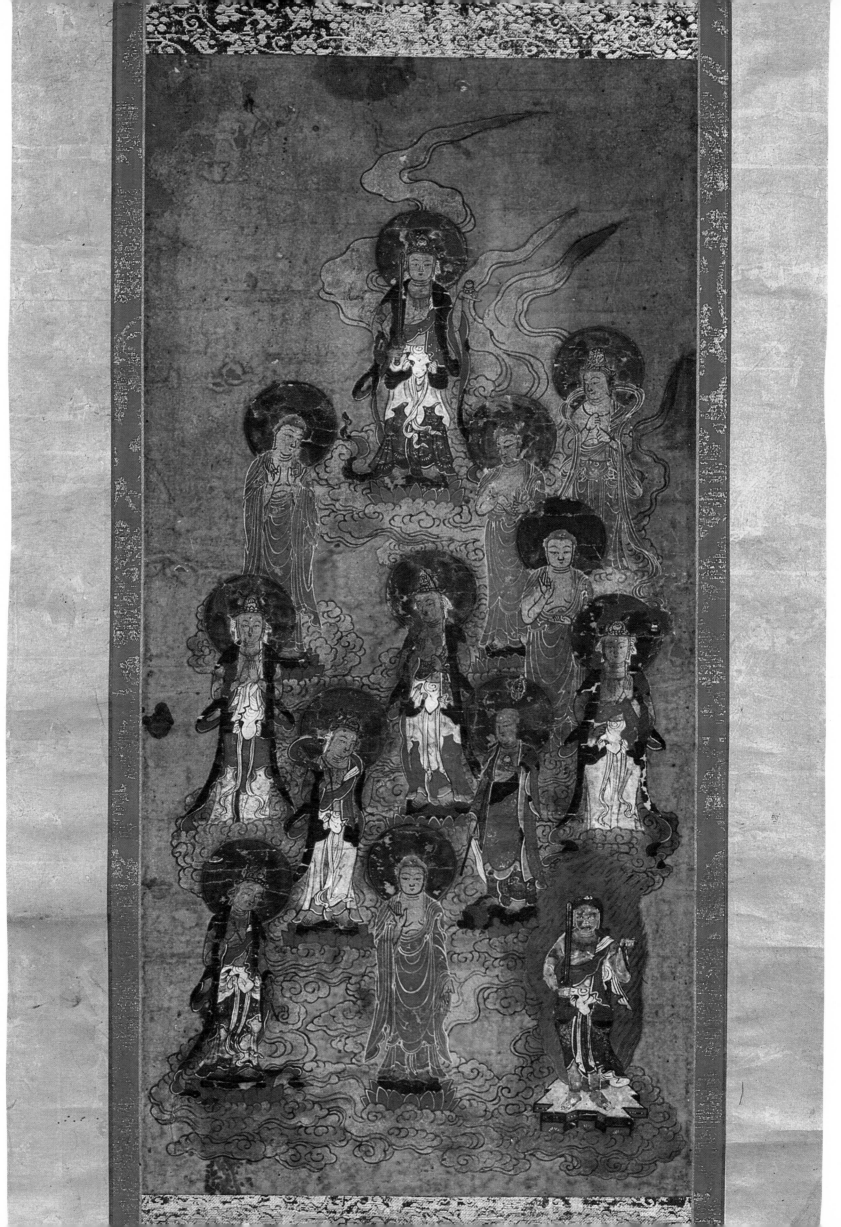

ON THE ART OF ESOTERIC BUDDHISM

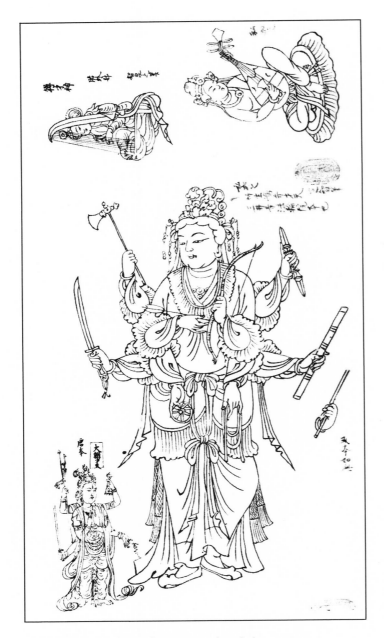

Detail from a plate of iconographical drawings, twelfth century.

The art of esoteric Buddhism is the expression of Form, it being of course understood that Form is none other than Emptiness. If Emptiness is expressed by Form, it is simply because beings, living as they do in the universe of Forms, are incapable of apprehending Emptiness directly. Although Form has no substantial reality, it is for us the only Reality that is tangible; it must not be rejected, because it alone can enable us to become aware of the Emptiness it "covers." It is from this point of view that we should approach the plastic manifestations of esoteric Buddhism.

> *"Pursue not the world, which is subject to causality.*
> *Linger not in an Emptiness excluding phenomena.*
> *If the mind rests in peace in the One, these double visions disappear of their own accord.*
> *If you try to escape from phenomena, they engulf you; if you pursue emptiness, turn your back on it."*

(Extracts from the Shin-shin-ming [inscription on the Spirit of the Law], one of the earliest known Ch'an treatises, by Seng-ts'an, Third Ch'an Patriarch after Bodhidharma, died at the beginning of the seventh century.)

It is very dangerous to talk about the "art" of esoteric Buddhism, because art is a relatively recent western concept which has no exact equivalent in the East. But I shall use the word, for want of a better, to speak of the plastic manifestations of Shingon, using it in the sense defined by Zeami (1363–1444), the Japanese dramatist who codified the practice of the Nō theatre:

> *"So that which is called 'art,' because it appeases the minds of all men, creating emotion in great and humble alike, may be the starting point of an increase in longevity and happiness, a means of prolonging life."*
> (Quoted by René Sieffert in
> *La tradition secrète du Nō,* Paris, Gallimard, 1960.)

In the context of esotericism, art is to be regarded as an *upāya,* a Sanskrit word usually translated as "stratagem," a "device or temporary means to achieve an end." Art is above all utilitarian. It is a tool; but like all tools it can be effective only when properly used.

Ritual is effective only if the *mantras* are correctly pronounced and the *mudrās* perfectly performed. Similarly, a painting or sculpture of a deity will only perform its "magic" role if it has been produced in strict accordance with the rules. These rules are derived from the *sūtras* and their commentaries. Proportion, gesture and colour are all minutely described in these texts, and the slightest mistake deprives the painting or sculpture of all virtue. *Mantras* and *mudrās,* paintings and sculptures are all cogs in a precision mechanism whose object is to lead the devotee to transcendence. The mechanism was perfected by generations of Indian sages who put its efficiency to the test, but instructions as to its use were divulged to none but those who had proved they would make good application of the powers it conferred. But although the codification of esoteric painting and sculpture was carried to an extreme, we should beware of concluding that we are in the presence of works which are purely mechanical and hidebound.

Although to us the "artist's" room for manœuvre may seem narrow and his personal contribution nonexistent, that is because we tend nowadays to ascribe to the artist a role he never possessed in traditional cultures. For him, then, it was not a matter of expressing his fantasies and his personal visions of the Universe. A painter or sculptor who has to create while obeying the instructions of texts and designs and models handed down by tradition is in the position of the conductor of an orchestra, who with the help of the players he directs has to interpret a work from the score left behind by the composer. The interpretation of any one text will be undistinguished or brilliant according to the talent of the artist. Mystification is impossible, because the text is known to all the spectators, who can distinguish at a glance between the work of the plodding copyist and that of the Master. The Master is the Enlightened One: only he can create models, since texts and models alike only transcribe the ineffable experience he himself has known. The devotees of Shingon believe that he who has attained Enlightenment, he who is master of the "three acts" of word, thought and action, is master of all the realms of art (painting, sculpture, music, literature, gesture). For the Enlightened One, art is the only means of transmitting the content of his Enlightenment to the Unenlightened, of expressing the Absolute through the Relative, and through Form the Emptiness of Ultimate Reality. But although tantric works of art are always meant to be instruments helping to lead to Enlightenment, they are not all genuine messages from Enlightened Ones. When they are, however, we recognize them at once, because they express our true nature and stir our whole being, just as we are stirred when we meet an Enlightened One face to face.

These paintings and sculptures were designed to give me real help in discovering who I am. There is a fundamental difference between an exoteric and an esoteric Buddhist sculpture. In the first I contemplate the Enlightened One; in the second I contemplate the Enlightenment that is in me. The first is silent; the second speaks to me. It is designed to communicate with me by every possible means, subconscious even more than conscious; its message should reach me through every pore. If the statue is anthropomorphic, that is so that communication may be more direct, so that I may feel I am looking into a mirror. When I contemplate the carved or painted face of the Tathāgata, of a Buddha, of a bodhisattva, or of any esoteric deity, I am contemplating my own true nature. Only my ignorance prevents me from recognizing myself. I think the deity is wearing a mask, when it is I who have not taken off my own. To become aware of my true nature is precisely to throw off my mask, to "relax," let go, let out all that I have obstinately been repressing in my subconscious. When I contemplate the deity I see myself unmasked, relaxed, liberated, awakened. To become aware of my oneness with the Buddha I must stop clinging to my illusory ego, to my "personality" (the word comes from "persona," the mask used in the ancient Greek theatre to amplify the sound of the actor's voice). Buddhas and bodhisattvas are thus a representation of my own true nature, the true nature of all beings. The difference between beings is merely illusory. Once they have taken off their masks they are the same—identical in their Emptiness. Is it possible to represent in terms of images, and thus in terms of Form, the non-substantiality of the self, its Emptiness, when the Absolute is by definition unthinkable and inexpressible? Yes, answered the Patriarchs of esoteric Buddhism. Images are even the only way of representing the innumerable facets and elements of the Ultimate Reality of the Universe. As we have already said, an image alone, which is an expression of the Relative and of our dualized thought, is not enough. But an image has life only when it is contemplated, and then it is no longer alone.

"It is through the subject that the object is object; it is through the object that the subject is subject. If you seek to know what they are in their illusory duality, know that they are nothing but a void."

Seng-ts'an, Third Ch'an Patriarch.

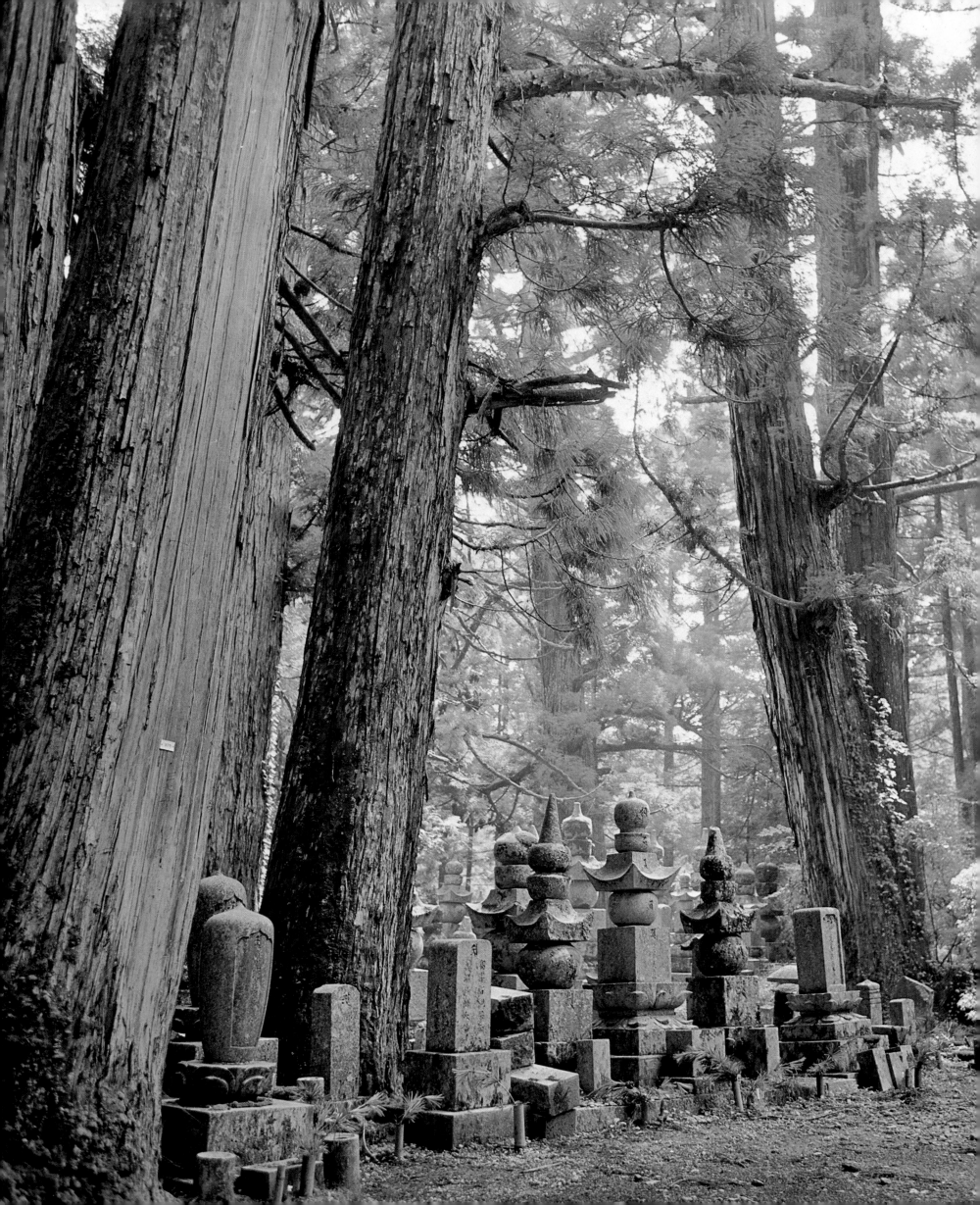

Bibliography

List of Illustrations

Glossary-Index

Table of Contents

The cemetery at Kōyasan
where Kōbō Daishi was
cremated in 835.

The author would like to express his thanks for help and advice received from Yokoyama Kiiko and Takehara Akiko, Tokyo; Terai Michiko, Kyoto; Janette Ostier and Nelly Delay, Paris; Professor Robert Heinemann and the Reverend Jean Eracle, Geneva; and the staff of Skira Art Books, Geneva.

Bibliography

Horiu TOKI, *Si-do-in-dzou. Gestes de l'officiant dans les cérémonies mystiques des sectes Tendai et Singon,* translated from the Japanese by S. Kawamura, Paris 1899. — Alice GETTY, *The Gods of Northern Buddhism, their history, iconography and progressive evolution through the Northern Buddhist countries,* Oxford 1914. — Paul PELLIOT, *Les grottes de Touen-houang. Peintures et sculptures bouddhiques des époques Wei, des T'ang et des Song,* Paris 1920-1924. — J. BUHOT, *La pluralité des bouddhas, les principaux personnages du Panthéon bouddhique,* Bulletin de l'Association française des Amis de l'Orient, Paris 1923. — Langdon WARNER, *Japanese Sculpture of the Suiko Period,* New Haven 1923. — *Hōbōgirin: Dictionnaire encyclopédique du bouddhisme d'après les sources chinoises et japonaises,* edited by Sylvain Lévi, J. Takakusu and Paul Demiéville, Tokyo 1929-1937. — Emile STEINILBER-OBERLIN and Kuninosuke MATSUO, *Les Sectes bouddhiques japonaises. Histoire, doctrines philosophiques, textes, sanctuaires,* Paris 1930. — B. BHATTACHARYA, *An Introduction to Buddhist Esoterism,* London 1932. — H.D. SANKAHA, *The University of Nālanda,* Madras 1934. — Sir Charles ELIOT, *Japanese Buddhism,* edited and with a final chapter by George B. Sansom, London 1935. — Ryujun TAJIMA, *Etude sur le Mahāvairocana-sūtra (Dainichikyō),* Paris 1936. — Osvald SIRÉN, *Chinese Sculpture from the Vth to XIVth Century. Studies on Chinese Art and Some Indian Influence,* London 1938. — Helmuth von GLASENAPP, *Buddhistische Mysterien, die geheimen Lehren und Riten des Diamant-Fahrzeugs,* Stuttgart 1940; *Mystères bouddhistes, Doctrines et rites secrets du "Véhicule de diamant",* translated by Jacques Marty, Paris 1944. — CHOU YI-LIANG, *Tantrism in China,* typewritten thesis, Harvard University 1944. — J. TAKAKUSU, *The Essential of Buddhist Philosophy,* Honolulu 1947. — M.T. de MALLMANN, *Introduction à l'étude d'Avalokiteśvara,* Paris 1948. — S.B. DASGUPTA, *An Introduction to Tantric Buddhism,* Calcutta 1950. — Jeannine AUBOYER, *Moudra et hasta ou le langage des signes,* London 1951. — Edward CONZE, *Buddhism, its Essence and Development,* introduction by Arthur Waley, New York and Oxford 1951. — YUNG-KANG, *The Buddhist Cave Temple of the Vth Century A.D. in North China,* Kyoto 1951-1956. — Heinrich ZIMMER, *Philosophies of India,* edited by Joseph Campbell, London 1951. — Edwin O. REISCHAUER, *Ennin's Travels in T'ang China,* New York 1955. — J. GERNET, *Les aspects économiques du Bouddhisme dans la société chinoise du Ve au Xe siècle,* Saigon 1956. — R. de BERVAL (editor), *Présence du Bouddhisme,* special issue of France-Asie, Saigon 1959. — Ryujun TAJIMA, *Les deux Grands Mandalas et la doctrine de l'Esotérisme Shingon,* Tokyo-Paris 1959. — Basil GRAY, *Buddhist Cave Paintings at Tun-huang,* London 1959. — E. Dale SAUNDERS, *Mudrā. A Study of Symbolic Gestures in Japanese Buddhist Sculpture,* New York 1960. — Giuseppe TUCCI, *The Theory and Practice of the Mandala, with special reference to the modern psychology of the subconscious,* translated from the Italian by A.H. Brodrick, London 1961. — Kenneth K.S. CH'EN, *Buddhism in China, A Historical Survey,* Princeton 1964. — A. BHARATI, *The Tantric Tradition,* London 1965. — A.F. WRIGHT, *Buddhism in Chinese History,* Stanford 1970. — C. LOKESH CANDRA, *The Esoteric Iconography of Japanese Mandalas,* New Delhi 1971. — KŪKAI, *Major Works,* translated with an account of his life and a study of his thought by Yoshito S. Hakeda, New York 1972. — T. SAWA, *Art in Japanese Esoteric Buddhism,* translated by R.L. Gage, New York-Tokyo 1972. — N. VANDIER NICOLAS, with S. GAULIER, F. LEBLOND, M. MAILLARD and R. JERA-BEZARD, *Bannières et peintures de Touen-Houang conservées au Musée Guimet,* descriptive catalogue, Paris 1974.

List of Illustrations

Unless otherwise indicated, all black and white photographs are by Pierre Rambach,
as are the colour photographs on pages 13, 56, 80-81, 131 (right) and 162

Photographs of temple ceremonies

Sculptures

Glossary-index of deities, places and temples, and of Japanese and Sanskrit words

Deities

Acala (in Japanese, Fudō). Deity found in the Vajradhātu mandala, mandala No. 8 (Trailokyavijayakarma mandala). The name means motionless, unshakable; it is associated with the idea of a mountain (the deity is depicted as sitting or standing on a rock). He is a "wrathful" aspect of Vairocana, one of the Five Great Kings of Light (Go dai Myōō) of the quarter of the Vidyādharas in the Garbhadhātu mandala 26, 34, 47, 76, 134, 136-140, 142, 152, 158.

Acalanatha. See Fudō Myōō 134.

Agni. Fire (Latin ignis, Japanese Katen). Deity of Hindu origin, one of the twelve devas of the outer quarter of the Garbhadhātu and one of the four elements (to the south-east) in the central mandala (maha mandala) of the Vajradhātu 53, 148, 149.

Akāsagarbha. "Womb of the sky, of the ether, of the void." In Japanese, Kokūzō. Chief deity of one quarter of the Garbhadhātu. Symbolizes the complete attainment of happy virtue and wisdom. In his right hand he holds a sword with a rounded point, in his left an open lotus surmounted by a flaming ball 104, 147, 158.

Akṣobhya. The unshakable (in Japanese, Ashuku Nyorai). Name of the Buddha of the East in the Vajradhātu mandala 72, 78, 86, 128, 158.

Amida. Japanese name of Amitābha, "infinite light," and of Amitāyus. Name of the Buddha of the West in the Vajradhātu mandala. Corresponds to Lokeśvararaja in the west petal of the central lotus in the Garbhadhātu 10, 47, 64, 76, 78, 80, 91, 94, 112-114, 116, 119, 122, 128, 130, 152, 158.

Amitābha (Muryōkō). See Amida.

Amitāyus (Sejizaio Nyorai). See Amida.

Amoghasiddhi. In Chinese, Pu-k'ung Ch'eng-chiu Ju-lai; in Japanese Fukūjōju Nyorai. Buddha of the North in the Vajradhātu 78, 128.

Avalokiteśvara. In Japanese, Kanjizai or more usually Kannon; in Chinese, Kuan-Yin. Bodhisattva who is the "cause" of Amida 52, 104, 119, 122, 123, 128, 130, 147, 148, 158.

Bhaiṣajyaguru. Master of Medicine: in Japanese, Yakushi Nyorai. Buddha not represented in the mandalas, but assimilated in esoteric Buddhism to the Vairocana of the Garbhadhātu mandala 12, 111, 158.

Bishamonten. In Sanskrit, Vaiśravana. Deity of the Vajradhātu mandala, also found in the outside quarter of the Garbhadhātu (to the north). One of the seven gods of happiness in popular mythology 149, 152.

Bonten. Japanese name of Brahmā, creative deity of Brahmanism. He figures in both mandalas 149.

Brahmā. See Bonten.

Candra. In Japanese, Gatten. Deity of the moon 149.

Candraprabha. Literally brightness, splendour (prabha) of the moon (candra); in Japanese, Gakkō. Deity often found on the right of statues of the Master of Medicine (Bhaiṣajyaguru, Yakushi Nyorai) 110, 111, 152.

Cintāmaṇi Cakra. One of the forms assumed by the bodhisattva Avalokiteśvara. In Japanese, Nyoirin Kannon 123, 124, 128.

Dainichi Nyorai. In Sanskrit, Mahāvairocana Tathāgata. Great solar or cosmic Buddha in the centre of both mandalas 97, 98, 108, 109, 113.

Daiitoku Myōō: Yamantaka, one of the Five Great Kings of Light in the quarter of the Wrathful Ones in the Womb mandala 144.

Emmaten or **Enmaten.** In Sanskrit, Yama, death; Yamarāja, king of death. One of the twelve devas of the Orients, in the south sky, to the south in the Garbhadhātu mandala. According to the Vedas, Yama is the god who controls the socio-cosmic order, who rules over life and death on earth 144, 149.

Fudō and **Fudo Myōō.** See Acala.

Fugen. See Samantabhadra.

Fūten. In Sanskrit, Vāyu. Wind god, one of the twelve devas in the north-west of the Heaven and in the Womb mandala 149, 154.

Gakkō. See Candraprabha.

Gatten. See Candra.

Gōzanze Myōō. See Trailokyavijaya.

Gundari Myōō. One of the Kings of Knowledge, Wisdom and Light 145.

Hayagriva. In Japanese, Batō Kannon. One of the aspects of Avalokiteśvara 128.

Indra. "Emperor of Heaven" (in Japanese, Taishakuten). Chief sky and thunder god in the Vedic period. Became less important in Hinduism and was incorporated into the Buddhist pantheon as one of the twelve devas, the one in the east of the Sky and in the Womb mandala. He occurs also in the Diamond mandala 76, 149, 151.

Iśāna. In Japanese, Ishanaten. One of the twelve devas, in the north-east corner of the Sky and in the Womb mandala 149, 150.

Ishanaten. See Iśāna.

Jikoku-ten. In Sanskrit, Dhṛtarāstra. One of the four guardian kings of the Sky 149.

Jizō. In Sanskrit, Kṣitigarbha, "womb of the earth"; in Chinese, Ti-tshang. Bodhisattva, "saviour from the hells" 56, 104, 116, 128, 130-133, 158.

Jūichimen Kannon. Literally, eleven-headed Kannon 124.

Kanjizai. See Avalokiteśvara.

Kannon. The bodhisattva Avalokiteśvara, who in China, under the name of Kuan-Yin, took on a feminine appearance 47, 76, 94, 119, 122-124, 127, 128, 130, 133, 152, 158.

Katen. See Agni.

Kokūzō. See Akāsagarbha.

Kṣitigarbha. See Jizō.

Kuan-Yin. See Avalokiteśvara.

Lakṣmi. Hindu god, the śakti of Viṣṇu 17.

Mahāvairocana. Literally the Great Illuminator, the Great Illuminating Principle (in Japanese, Dainichi). Chief deity of the Shingon School, in the centre of both mandalas 15, 18, 20, 22, 25, 46, 52, 64, 78, 80, 93, 95, 98, 102, 104-106, 108, 113, 130, 134, 146, 147, 158.

Maheśvara. In Japanese, Daijizaiten. Hindu deity assimilated to Śiva 142, 143.

Maitreya. Benevolence. In Japanese, Miroku. The Buddha of the future 52, 93, 104, 119, 120, 130, 158.

Mañjuśrī. In Japanese, Monju; in Chinese, Wen-chu. One of the four bodhisattvas 52, 104, 119, 120, 146, 158.

Monju. See Mañjuśrī.

Nichiyō. In Sanskrit, Sūrya, sun god of the Hindus, solar aspect of Viṣṇu 149.

Nikkō. In Sanskrit, Sūryaprabha, "brightness of the sun." His statue is often to the left of that of the Master of Medicine (Yakushi Nyorai) 110, 111, 152.

Nirṛti or **Nairṛti.** Destruction, calamity. Hindu divinity of death 136, 149.

Nirṛtirāja. In Japanese, Rasetsuten. One of the eight devas of the Orients in the south-west of the Sky and in the Womb mandala. A malevolent demon, wearing a breastplate, holding a sword and riding a white lion 149, 154.

Nyoirin Kannon. See Cintāmaṇi Cakra.

Parvati. Śakti of Siva 17.

Pṛthivi. In Japanese, Jiten. One of the twelve devas of the Orients. Corresponds to the Nadir in the Womb pattern. One of the four deities of the elements: the Earth, in the north-east of the Maha mandala of the Diamond pattern 53, 149.

P'u-hien. See Samantabhadra.

Rasetsu. In Sanskrit, Rāksasa. Malevolent nocturnal demon, deity of the Diamond pattern 154.

Rasetsuten. See Nirṛtirāja.

Ratnasambhava. In Japanese, Hōshō Nyorai; in Chinese, Pao-sheng Ju-lai. Buddha of the South in the Diamond pattern 72, 78, 128.

Roshana Butsu. Japanese transcription of the Sanskrit Vairocana Buddha 15.

Samantabhadra. In Japanese, Fugen; in Chinese, P'u-hien. Samanta means everywhere and bhadra means happy 52, 93, 104, 118, 119, 158.

Shōzanze Myōō. See Trailokyavijaya.

Śiva. Hindu god of creation and destruction 17, 69, 70.

Suiten. See Varuṇa.

Sūrya. See Nichiyō.

Sūryaprabha. See Nikkō.

Taishakuten. See Indra.

Ti-tshang. See Jizō.

Trailokyavajra. See Trailokyavijaya.

Trailokyavijaya. In Japanese, Shōzanze Myōō. One of the five deities of the quarter of the Wrathful Ones in the Womb mandala. The same as Trailokyavajra. According to some texts, they are the same deity in two persons 102, 134, 142.

Vairocana. See Mahāvairocana 53, 62, 66, 67, 69, 70, 86, 91, 93, 95, 98, 101, 106-108, 113, 119, 128, 142, 149, 152.

Vairocana Tathāgata. In Japanese, Roshana Butsu 15, 29, 57, 72, 106, 111.

Vaiśravana. See Bishamonten.

Vajradhara. In Sanskrit, he who carries the vajra; in Japanese, Kongōji 157.

Vajradhūpā. In Japanese, Kongōshōkō bosatsu 128.

Vajragandhā. In Japanese, Kongōzuko bosatsu 128.

Vajragitā. In Japanese, Kongōka bosatsu 128.

Vajralāsyā. In Japanese, Kongōki bosatsu 128.

Vajrāloka. In Japanese, Kongōtō bosatsu 128.

Vajramālā. In Japanese, Kongōman bosatsu 128.

Vajrānkuśa. In Japanese, Kongōkō bosatsu 128.

Vajranṛtyā. In Japanese, Kongōbu bosatsu 128.

Vajrapaṇi. Indian protective deity. Pairs of them (ni-ō) guard temple gates 104, 148.

Vajrapāṣa. In Japanese, Kongōsaku bosatsu 128.

Vajrapuṣpā. In Japanese, Kongōke bosatsu 128.

Vajrasattva. In Japanese, Kongōsatta. Deity of the Vajradhātu mandala and image of humanity receiving the secret message of the Tathāgata 15, 16, 20, 86, 101, 102.

Vajraphota. In Japanese, Kongōsa bosatsu 128.

Vajrāvesa or **Vajraghaṇta.** In Japanese, Kongōrei bosatsu 128.

Varuṇa. In Japanese, Suiten. Water deva, found in both mandalas. One of the eight devas of the Orients, the one corresponding to the west 53, 149, 154.

Vāyu. In Japanese, Fūten. Wind deva, found in both mandalas. One of the eight devas of the Orients, in the north-west of the Sky and of the mandala 53, 149, 154.

Viṣṇu. One of the three chief Hindu deities, whose role is to maintain life on earth 17.

Wen-chu. See Mañjuśrī.

Yakushi Nyorai. In Sanskrit, Bhaiṣajyaguru Tathāgata. The Master of Medicine 12, 110, 111, 113, 152.

Yama. See Emmaten.

Yamantaka Myōō. In Sanskrit, Yamantaka. One of the Five Great Kings of Light in the quarter of the Wrathful Ones in the Womb mandala. Also found in the eighth mandala of the Diamond pattern 134, 144.

Places

Aiholli or **Aihole.** Present name of an Indian village in the Bijapur district of the Deccan. First capital of the Chalukya kings, fifth century A.D.; they called it Aryavole, city of the Aryas 17, 18.

Badami. Present name of an Indian village in the Deccan, second capital of the Chalukya kings in the sixth century A.D. 18.

Borobudur. Tantric Buddhist temple in central Java, built by the kings of the Sailendra dynasty, eighth-ninth century A.D. 18.

Ch'ang-an. Capital of T'ang China 20, 22, 24-27, 33, 36.

Heian-kyō. Name of the capital founded in 794 by the Japanese Emperor Kanmu and modelled on Ch'ang-an. The present Kyōto, which remained the imperial capital until 1869 24, 26.

Heijō-kyō. Ancient Japanese capital built in 710 and modelled on Ch'ang-an, on the site of the present Nara, abandoned in 740 25.

Hiei. Mountain 830 metres high dominating Kyōto from the north-east. The monk Saichō (767-822), fleeing from the capital Heijō-kyō, settled in a hut here in 788. When the Emperor Kanmu founded Heian-kyō in 794 at the foot of Mount Hiei, he asked Saichō to build a temple on the mountain to protect the city from evil spirits supposed to come from the north-east. The temple (Hieizan-ji) later came to be known as Enryaku-ji. In the Middle Ages the monks of Mount Hiei, now rich and belligerent, made frequent raids on Kyōto. In 1571 they were massacred, and the temples destroyed, by Oda Nobunaga; the temples were rebuilt by his successor Hideyoshi 30, 77, 80, 157.

Kōya. Mountain 2,858 feet high on the Kii peninsula, 100 km. south of Kyōto 32, 33, 38, 46, 57.

Kōyasan. Mount Kōya 32, 34, 38, 47, 56-58, 84, 97, 98, 111-114, 132, 133, 138, 142, 144, 145, 161.

Kyōto. Town founded in 794 under the name of Heian-kyō and modelled on Ch'ang-an. The imperial capital of Japan until 1869 16, 24, 29-33, 36, 37, 43, 46, 49, 69, 71, 78, 80, 101, 124, 127, 134, 142, 152, 157.

Kyūshū. One of the four main islands of the Japanese archipelago, the one farthest west and closest to Korea 26, 29, 34, 130, 131, 152.

Nagaoka-kyō. Japanese capital founded at the end of the Nara period, in 784, by the Emperor Kanmu, ten years before the founding of Heian-kyō (Kyōto) 25.

Nālanda. Big Buddhist monastery in northern India which flourished until the eighth century A.D. The starting point of orthodox esoteric Buddhism 16, 18-20, 22, 24, 34.

Nara. Town built on the site of the former capital at Heijō-kyō. It gave its name to a period of Japanese history (710-794) 12, 15, 24, 25, 30, 32-34, 36, 58, 76, 98, 111, 116, 123, 124, 130, 139, 152.

Ōsaka. Second largest city in Japan 38.

Paekche. Korean kingdom from the beginning of the Christian era up to 663 A.D. 24.

Pattadakal. Second capital founded in the Deccan, eighth century A.D., by the Hindu Chalukya kings 17, 18.

Takao. Hill north-west of Kyōto on which stands the Jingo-ji 30-32, 36, 46.

T'ien-t'ai. Mountain in China, site of a large Buddhist centre which gave its name to a School of Buddhism; in Japanese, Tendai 29, 30.

Tun-huang. Town in Central Asia on the Silk Road. An important Buddhist centre of T'ang China. The French Sinologist Paul Pelliot (1878-1945) brought back to France a large group of paintings from the cave library discovered there in 1900 by the Chinese (in the Ts'ien-fo-tong shrine, walled up during an invasion in the eleventh century A.D.) 118, 120, 123, 128, 132.

Vīkramaśīla. Buddhist monastery in north-west India. In the eighth century an important Tantric centre which sent out missionaries to teach in Tibet 22.

Yamato. The present region of Nara, the historical centre of ancient Japan 24.

Temples

Asuka-dera. Ancient temple in the Nara region, now known as the Ango-in 9, 24, 25, 137.

Chishaku-in. Temple in Kyōto, built in 1598, destroyed by fire in 1947 and since rebuilt. Headquarters of the Chizan branch of the Shingon school 36, 80.

Daigo-ji. Famous temple of the Shingon school, founded in 874 south of Kyōto. It is divided into two parts: at the foot of a mountain, a temple, a treasure chamber, and a pagoda built in 951; on the mountain top, a group of temples (Kami Daigo-ji) housing many tantric sculptures 36, 38, 101, 124, 134, 142-145, 157.

Daikaku-ji. Temple west of Kyōto 36.

Danko-ji. Temple in Nara 58.

Enryaku-ji. Temple on Mount Hiei which overlooks and protects Kyōto from the north-east. Founded in 788 by Saichō (767-822). Main temple of the Tendai sect 30, 77, 80, 157.

Contents

PRINTED BY
ROTO SADAG S.A., GENEVA
MAY 1979

PRINTED IN SWITZERLAND